COLORING THE UNIVERSE

COLORING THE UNIVERSE

AN INSIDER'S LOOK AT MAKING SPECTACULAR IMAGES OF SPACE

Dr. Travis A. Rector, Kimberly Arcand, and Megan Watzke

University of Alaska Press, Fairbanks

Cover image by T.A. Rector (University of Alaska Anchorage) and H. Schweiker (WIYN and NOAO/AURA/NSF). Formally known as IC 1396A, this dark nebula is more commonly known as the Elephant Trunk Nebula.

Back cover images by T.A. Rector and B.A. Wolpa (NRAO/AUI/NSF). The Eagle Nebula.

Author images by P. Michaud/Gemini Observatory (Rector) and Adeline & Grace photography (Arcand and Watke)

Cover and interior design and composition by Kristina Kachele Design, llc

This publication was printed on acid-free paper that meets the minimum requirements for ANSI / NISO Z39.48–1992 (R2002) (Permanence of Paper for Printed Library Materials).

SECOND PRINTING
PRINTED IN CHINA

University of Alaska Press
PO Box 756240
Fairbanks, AK 99775-6240

Library of Congress Cataloging-in-Publication Data
Rector, Travis A. (Travis Arthur)
Coloring the universe : an insider's look at making spectacular images of space /
by Travis Rector, Kimberly Arcand, and Megan Watzke.
pages cm
Includes bibliographical references.
ISBN 978-1-60223-273-0 (cloth : alk. paper) — ISBN 978-1-60223-274-7 (e-book)
1. Space photography. I. Arcand, Kimberly K. II. Watzke, Megan K. III. Title.
TR713.R43 2015
778.3′5—dc23
 2014049536

CONTENTS

FOREWORD

The night sky has always been a mystery, since the beginning of time, or at least since our species developed the intellect to wonder. While the motions of the planets and the cycles of the seasons were appreciated thousands of years ago, the stars remained a mystery until the first telescopes were turned on them, over two hundred years ago. The simple lenses of these primitive instruments funneled more light into the eye, giving the impression of a closer view with more detail than the eye alone could achieve. This revealed that the Moon has craters and the Sun has spots; planets were seen as discs of light with unexpected features such as rings and moons. These early discoveries soon transformed our understanding of the Universe around us and of our place within it, and encouraged a way of thinking that we now call science.

A similarly transformative technology was photography, invented in 1839 and first seriously applied to nighttime astronomy about forty years later. Photographic plates and films were sensitive to radiation the eye could not see, eventually aiding the discovery of X-rays and radioactivity. However, photography rapidly revolutionized astronomy with its ability to capture and retain the impression

of faint light during long exposures, something the eye cannot do. More recently, traditional photography has given way to digital imagery, which is not only more sensitive to faint light than photography but can also be transmitted over a radio link, enabling images to be received from Earth-orbiting satellites such as the *Hubble* Space Telescope and distant space probes such as *Cassini*.

We eventually see these images as pictures, but they are initially recorded by electronic sensors and analyzed as sets of scientific data with all the power and flexibility that modern computer processing can offer. This allows the data to be manipulated and presented in ways that were never possible in an analogue photographic darkroom. However, some ideas developed in darkrooms persist in modern software.

The term "manipulated" here must not be misinterpreted. The data are manipulated to extract and reveal scientific information. That's why the data are obtained in the first place, using sophisticated instruments and expensive facilities intended primarily for scientific research. But many scientifically oriented data sets can also be presented as images of incredible beauty, replete with information that appeals to scientist and artist alike. This often-complex process of making images that are both aesthetically pleasing and scientifically useful is at the heart of this book.

Vision is the richest of the senses, and we are used to interpreting the endless colors and varied textures of the world around us through our eyes. But even when viewed through the largest telescopes, most of the amazing star-forming nebulae and nearby galaxies that appear in these pages seem as faint gray smudges to the eye. Color is there but we cannot see it. By building up the faint signal from distant objects in an electronic detector the true colors can be revealed. But the question arises: If the colors of space have never been seen, how do you know what they should look like? That is a good and valid question, also addressed at length in these pages.

Adding to the suspicions aroused by words such as "manipulated," the term "false color" is also used in astronomical imagery. That is when colors are used to represent data in images that have been captured at wavelengths we cannot see under any circumstance, including radio, X-ray, or infrared data. But the interpretative power of combining data that include invisible wavelengths into a single image is enormous, and to do so real colors must be used. To that extent the result is unreal, but it is not false. Indeed such images can be remarkably revealing as well as unusually eye-catching.

Finally, the authors of this book are widely experienced in creating images that include both visible and invisible light over a very wide range of wavelengths, to be used for scientific and other purposes. While the procedures for extracting the

best scientific information and the most attractive images are very similar and sometimes identical, it is also possible to emphasize the essential beauty of what is a part of the natural world for a broader audience. This too is discussed in this richly illustrated book in a nontechnical style that will appeal to specialist and novice alike.

—Dr. David Malin

PREFACE

It's a clear August night in Mountain View, a northern neighborhood of Anchorage, Alaska. We were assembled to celebrate the grand opening of the MTS Art Gallery. Over thirty artists from the area were invited to present their work in a former mobile trailer supply store converted into an art space. While not technically an artist, I was given the opportunity to show my astronomical images on a wall in what was once a giant RV service bay. It was a room that called for something big, and I was invited to fill it with space itself.

Even though it was approaching 10:00 p.m., the bright summer night skies of Alaska meant viewers entering the darkened service bay could, at first, only see the giant images on the wall before them. It was almost as if they were walking into outer space. As they waited for their eyes to adapt to the darkness, I guided them into the gallery with my voice and answered questions. It was a rare opportunity to watch people interact with my images and freely ask what was on their mind.

"Are these real?"

"Is this what it really looks like?"

"If I were standing right next to this, is this what I would see?"

While most of the questions were eventually about what was in the images, nearly all of the first questions were about their authenticity. In a world made surreal with the magic of science-fiction special effects and digital image manipulation, there was a need to know that what we were seeing was real. That these fantastic cosmic starscapes were places that truly existed. Places perhaps we could someday visit.

The first question is easy to answer. Yes, everything you are seeing is real. These images are of real objects in outer space. They aren't creations of a graphic artist's imagination. But answering the other questions is not as simple. How a telescope "sees" is radically different from how our eyes see. Telescopes give us superhuman vision. In most cases they literally make the invisible visible.

All astronomical images, including the ones in this book, are translations of what the telescope can see into something that our human eyes can see. But how is it done? This is a question that has challenged astronomers and astrophotographers for decades. Many people, including my collaborators and me, have developed and refined techniques to take the data generated by professional-grade telescopes and turn them into color images. Along the way we've worked to develop a visual language to better convey an understanding of what these pictures show.

My coauthors, Kim Arcand and Megan Watzke, have worked in astronomy and with NASA data for almost twenty years. They have also studied how people interpret and interact with cosmic images. Together, we will show you how the scientists, visualization specialists, and public communications staff at the professional observatories create and share images of space. We'll talk about what they do and, perhaps more important, *do not do* when making an image. The knowledge we share in this book is drawn not only from our experiences but also from the expertise of the many talented individuals we've had the privilege to work with over the years. Throughout the book we've put many words and phrases in **bold** text. These are terms you are likely to see elsewhere (for example, in a science press release) and are worth knowing. We invite you to use this book to discover for yourself how the telescopes at the professional observatories are used to see and share the real Universe that we all live in.

—Dr. Travis A. Rector

ACKNOWLEDGMENTS

We'd like to thank our agent Elizabeth Evans of the Jean V. Naggar Literary Agency and our publisher, the University of Alaska Press, for making this book a reality. We also thank the scientists, photographers, and artists who let us use their materials. If it takes a village to raise a child, it takes an entire community to learn about the wonders of the cosmos. This book would not be possible without the countless women and men who have contributed to the quest to explore our Universe and communicate that knowledge to the widest possible audiences.

The three of us are indebted to Jeffrey Bennett, Andrew Fraknoi, and David Malin for their input on earlier versions of the manuscript. Travis would like to thank the many collaborators with whom he has worked on images, especially Heidi Schweiker, Peter Michaud, Kirk Pu'uohau-Pummill, Zolt Levay, Lisa Frattare, Jayanne English, Pete Marenfeld, Mark Hanna, Tim Abbott, and Nicole van der Bliek. Of course these images wouldn't be possible without the amazing telescopes and instruments at Gemini Observatory, the National Optical Astronomy Observatory (including Kitt Peak National Observatory and Cerro Tololo Interamerican Observatory), and the National Radio Astronomy Observatory,

which are owned and operated by the National Science Foundation. We also thank NASA for the many wonderful images produced by the *Hubble* Space Telescope, the *Chandra* X-ray Observatory, and the *Spitzer* Space Telescope. None of these images would be possible without the scientists, engineers, and staff who design, build, and operate all of these telescopes. This material is based upon work supported by the National Science Foundation under grant DUE-1523583. Any opinions, findings, and conclusions or recommendations expressed in this material are those of the author(s) and do not necessarily reflect the views of the National Science Foundation.

Kim and Megan would be greatly amiss if they did not mention the support from their colleagues at the *Chandra* X-ray Observatory Center. Kim would also like to thank the Aesthetics & Astronomy (A&A) group members, Lisa and Jeffrey Smith, Randall Smith, and Jay Bookbinder, as the A&A project has informed her work in astronomy imaging.

Personally speaking, Kim could not write any books without thanking her husband, John, for his loving support, her kids, Jackson and Clara, who are her tireless cheerleaders, her parents who are her biggest fans, and her dear family and friends for all of their support. Megan is forever thankful for Kristin, Anders, Jorja, Iver, and Stella, who help guide her way through this Universe, as well as for all of the love and encouragement from friends and family. *Travis dice: Abrazos y mil besos a mi Paolita y Claudita. Son mis estrellas y el cielo.* Every star you see is how many times I think of you.

COLORING THE UNIVERSE

HUMAN VERSUS TELESCOPE

Comparing Telescopic Vision with Human Vision

SEEING IS BELIEVING

Images of space can inspire awe and wonder. But in many urban and suburban spaces, the light from stars is mostly drowned out by the artificial glow (called **light pollution**) that humans have created. This is one reason that the pictures taken by telescopes on the highest mountaintops and remote deserts on Earth, as well as the armada of observatories in space, are so important. They are dramatic windows into our Universe.

The popularity of cosmic images is easy to spot. We see space pictures on computer screens and tablets, splashed on billboards, album covers, clothing, and everywhere in between. Despite our attraction and connection with space images, many people are not sure that what these images show is real. When one of our images was recently featured on a blog, several commenters were skeptical. "Really? Not Photoshopped? Amazing." Another person commented in Spanish, "Me estas jodiendo, no puedo creer que no esté trucada." (Rough translation: "Are you kidding me? I don't believe this hasn't been modified.") Others express doubt that we can even see that far away.

▶ The iconic Horsehead Nebula is part of a dense cloud of gas in front of an active star-forming region known as IC 434. Credit: T. A. Rector (NOAO/AURA/NSF) and the Hubble Heritage Team (STScI/AURA/NASA).

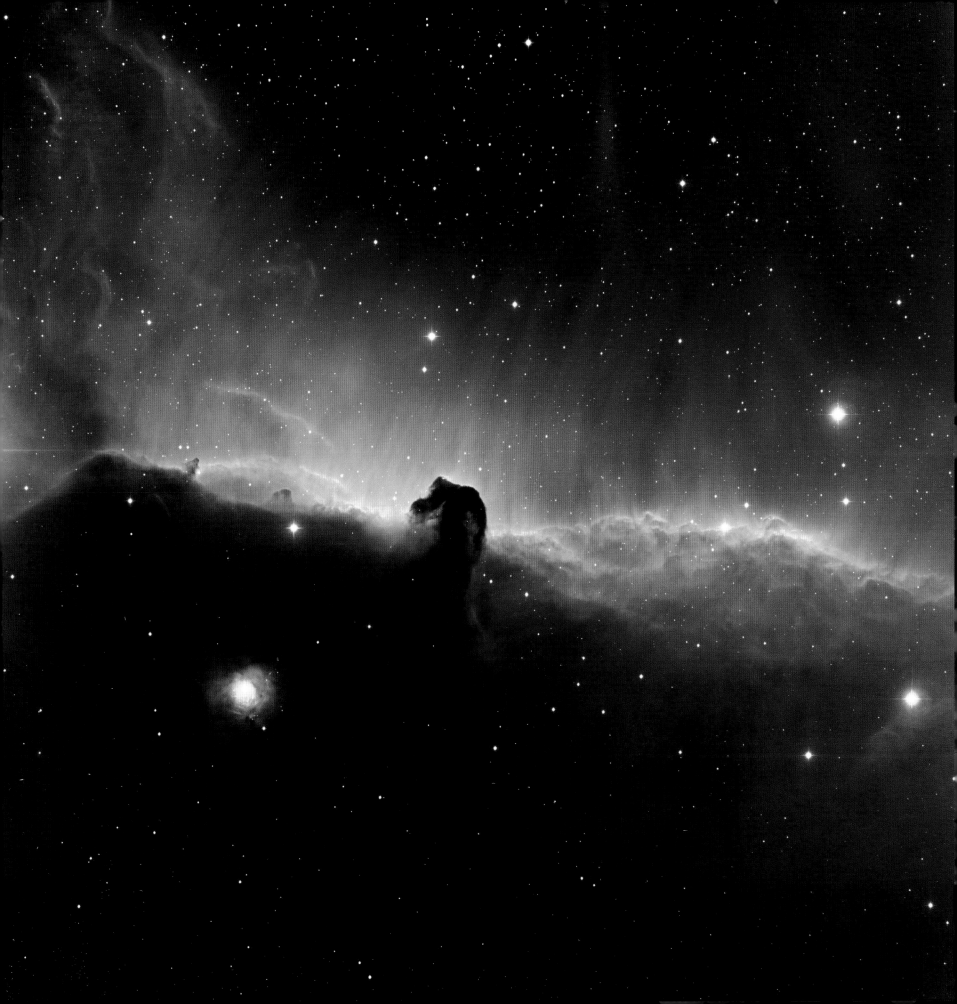

These are important questions for us to ask and, just as critically, ones that need to be answered. So where and why does the confusion, or even controversy, arise?

Let's look at an example. For many space aficionados, the picture on the previous page is iconic. It captures a famous object called the Horsehead Nebula, which gets its name from the distinctive dark shape at the center of the image. It is part of a large cloud of gas and dust called a nebula, found in the constellation of Orion, where hundreds of stars are being born.

The image was taken with an advanced digital camera from a telescope at the Kitt Peak National Observatory (KPNO)[1] in southern Arizona. This is what the telescope and its camera can see. But let's pretend you had the ability to board a spaceship and fly to the Horsehead Nebula—what would *you* see? After a journey of more than a thousand light-years,[2] you would finally arrive at your destination. You look out of the window of your spaceship at this same scene, but you're now at a distance one hundred times closer than before, when you were standing on the Earth. The image on the right shows what you would see.

You'd see some of the brighter stars but none of the dust and gas in the nebula, including the horsehead shape. Why?

THREE THINGS A TELESCOPE DOES

To better understand what's going on, it helps to know what a telescope does. Just as a pair of binoculars can make the upper-level seats in an arena almost as good as courtside, a telescope can make a distant object appear much closer. But a telescope does more than this. It doesn't just magnify an object; it also *amplifies* it. It makes something faint appear much brighter.

Some people might think that the reason why a telescope can see objects our eyes can't is because it magnifies something that is too small for us to see. And this is often true. But the Horsehead Nebula is actually not that small. The fields of view of these images of the Horsehead are about twice the size of the full Moon in the sky. You can't see it because it is too *faint*, not because it is too small.

Why couldn't you see the Horsehead Nebula even if you were much closer? For objects that appear to be larger than a point of light (for example, galaxies and nebulae, but not stars), how bright it appears has nothing to do with how far away it is. Moving closer to it will make it bigger, but not brighter. This may seem counterintuitive, but you can try it at home. Walk toward a wall. As you approach you'll notice that the wall is getting bigger but otherwise is the same brightness. The same is true of the Horsehead Nebula. If you can't see it with your eyes while standing on Earth, you still won't see it from your spaceship.

▸ The same area of the sky as shown in the first image of the Horsehead Nebula, but shown as you would see it with your naked eye. Credit: T. A. Rector (NOAO/AURA/NSF).

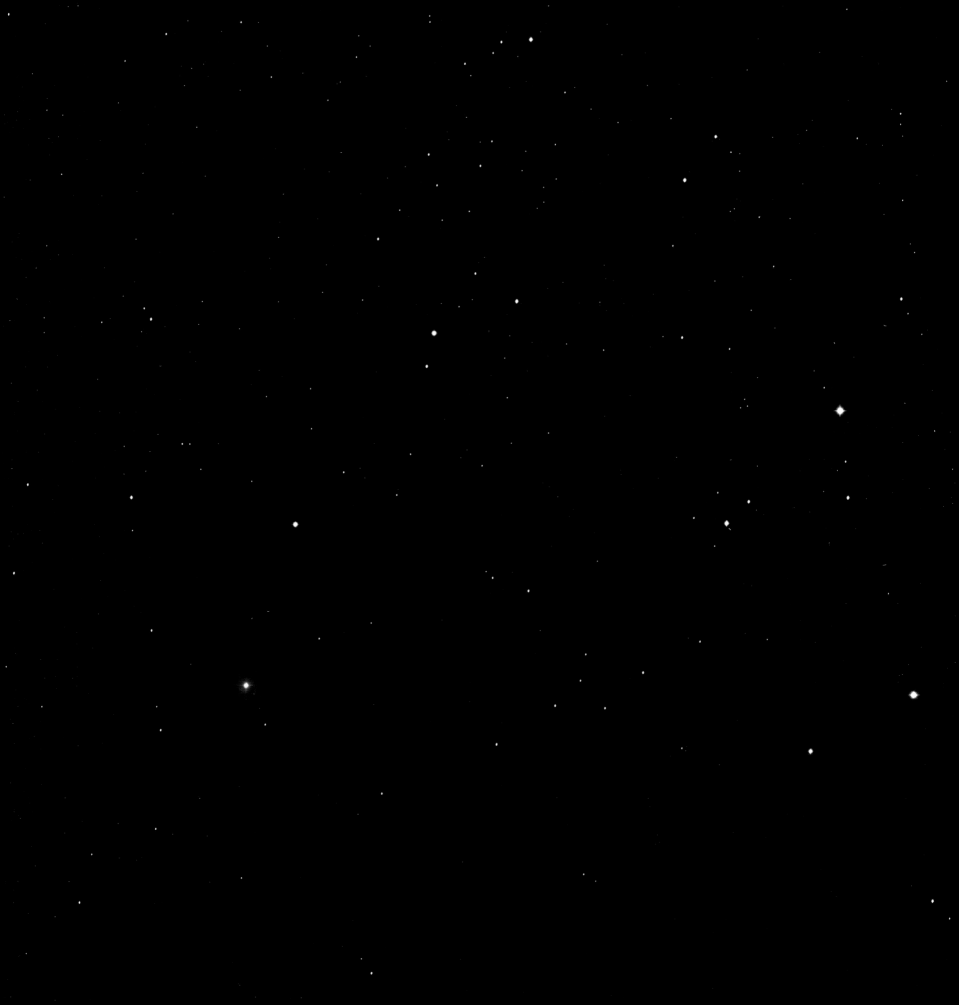

Why then can a telescope see it? A telescope offers several advantages over our eyes. As marvelous as the human eye is, it's not that well suited for nighttime observing. First, our eyes are tiny. The opening that allows light to enter, known as the pupil (the black area at the center of the eye), is only about one-quarter of an inch wide when fully open.

In comparison, the mirror that collects light for the *Gillett* Gemini North telescope, at one of the professional observatories atop Mauna Kea in Hawai'i, is about 27 feet[3] across. What this means is that, at any given moment, this mirror is collecting more than a million times more light than your eye. The more light you can collect, the fainter an object you can see.

Human eyes also don't collect light for long. Our eyes function like a video camera, taking images about thirty times every second. So the exposure time for each image captured by the human eye is only *one-thirtieth* of a second. With digital cameras attached to the telescope we can collect light for as long as we like. The longer the exposure, the more light the telescope collects.

What can our eyes see? We can gaze at the night sky but beyond picking out the constellations, we need specialized equipment to help us see faint objects in any detail, or to see other kinds of light beyond a small range of visible light. Credit: Petr Novák, Wikipedia CC License v2.5.

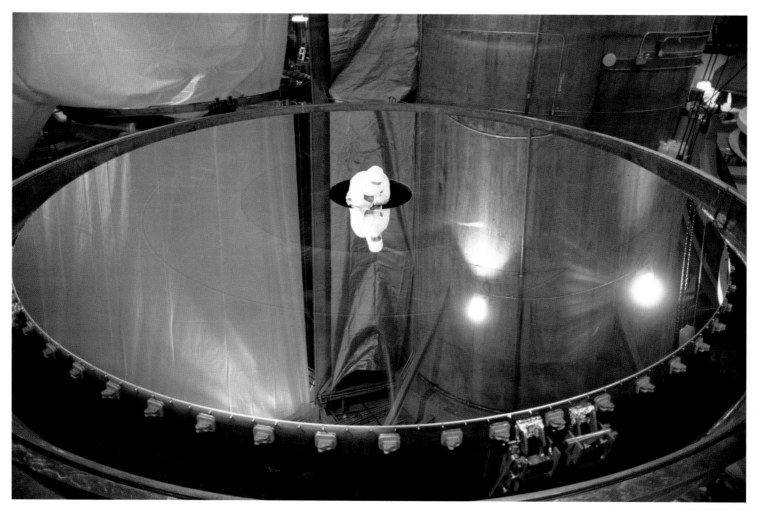

A specialist in a white "clean suit" sits at the center of the light-collecting mirror that was later installed in the Gemini North telescope in Hawaii. The mirror is 27 feet wide but only 8 inches thick. Credit: Gemini Observatory/AURA.

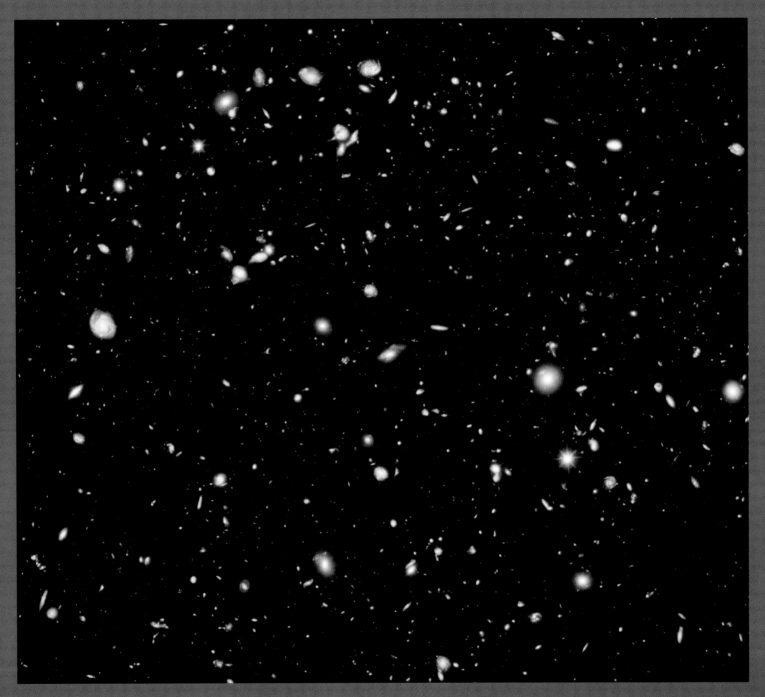

▲ The *Hubble* eXtreme Deep Field represents over 50 days worth of observations of a single portion of the sky with a cumulative exposure time of about 2 million seconds. The faintest objects in this image are galaxies about 30 billion light years away. Credit: NASA; ESA; G. Illingworth, D. Magee, and P. Oesch, University of California, Santa Cruz; R. Bouwens, Leiden University; and the HUDF09 Team.

Typically a single exposure is not more than ten to twenty minutes, but multiple exposures can be added together to make a single image with an exposure time that is, in effect, much longer. To create the most sensitive image ever made, astronomers collected over fifty *days* worth of observation time with the *Hubble* Space Telescope of a single portion of the sky. Known as the *Hubble* eXtreme Deep Field (XDF), this image represents a cumulative exposure time of about 2 million seconds.

As we'll talk about more in chapter 7, the human eye is complex. It isn't as sensitive to faint light, and it only detects amounts that are above a certain threshold. To prevent confusion, our brain filters out the "noise" below that level. In comparison, modern electronics detect nearly all of the light that enters a telescope's camera, even if it takes hours to collect the light. All of these factors enable telescopes to go far beyond the limits of human vision. The faintest objects in the XDF are about 10 *billion* times fainter than what the human eye can see.

Finally, the Universe and the amazing objects in it glow in other types of light— from radio waves to gamma rays—that are impossible for our eyes to see. We'll talk about these kinds of light, and the telescopes that observe them, in chapter 10. It's taken the ingenuity of scientists and engineers over the course of many decades to develop our abilities to capture the views of the Universe that we enjoy today. Without these technical tools, many phenomena and objects would simply be invisible to us entirely.

It's no exaggeration to say that telescopes give us superhuman vision. Nearly every astronomical image contains objects too small and/or too faint for us to see. And these images often show us kinds of light our eyes can't detect. How do astronomers take what the telescope sees and convert it into something we can see? Are these images showing us what the Universe *really* looks like? Turn the page and let's find out.

▶ This picture shows NGC 602, a cluster of bright young stars within the Small Magellanic Cloud. The image was made with kinds of light we can see (visible) as well as kinds we cannot see (infrared and X-rays). Credit: X-ray: NASA/CXC/Univ.Potsdam/L.Oskinova et al; Visible light: NASA/STScI; Infrared: NASA/JPL-Caltech.

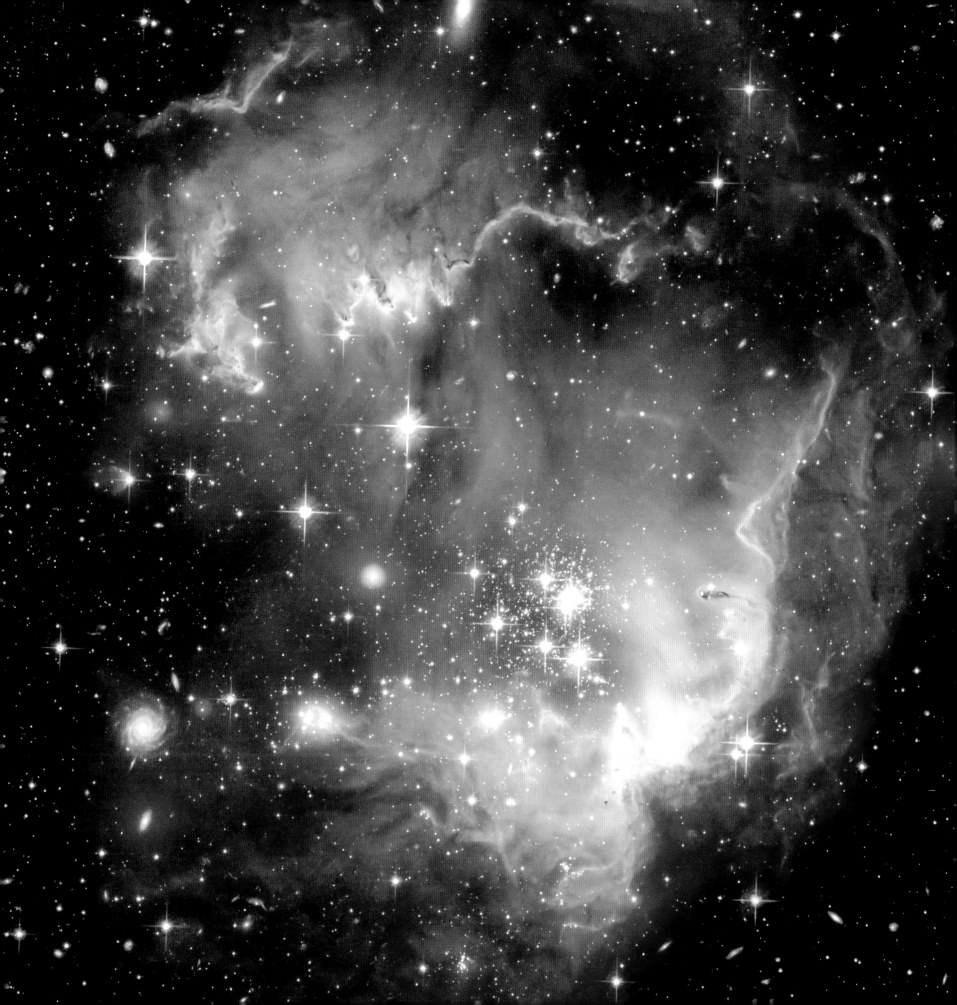

THIS IS NOT A SELFIE

How Telescopes and their Cameras Work

When a news story reports something like, "Astronomers have taken a picture of a new galaxy," it's easy to imagine scientists pointing a camera toward outer space, pressing a button ("click!"), and the image appears on the back of the camera. Perhaps even a flash goes off (it is nighttime after all). In reality, taking an image of a cosmic source is not the same as taking a picture with your phone.

HOW A "VISIBLE-LIGHT" TELESCOPE WORKS

As we mentioned in the last chapter, there are many different kinds of telescopes that detect different types of light—everything from radio waves to gamma rays and a bunch in between. In chapter 10 we'll talk about these other kinds of light. But we're going to start first with how a telescope looks at "visible"[4] light, which is the small slice of light we can see with our eyes.

Starting with visible-light telescopes is useful because they are the most familiar. If you have ever seen a telescope on top of a mountain, it probably detects visible light. The telescope you can buy at a toy store, science center, or a planetarium?

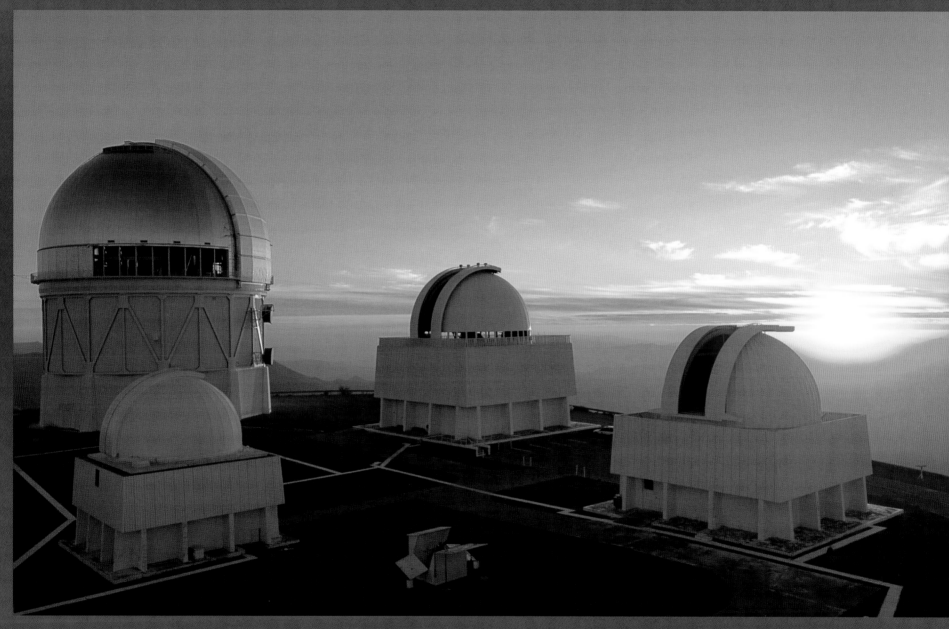

▲ The telescopes at Cerro Tololo Interamerican Observatory in Chile. As the sun sets, the domes for each telescope open their shutters in preparation for a night of observing. These telescopes are used to make many of the images you see in the news. So how do they work? Credit: T. Abbott and NOAO/AURA/NSF.

Also a visible-light telescope. And, the most famous telescope in the world—the *Hubble* Space Telescope[5]—can observe in visible light (and then some, as we'll talk about later).

Telescopes are sophisticated pieces of technology and engineering, but they can all be broken down into some simple pieces. Visible-light telescopes have either lenses or mirrors, or some combination, to collect and redirect light. To where does the telescope send this collected light? On a simple backyard telescope, it is sent to your eye. On more complex telescopes, the light is delivered to a camera or detector that can capture and store it.

Another way to think about it is that the telescope itself acts as a giant telephoto lens.[6] In short, a telescope is a device that collects light from a distant object. The camera then uses that light to make an image. For this reason, telescopes are often referred to as "light buckets." (Remember, the more light you can collect, the more you can see. This is why astronomers strive to build bigger telescopes—to have, in essence, bigger buckets for collecting light.)

There are many ways to build telescopes. And over the years scientists and engineers have come up with some ingenious designs. For ground-based telescopes, the challenge is to build them with high-quality optics that function well in a wide range of conditions. Telescopes must be built onto sturdy mounts that are capable of holding the telescope stable in winds of up to 40 miles per hour. If the telescope shakes, the image will be blurry. Because the Earth is rotating, telescopes are also designed to carefully track the night sky as it slowly moves. Without this tracking, stars would appear as streaks across the image. To prevent these streaks, telescopes monitor a **guide star**, a bright star in the telescope's field of view. Modern telescopes have computers that carefully control and adjust the telescope's movement to keep the guide star in the same spot in the image.

For telescopes on the ground, another issue is that the Earth's atmosphere can make an image blurry. This happens because of the motion of warm and cold air in our atmosphere. It's the same effect that causes objects to look distorted when seen through the hot air rising off of a hot road or from behind a jet engine. It's also what makes stars "twinkle." Astronauts in space don't see twinkling stars.

Fortunately there's a technique, known as **adaptive optics**, that can correct for most of the atmosphere's blurring effects. An adaptive-optics system makes extremely rapid but slight adjustments to the shape of the telescope's mirrors to counteract the blurriness our atmosphere causes. A computer calculates adjustments to the telescope's mirrors as it monitors a bright reference star. Some adaptive optics systems create their own reference star (or stars) by shining a laser into the sky in the same direction that the telescope is looking. The laser energizes sodium atoms in the atmosphere about 60 miles above the Earth, creating an

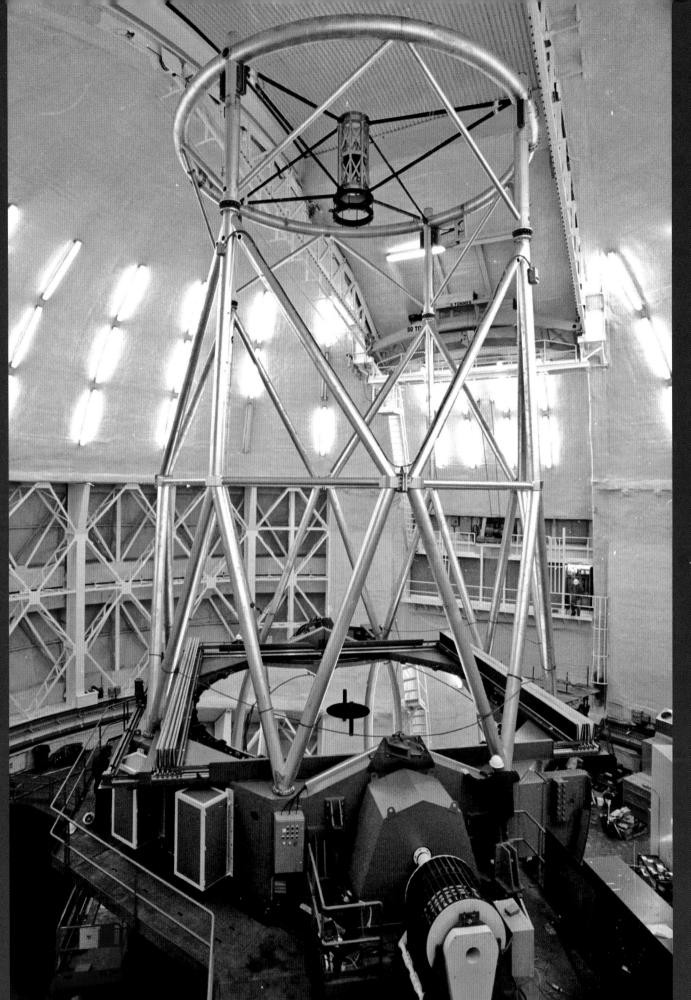

◄ The Gemini North telescope is more than 80 feet tall and weighs 380 tons. To save weight, the telescope is not inside a tube but rather uses a lighter metal structure to hold the mirrors. When the telescope is pointed at a target, the light comes through the top of the telescope and bounces off of the large mirror at the bottom (known as the primary mirror). The primary mirror focuses the light onto the secondary mirror, which is in the cylinder on the top of the telescope. The secondary mirror reflects the light back down through the hole at the center of the primary mirror. The cameras are on the bottom of the telescope, underneath the primary mirror, and can't be seen in this picture. Credit: Gemini Observatory/AURA.

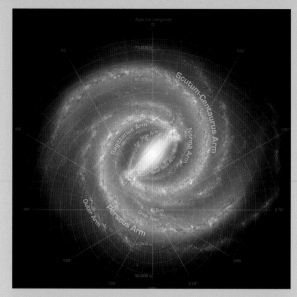

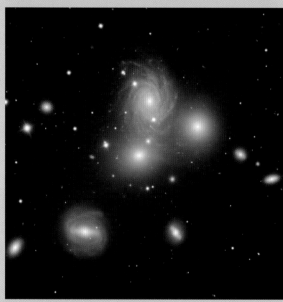

▲ An artist's rendering (top) shows a view of our own Milky Way galaxy and its central bar as it might appear if viewed from above. Our galaxy is thought to consist of two major spiral arms (named Scutum-Centaurus and Perseus) that are attached to the ends of a thick central bar. Our Sun resides in a minor spiral arm known as the Orion Spur, as do many of the objects pictured in this book. The galaxies in the cluster VV 166 (bottom), including the blue spiral near the top (NGC 70), are roughly 100 times farther away than M31. Top credit: NASA/JPL-Caltech/R. Hurt (SSC/Caltech). Bottom credit: Gemini Observatory/AURA and T. A. Rector (University of Alaska Anchorage).

HOW BIG IS THE UNIVERSE?

When people learn about the giant telescopes professional astronomers use, a common question is, "How far can they see?" But perhaps a more interesting question to ask is how *faint* can they see. That's because how bright an object appears depends not only on its distance from us but also on its intrinsic brightness (that is, how much light in total does it reflect or emit). It can actually be easier to see a quasar, a luminous type of galaxy, halfway across the observable Universe than it is to see a small, Pluto-like object on the outskirts of our own Solar System.

A brief tour of our Universe will help provide a sense of the distances to the different kinds of objects in this book. When talking about distances, astronomers often use the speed of light as a reference. Nothing can go through space faster than the speed of light, which is about 186,000 miles *per second* (300,000 kilometers per second). The Earth's moon is about 239,000 miles away, meaning that it takes a beam of light about 1.3 seconds to travel that distance. The Moon can then be said to be 1.3 light-seconds away. The Sun is 93 million miles, or about 500 light-seconds away (roughly eight light-minutes, which means that sunlight has just barely enough time to listen to all of Led Zeppelin's *Stairway to Heaven* before arriving at Earth.) Jupiter and Saturn are roughly five and ten times farther away, respectively. And Neptune, the farthest planet in our Solar System, is over four light-*hours* away. Contrast one second to four hours, and it'll give you a sense of how much farther away is Neptune, at least compared to our Moon.

Beyond our Solar System distances are best measured in light-years. The distance to Proxima Centauri, the nearest star beyond our Sun, is 4.3 light-years. Most of the stars you see in the night sky are within 100 light-years of us. We live in a **barred-spiral galaxy**, known as the Milky Way, that spans a distance of 100,000 light-years from one side to the other. Located about halfway between our Galaxy's center and the outer edge, our Sun is but one of several *hundred billion* stars inside. With a few exceptions, the many different types of star clusters and nebulae pictured in this book lie within a few hundred to tens of thousands of light-years of the Sun. They are therefore mostly confined to the small region of the Milky Way nearby.

Beyond our Galaxy lie many others. The Andromeda Galaxy (M31) is the nearest one similar to our own. Its distance of about 2.5 million light-years is downright neighborly compared to most galaxies. For perspective, consider that telescopes such as *Hubble* and Gemini can see rich detail in galaxies more than 100 times farther away. Amazingly, the most distant galaxies known (like those in the *Hubble* XDF) are yet another 100 times farther than this, at a distance of about 10 billion light-years. Finally, currently at a distance of about 45 billion light-years (due to the expanding Universe), the Cosmic Microwave Background defines the farthest limits of our observable Universe. While such distances are hard to fathom, hopefully these numbers give you a perspective on the relative distances to the objects you see in this book.

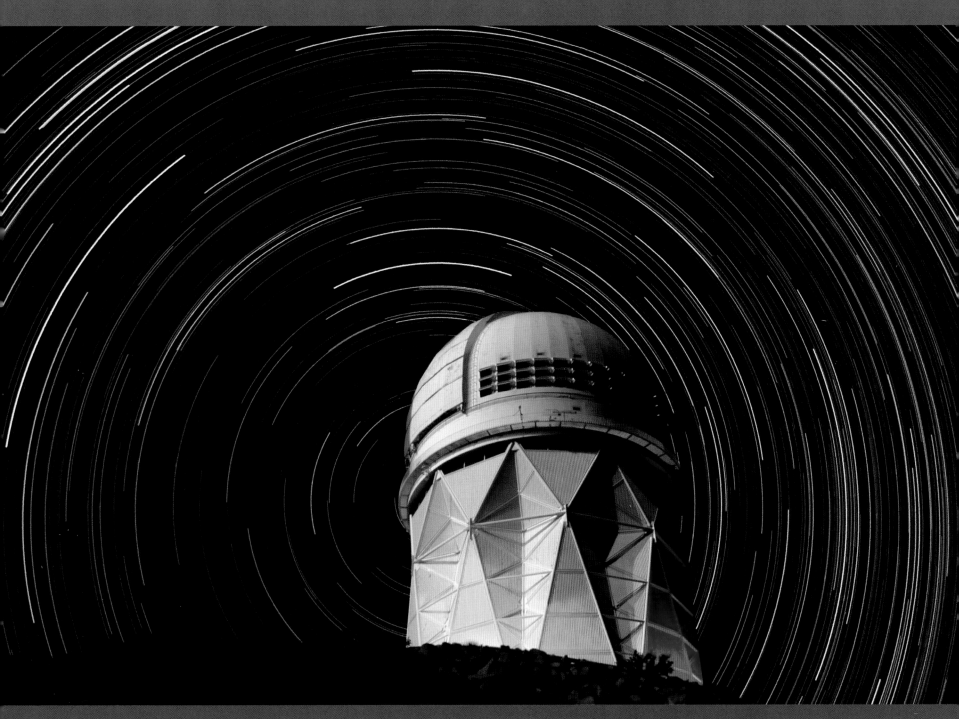

▲ This time-lapse photo shows star trails over the KPNO *Mayall* 4-meter telescope. This picture was taken by leaving the camera's shutter open for several hours. As the Earth rotates, the positions of the stars in the sky change. Telescopes are built to move with the sky, so our images do not have star streaks like this one. Credit: P. Marenfeld & NOAO/AURA/NSF.

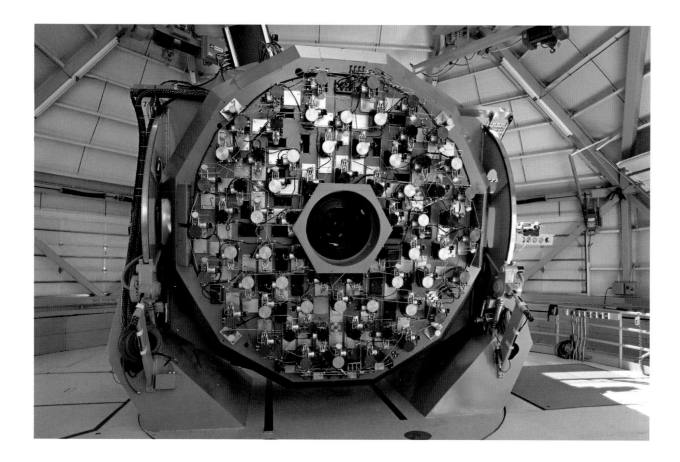

▲ The WIYN telescope is a visible light telescope located on Kitt Peak in Arizona. This is the underside of the WIYN's 3.5-meter primary mirror, which is visible when the telescope is tipped over. It is covered with a complex array of motors that precisely control the shape of the mirror. As the telescope moves, the weight load on the mirror changes; e.g., when tipped on its side the mirror "slumps" ever so slightly. If these motors didn't correct the shape of the mirror, the resulting image would be distorted. Credit: NOAO/AURA/NSF.

artificial reference star. By using the reference star as a benchmark, the adaptive optics system knows how much to correct for the effects of the atmosphere.

Adaptive optics can improve the resolution, or "sharpness," of an image by a factor of five times. This enables telescopes on the ground to achieve images as sharp—or sharper—than *Hubble*. Currently, adaptive optics systems only work well for observations of near-infrared light, which falls just beyond what the human eye can see. So *Hubble* is still the champion for high-resolution images with visible light.

▶ This nighttime picture shows the laser guide star in use with the Gemini Multi-Conjugate Adaptive Optics System (GeMS) on the Gemini South telescope. The laser creates an artificial guide star in the upper atmosphere that the adaptive optics system uses to correct the blurring effects of the atmosphere. Credit: Gemini Observatory/AURA.

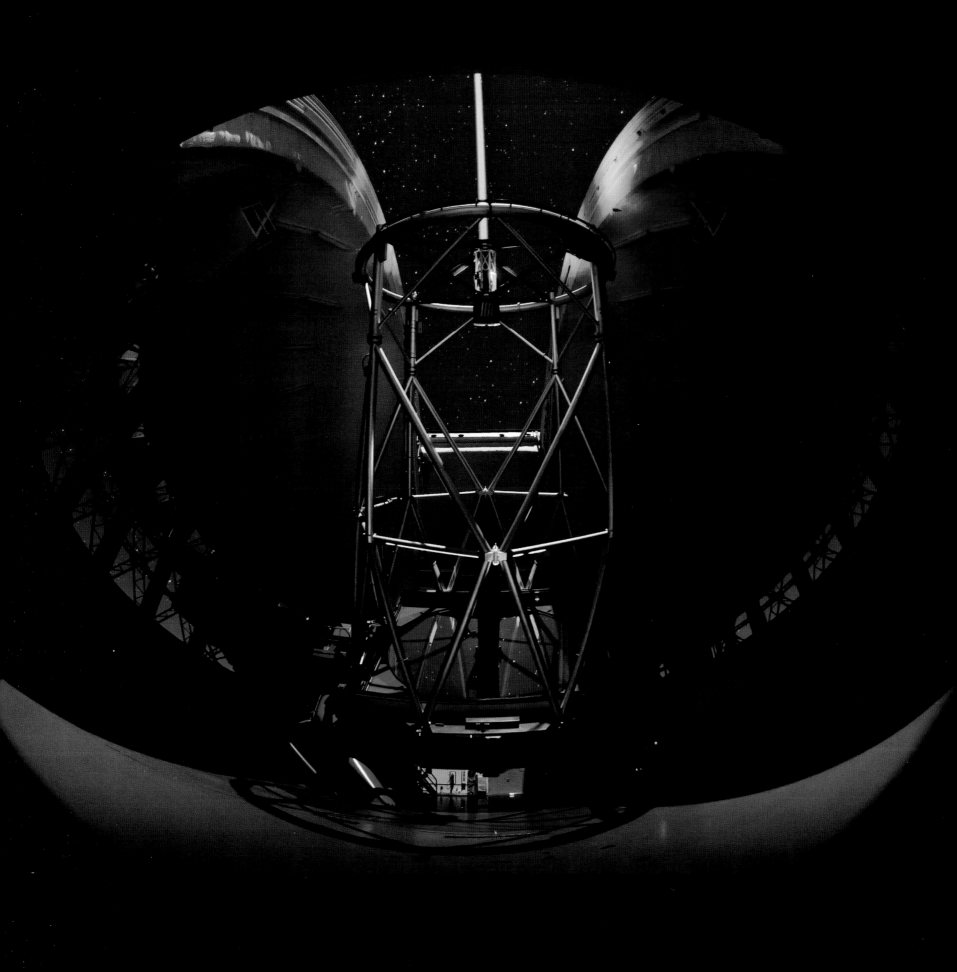

▶ Over the years, as technology has improved, new cameras have been developed. This has breathed new life into older facilities, such as the KPNO 4-meter telescope. The telescope itself is over 40 years old but continues to do cutting-edge science because new cameras have made this telescope more than 20 times more sensitive than it originally was. It can now also see more than just visible light; it can also see near-infrared. Credit: P. Marenfeld & NOAO/AURA/NSF.

▼ The electronic detectors inside the KPNO Mosaic camera. Mosaic is so named because it has eight detectors, tightly packed into a 5 by 5 inch square, much like mosaicked tiles on a floor. (One of the eight detectors is missing in the photo below.) Each detector has eight million pixels. The camera therefore has a total of 64 million pixels. This made it one of the largest cameras ever built when it was finished in 1997. It is still one of the largest operating today. Credit: Kenneth Don/NOAO/AURA/NSF.

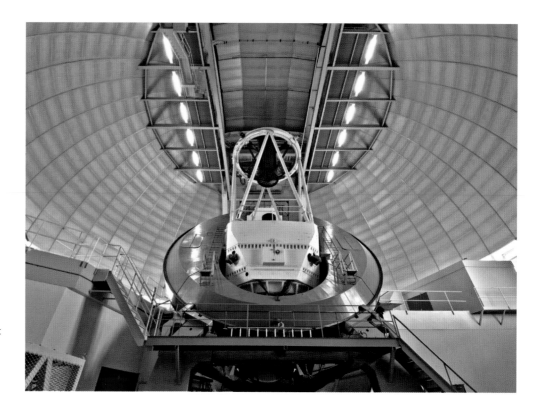

STARLIGHT, CAMERA, ACTION!

Whether using adaptive optics or not, the goal of the telescope is to bring the light to the camera. The camera is attached to the telescope at a location where the collected light comes into focus. Some telescopes allow for more than one camera to be attached, although usually only one can be used at a time.

The purpose of the camera is to capture that light and assemble an image from it. The digital cameras on a telescope are, at the most fundamental level, essentially the same as the digital cameras you own. In fact, the technology in everyday digital cameras was first developed and used on telescopes. At the heart of any digital camera—on a telescope or not—is its detector, the piece of hardware that actually captures and stores light.

Digital cameras use detectors that are made of semiconducting materials that are sensitive to light. They work in a way similar to a solar panel, which generates electricity when light hits it. A detector is divided up into millions of little squares, each one called a **pixel**. Each pixel is its own solar panel, and you can measure how much light has hit the pixel by measuring how much electricity it has generated.

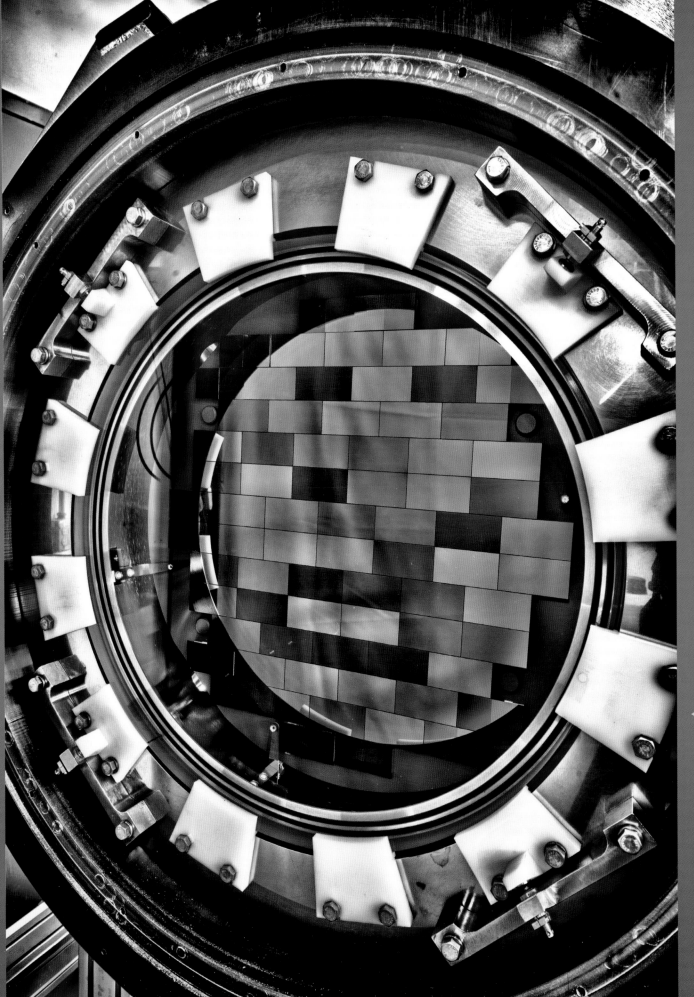

◄ Mosaic, however, is dwarfed in size compared to the Dark Energy Camera (DECam) on the Cerro Tololo Inter-American Observatory (CTIO) *Blanco* 4-meter telescope in Chile. DECam uses electronic detectors similar to those in Mosaic, except that it has 62 of them. This gives DECam 520 million pixels. Each image is over 1 gigabyte in size. Credit: Fermilab.

And by measuring the light collected by each pixel you can assemble an image of all the light that hit the detector.

When an exposure is taken, the camera's shutter is opened and light from the telescope is allowed to go into the camera. As the light hits the detector it generates electricity in each pixel. After the exposure is done, the shutter is closed and then the electronics in the camera measure how much electricity is in the individual pixels. This can take from several seconds to several minutes depending on the camera.

It's difficult to build detectors that are large, so many astronomical cameras have more than one detector in them. It's like having more than one camera look at the sky at once, allowing you to either see a larger portion of the sky or see objects in greater detail (or both).

CALIBRATING THE CAMERA

Imagine you turned on your television to watch a football game and everything was distorted. The sky was yellow, the grass was blue, and the people were green. You'd know that something was wrong with your TV because normally the sky isn't yellow (unless the game is in Los Angeles), the grass isn't blue (unless you're watching Boise State play football), and people aren't green (unless you're in Roswell, New Mexico).

But what if you were looking into space at something you've never seen before? You might not know anything was wrong. For this reason, astronomers use a variety of tools and techniques to carefully calibrate their cameras. They want to be certain what we're seeing is real and accurate. These calibrations are mostly done during the daytime, when the telescope and camera are put through a range of tests to characterize how they're going to work on that particular night. After the night's observations are done, the calibrations are used to correct for known imperfections in the telescope and camera.

Now we've seen how telescopes, along with their cameras and detectors, let us capture far more light than we ever could with just our eyes. Telescopes are incredible tools that, when carefully tuned and maintained, can give us superhuman sensitivity to objects and phenomena in space. However, just as a canvas and paints cannot make art without an artist, neither can a telescope produce images of the cosmos without the astronomers who use them. Now let's explore how telescopes are used to make color images.

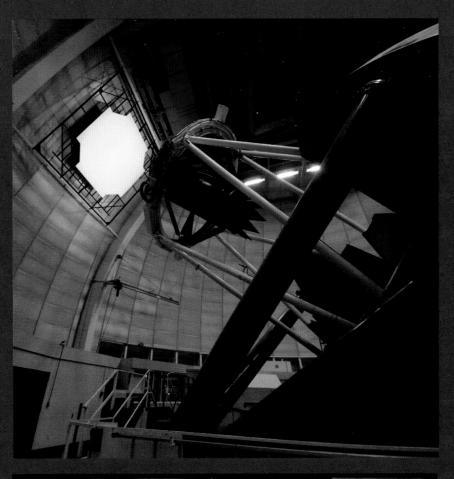

◄ One of the ways in which the camera is calibrated is by taking pictures of a uniformly lit screen called the "white spot," which is often mounted on the side of the dome. The picture on top shows the KPNO 4-meter telescope pointed at the white spot, as it takes calibration images for its Mosaic camera. The picture on the bottom shows what the camera sees. If the telescope and camera were perfect, this image would be smooth, just like the white spot. The image on the bottom is used to calibrate the camera, to remove the effects from imperfections in the optics and detectors. Top credit: P. Marenfeld & NOAO/AURA/ NSF. Bottom credit: T.A. Rector (University of Alaska Anchorage) and H. Schweiker (WIYN and NOAO/AURA/NSF).

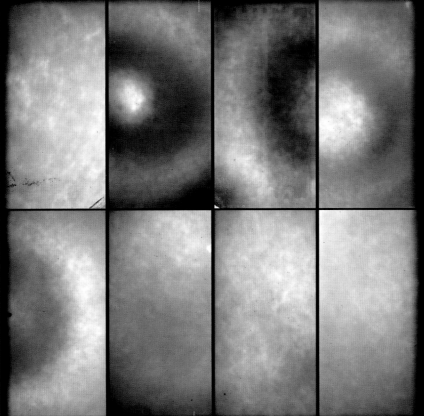

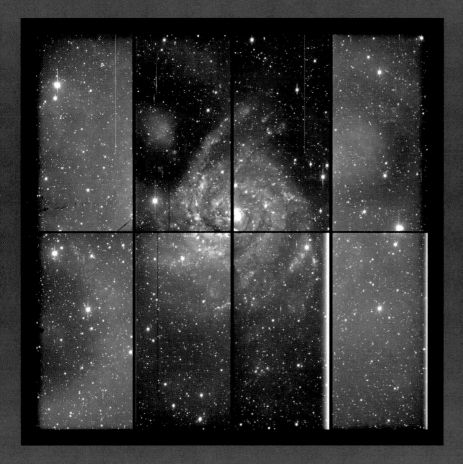 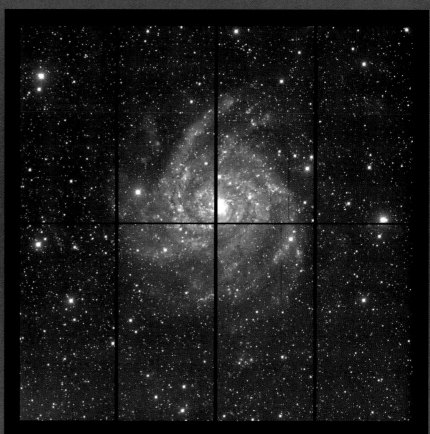

▲ An image of the spiral galaxy IC 342 from the Mosaic camera before it is calibrated (left) and after (right). Note that the black lines across the image are due to the gaps between the eight detectors. Credit: T.A. Rector (University of Alaska Anchorage) and H. Schweiker (WIYN and NOAO/AURA/NSF).

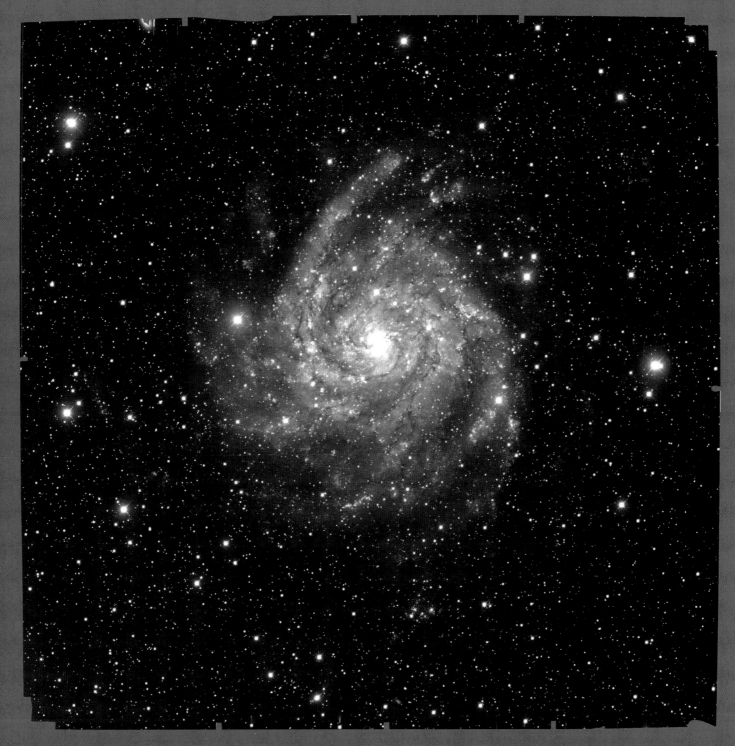

▲ To produce an image without gaps (i.e, the black lines) astronomers take multiple exposures with a slight shift of the telescope between each picture. When the images are "stacked" together, the gaps are filled in and you see the entire picture. Credit: T.A. Rector (University of Alaska Anchorage) and H. Schweiker (WIYN and NOAO/AURA/NSF).

COLORING THE UNIVERSE

Broadband Images and How We Use Color

Digital cameras are remarkable tools for detecting faint light from stars and galaxies across the Universe. But there's one problem. Measuring the electricity in a pixel tells you the intensity of the light *but not the color*. In other words, digital cameras can only see in black and white (or, more precisely, gray scale). How then do we get a color image? This is an important difference between the cameras you own and the ones used on telescopes.

SHOW YOUR TRUE COLORS

First off, what is color anyway? What does it mean for something to be, say, green? Even though most of us experience it every day, it's worth talking about the nature of the light we see with our eyes, which is known as "visible" light. When you take visible light and spread it out into a spectrum (using a prism, for example,[7] or looking at a rainbow), the colors correspond to the energy of the light. Red light is the lowest energy kind of light we can see. Next up in energy is orange, then yellow,

▶ A detailed spectrum of our Sun. It reads like a book, with each horizontal line being like a sentence. The lowest-energy color of red light is in the upper left, and the highest-energy color of violet light is in the bottom right. The Sun emits roughly equal amounts of all the colors, giving it a yellow-white color. Credit: N. A. Sharp, NOAO/NSO/Kitt Peak FTS/AURA/NSF.

green, blue, indigo, and finally violet. Violet is the highest energy form of light we can see. You may have learned "ROY G. BIV" in school to remember this.

The way we see color is somewhat complex. In some cases, a star may look red simply because it is emitting more red light than the other colors. Some colors, however, can be created in more than one way. For example, there are two ways to see yellow light. You could either have an object that emits *just* yellow light (like the low-pressure sodium lamps often seen in parking lots). Or, you could have an object that emits a range of light that includes red and green but not much blue. Red and green light, when added together, combine to produce yellow.[8] When all of the colors are added together in equal amounts you see white. Note that this is true only for visible light, a.k.a. the type we humans can see with our eyes. In chapter 10, we'll talk about the other kinds of light that span the entire range of what scientists call the "electromagnetic spectrum," from radio waves to gamma rays.

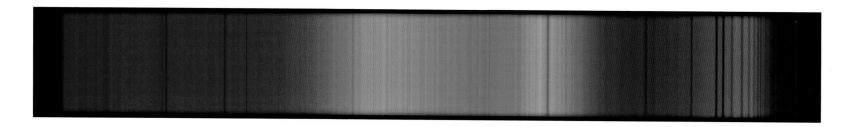

▲ "Spectroscopy" is the technique of taking the light from an object, spreading it out into a spectrum similar to how a prism does, and measuring the amount of each kind of light. This is the spectrum of a hot, massive star called "BD−00 3227." Notice that the star is brighter in the blue and green compared to the red, meaning the star has a bluish-white color. Also note that there are a lot of vertical black lines in the spectrum. These are called absorption lines. They are specific colors of light that are "missing" because different kinds of gases in the star absorb them. As we'll discuss later, we can use these lines to identify what kinds of gases are in the star. Credit: S. Howell/NOAO/AURA/NSF.

MAKING COLOR IN PHOTOGRAPHY

Historically, making a color image hasn't been easy. Black-and-white photography was first developed at the start of the nineteenth century. The first successful color photographs came about fifty years later, with a technique first proposed by Scottish physicist James Clerk Maxwell (who also is famous for coming up with the theory that tied electricity, magnetism, and light together). Known as the three-color process, it is in one form or another the basis for all modern color photography. Originally the technique consisted of taking black-and-white images through blue, green, and red filters. These were then combined to produce the color image.

Remarkably, by mixing the "primary"[9] colors of red, green, and blue in different amounts, we can create all the colors we can see. (Again, we can make yellow by adding red and green light in roughly equal amounts with little to no blue.) This is also how your eyes see color, which we'll delve into more deeply in chapter 7.

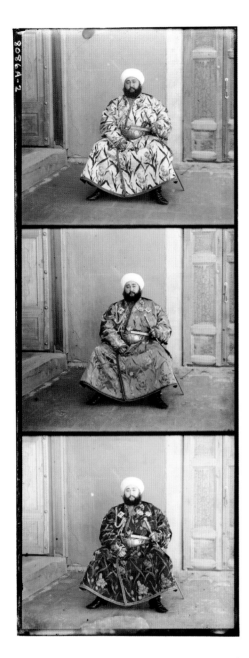

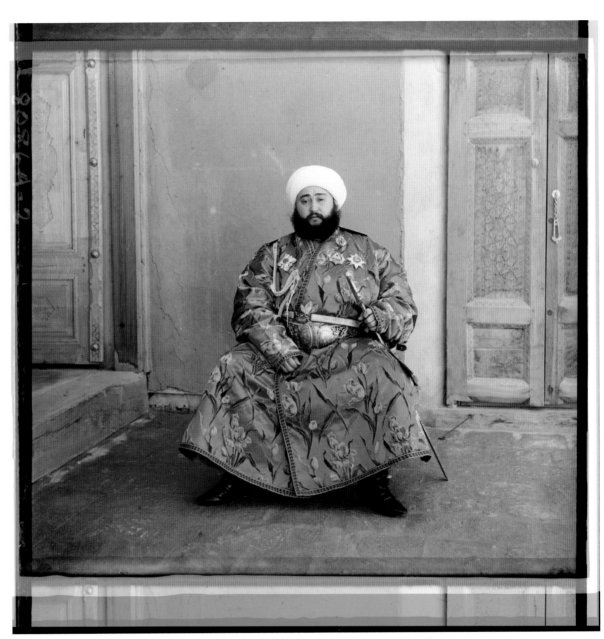

▲ This photograph (right) of Alim Khan, the emir of Bukhara, is one of the earliest examples of a color image made with the three-color process. It was taken in 1911 by Russian chemist Sergei Mikhailovich Proku-din-Gorskii. Three black-and-white photographs (left) were taken through blue (top), green (middle), and red (bottom) filters. The three images were then combined to produce the final color image. Note how the emir's robe is bright in the top left (blue) image and dark in the bottom left (red) image. The emir's white turban is bright in all three filters. The colorful border of the right image is the result of the three black-and-white images not being perfectly aligned. Credit: Library of Congress, Prints and Photographs Division, Prokudin-Gorskii Collection (reproduction number, e.g., LC-DIG-prok-02044).

This technique works fine as long as the camera, or the person in the photograph, doesn't move between pictures. The subjects of a photo don't often sit still, so a different method is used inside a typical consumer digital camera (for example, the one in a cellular phone). Instead, it has an electronic detector with tiny color filters over each pixel in what's called a Bayer pattern. The filters only let red, green, or blue light pass through them. The camera measures how much light of each color there is by looking at a group of four adjacent pixels. So, in reality, a digital camera has four times as many pixels as what you see in the final color image. This technique enables the camera to quickly make a color image from a single picture without worrying about anything moving.

PUTTING COLOR INTO ASTRONOMICAL IMAGES

The process used with digital cameras on professional astronomical telescopes is more like the original method Maxwell proposed. These detectors do not have tiny filters on each pixel. Instead they use larger filters that cover the entire detector, so that all of the pixels are looking through the same filter at the same time. Then astronomers take one or more pictures of the same field of view through each filter. As long as the objects don't move noticeably between pictures—and usually they don't—the images can be combined to form a color image.

This is done for a variety of reasons, most notably because astronomers use more than just red, green, and blue filters. The telescopes at KPNO have more than

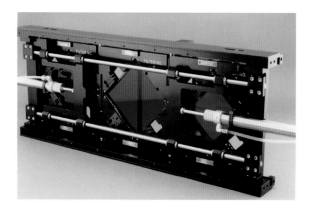

▲▲ The **Bayer pattern** for a commercial digital camera. Each gray square represents a pixel on the electronic detector. Atop each pixel is a filter that allows only red, green, or blue light to pass through. A single color pixel is produced by combining an adjacent group of four pixels (in a 2 x 2 grid) that contains one red, one blue, and two green filters. Credit: Colin M. L. Burnett and the GNU General Public License.

▲ Some of the broadband color filters for the KPNO Mosaic camera. Each filter is 5 by 5 inches so that it covers all eight of the detectors at once. A color image can be made by taking images of an object through two or more filters. Mosaic can have up to eight filters installed, although only one is used at a time. Credit: NOAO/AURA/NSF.

▶ An uncropped image of the galaxy NGC 4490 as a work in progress. Four filters were used. Like the photograph of Alim Khan, the color borders for each filter are visible. The borders do not closely line up because the data for each filter were obtained over several nights spread out over many years. And each time the galaxy was observed the telescope was pointed in a slightly different location. The final image will be cropped to remove the borders. Credit: T. A. Rector (University of Alaska Anchorage) and H. Schweiker (WIYN and NOAO/AURA/NSF).

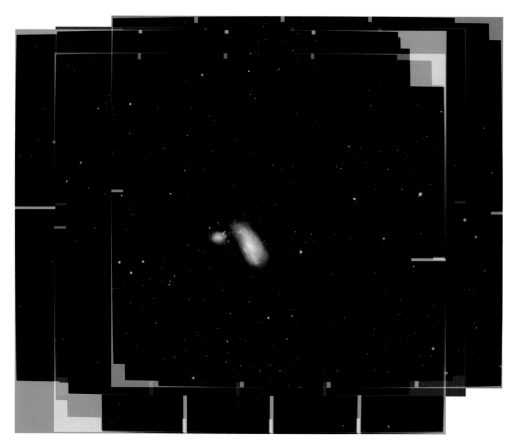

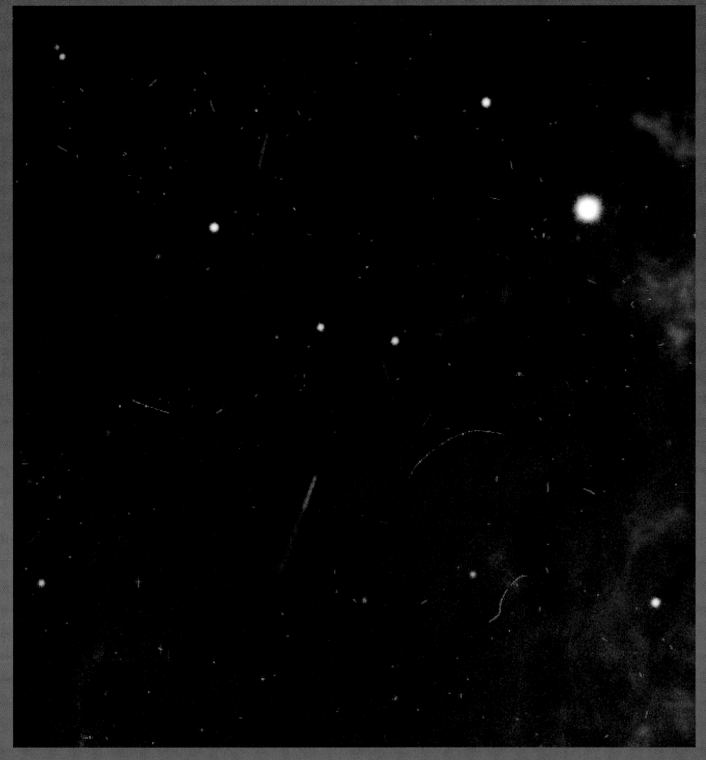

▲ In general, astronomical objects do not move noticeably between exposures because they are so distant. A notable exception to this rule is small solar system bodies such as asteroids and Kuiper Belt Objects. In this picture of a portion of the nebula Sharpless 239, two asteroids are visible as red-green line segments. They look that way because the asteroids were moving (from bottom to top) when the images were taken. First the red filter was used, followed by the green filter. The red segment is longer because those exposures took more time. The asteroids aren't visible in the other filters because those observations were done on a different night and the asteroid had since moved out of the field of view. You'll also notice many small specks and lines that look like scratches. These are called **cosmic rays** and are the result of particles (such as electrons and muons) hitting the camera while an exposure was underway. Normally the software that processes the data removes the asteroid streaks and cosmic rays. Credit: T. A. Rector (University of Alaska Anchorage) and H. Schweiker (WIYN and NOAO/AURA/NSF).

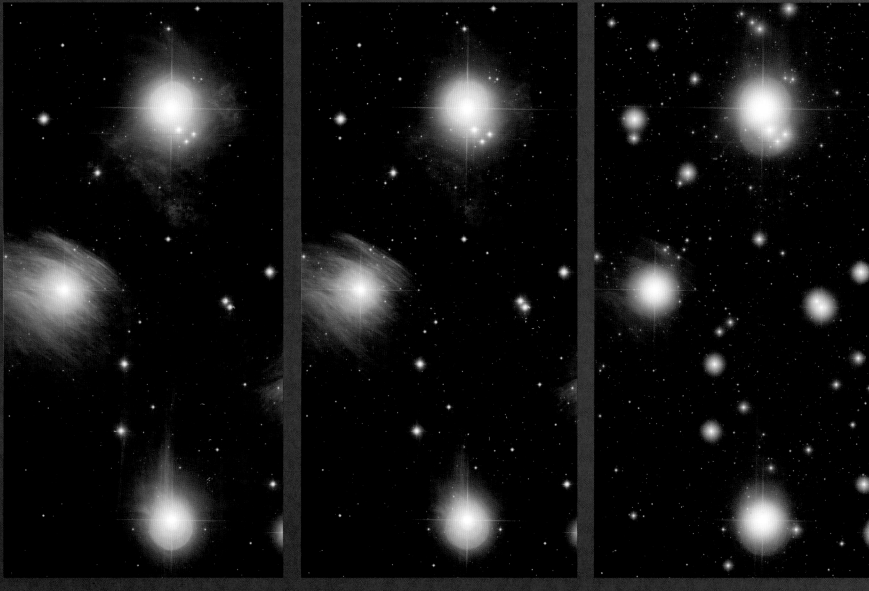

▲ A portion of the Pleiades star cluster as seen through the B, V, and I filters (left, center, and right, respectively). The B filter corresponds to mostly blue light. The V filter corresponds mostly to green light (V is for visible). And the I filter corresponds to red light, just below what our eyes can see (I is for infrared). The cluster looks noticeably different between each filter, with the nebulosity around the bright stars most apparent in the B filter and almost invisible in the I filter. Credit: T. A. Rector (University of Alaska Anchorage), Richard Cool (University of Arizona), and WIYN.

one hundred filters that are used for a wide range of purposes. The choice of filters is primarily dependent on the *science* to be done. For example, by measuring the brightness of a faraway galaxy through different filters, astronomers can estimate its distance from us. Also, they don't always use three filters. Sometimes they use only one. And sometimes they use many more than three. Some of the images in this book were made using as many as thirteen filters!

In a nutshell, the process for making a color astronomical image works like this:

- Take images of an astronomical object through multiple filters.
- Assign a color to each image ("colorize" it).
- Combine them to make the final color image.

It sounds simple. But astronomers use a wide range of filters to look at many different kinds of objects for a variety of reasons. So there's no simple rule for how to choose colors for each filter. It depends on the filters used, the object studied, what's interesting about it, and the person who is putting the image together. There are many examples of how astronomers do this, but first let's start with a common scenario.

BROADBAND FILTERS

Astronomers often use what are known as "broadband" filters, so named because they allow a wider range of the electromagnetic spectrum to pass through. Sometimes astronomers will use red, green, and blue filters similar to those used on your camera. In this case, the image would not be too far from what you'd see if your digital camera were mounted to the telescope (and if it were much more sensitive). Once the black-and-white images captured through the different filters are available, assembling the color image is then usually straightforward: the image taken through the red filter is colored red, the image taken through the green filter is colored green, and image taken through the blue filter is colored blue.

Most often, astronomical images are made with broadband filters *other* than simple red, green, and blue. There are filters of other colors as well. In general, when assigning colors to each image we give the image the color that the filter appears to have when held up to a bright, white light. In some cases, however, the filters used in visible telescopes are of energies of light just beyond what the human eye can see. For example, the "U" filter (for "ultraviolet") in the widely used Johnson-Cousins UBVRI filter set shows the energy range just above what the eye can see. And the "I" filter (for "infrared") captures the energy just below what we can see. Since they are close to those colors, they are often colored violet and red respectively.

▲ The SDSS "r" filter has an orange color when held up to a bright, white light. This is a special broadband filter specifically designed for the Sloan Digital Sky Survey. Credit: P. Marenfeld and NOAO/AURA/NSF.

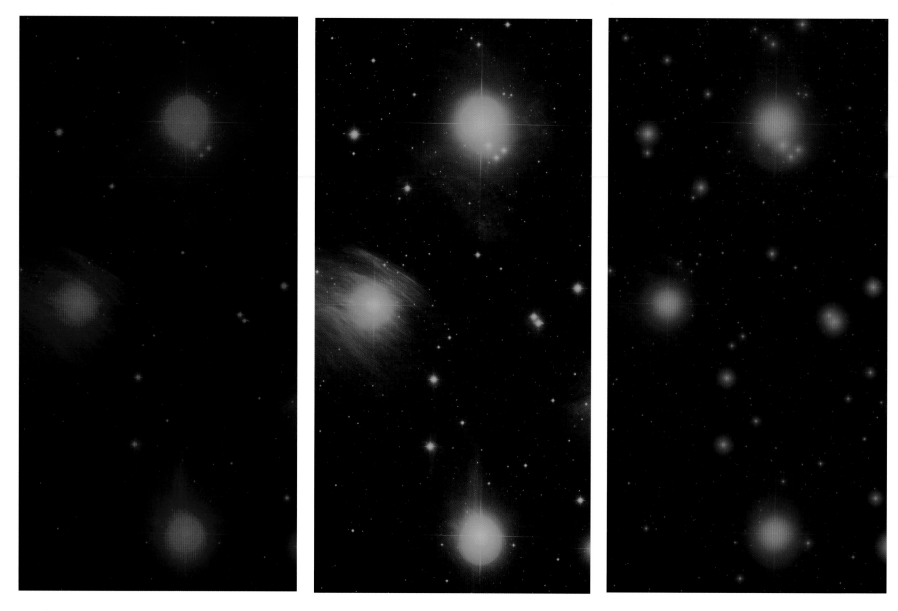

▲▶ The three images above show a portion of the B, V, and I images used to make a full-color image of the Pleiades cluster. They have been "colorized" to be blue, green, and red. These three images were then combined to produce the full-color image on the opposite page. Credit: T. A. Rector (University of Alaska Anchorage), Richard Cool (University of Arizona), and WIYN.

This technique of combining colorized layers can be used for any type of light the cosmos gives off—such as microwaves or X-rays. When using broadband filters, astronomers almost always choose to use **chromatic ordering**. By that, we mean that the lowest-energy light is assigned red, the middle-energy light is green, and the highest-energy light is blue. Objects that emit relatively more low-energy light

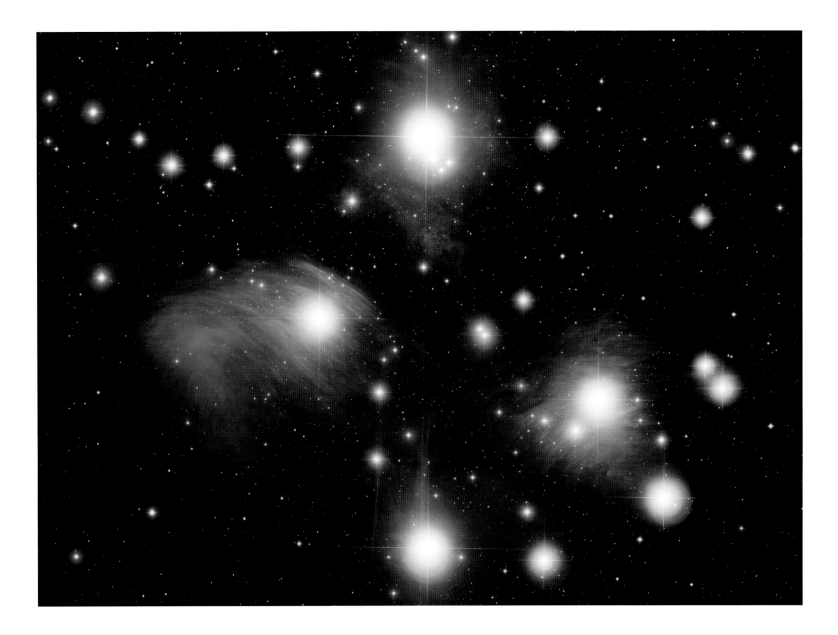

will be redder, whereas objects that emit relatively more high-energy light will be bluer.

 While color is a way to make an astronomical image more aesthetically pleasing, it can also serve as a vehicle to convey information to the trained eye. What exactly can color tell us? Let's find out.

COLOR IS KNOWLEDGE

What Scientists Learn from Color with Broadband Filters

When you look at an astronomical image, you may see a magnificent celestial landscape awash in complex detail and resplendent color. As delightful as they are, the colors are more than just pretty. They tell a story. Let's look at how astronomers use the color from broadband filters—that is, those that let in a relatively wide swath of light—to learn about the physics going on inside stars, gas, and galaxies.

STARS IN LIVING COLOR

Astronomers often use three or more broadband filters to measure the brightness of stars in visible light. The relative brightness between the filters can be used to accurately measure the temperature of a star. This is possible, in simple terms, because the hotter stars are bluer and the cooler stars are redder. (We'll explain why in chapter 7.) By looking at a color image of a group of stars made through broadband filters you can immediately tell which stars are the hottest. This is incredibly useful, as it would be impossible to stick a thermometer into a star—even if you could get close enough to it!

▶ This image of the dark nebula LDN 810 shows a wide range of star colors. Why are they different colors? What can scientists learn from their colors? Credit: T. A. Rector (University of Alaska Anchorage) and H. Schweiker (WIYN and NOAO/AURA/NSF).

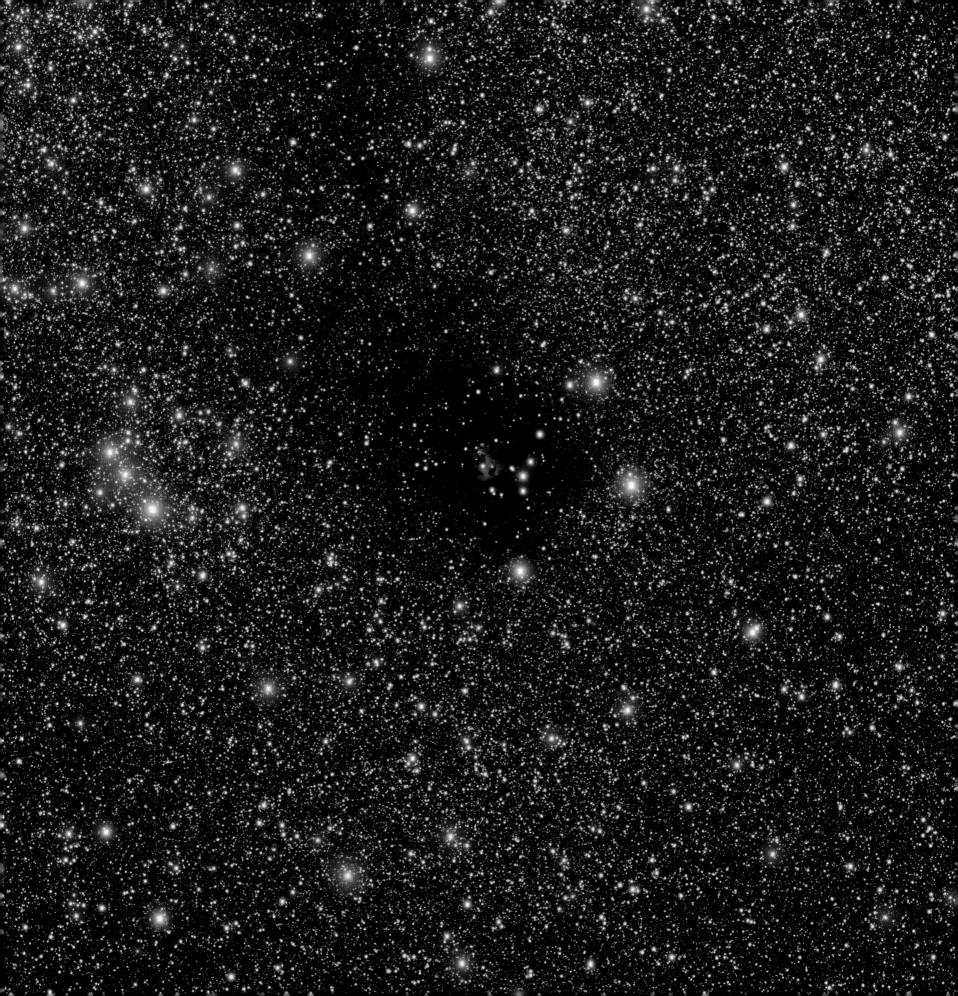

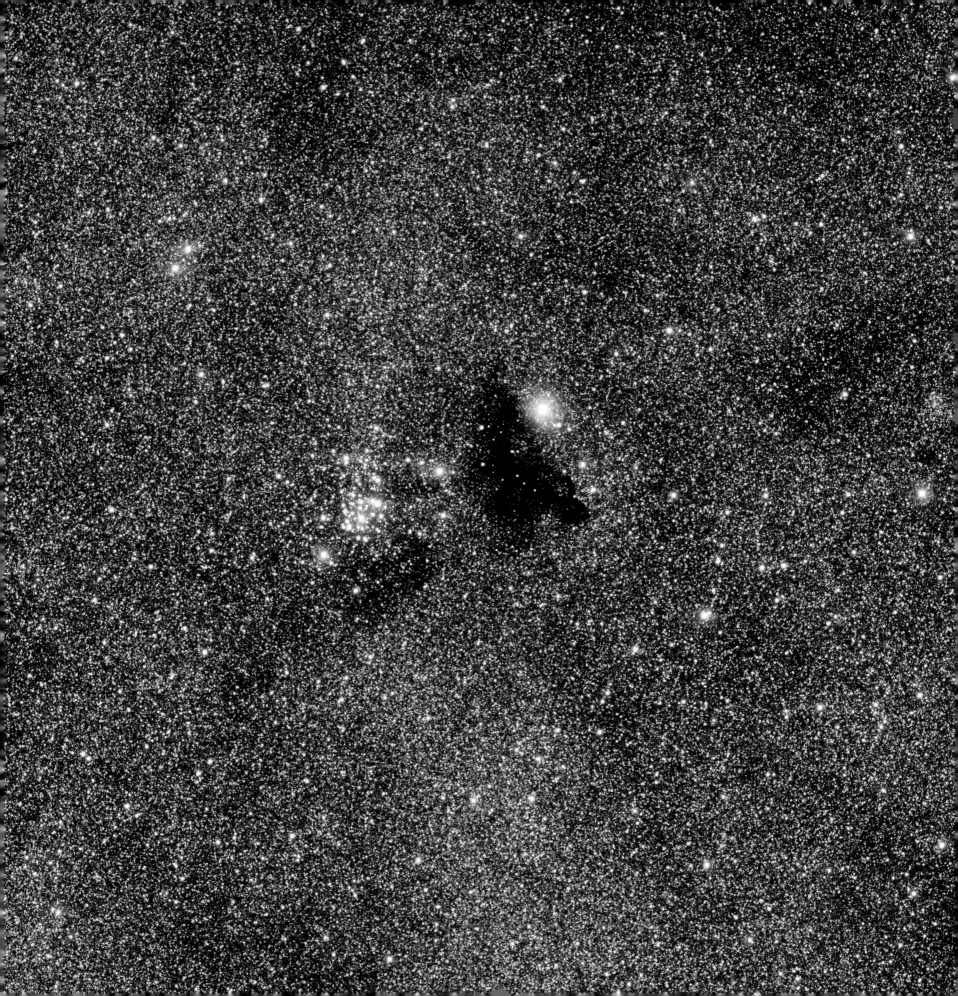

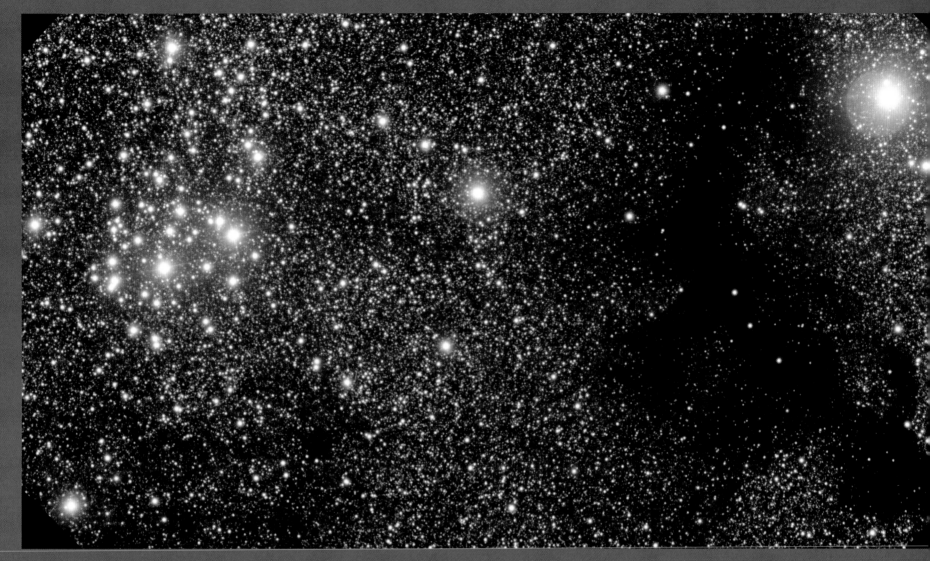

◄ NGC 6520 is an open cluster of stars seen in the direction toward the center of our Milky Way galaxy. This wide-field image, taken by the CTIO 4-meter telescope, was made with four broadband filters (U, B, V, and I) to accurately show the colors of the stars. The U filter is sensitive to the high-energy visible light produced by the hot, massive stars in the cluster. In this image the U filter helps these bright, blue stars (just to the left of the center of the image) stand out against the backdrop of stars behind them. Credit: T. A. Rector (University of Alaska Anchorage) and T. Abbott (NOAO/AURA/NSF).

▲ A close-up image of NGC 6520, taken by Gemini South, better shows the stars in the cluster on the left by also using broadband filters sensitive to ultraviolet light. The presence of massive blue stars indicates that NGC 6520 is relatively young compared to the other stars in the image. In stark contrast, the nebula (a cosmic cloud of dust and gas on the right) is dark because dust grains inside the nebula absorb light. Notice that it blocks out the light of most of the stars behind it. Credit: Gemini Observatory/AURA and T. A. Rector (University of Alaska Anchorage).

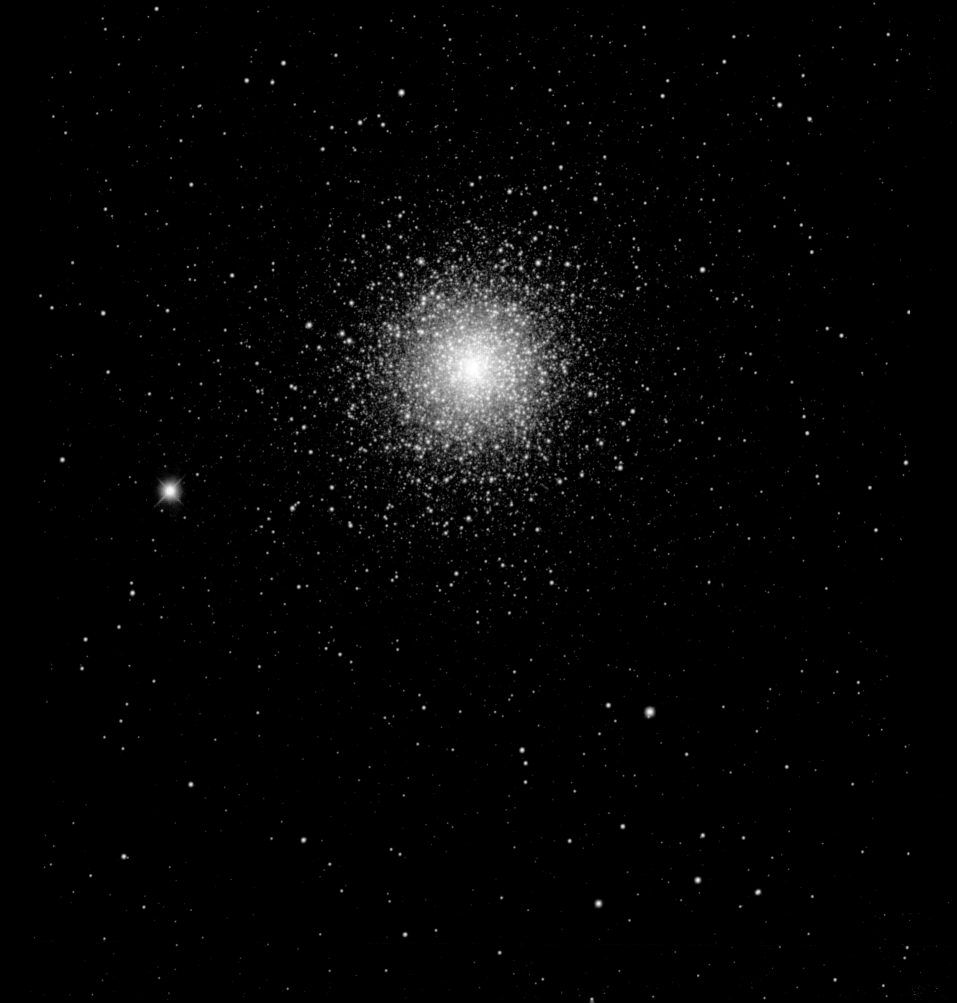

The colors of stars in a group, or cluster, can also reveal how old they are. How does that work? To understand this, it is helpful to know a little about how stars live. Like people, all stars have finite lifetimes. That is, they are born, live for a period of time, and then ultimately die in some way or another. As permanent as they may seem from our vantage point on Earth, stars aren't forever. For about 90 percent of their lives, stars produce their energy by fusing hydrogen atoms into helium atoms through nuclear reactions.

Stars come in a wide range of sizes, and their size determines how quickly they burn through their hydrogen. The more massive stars use their hydrogen fuel faster, produce more energy, and are searing hot and extremely luminous. The less massive stars, including those like our Sun, are cooler and give off less light.

Massive stars are so bright they can easily outshine all of their smaller counterparts. But there's a catch. They form less frequently and don't last for long. These high-mass stars shine so strongly because they are whipping through their reservoirs of hydrogen, like an inefficient, gas-guzzling SUV. For example, a star that is fifteen times the mass of our Sun will live for about 9 million years. This sounds like a long time, but it's a mere blink of the eye compared to the 9 *billion* years that our Sun will live. Our Sun is like a hybrid that sips its fuel, allowing it to live for a thousand times longer than this high-mass star. For perspective, let's compress the lives of stars to human timescales. Let's shrink the lifetime of the Sun to an average human lifespan of eighty years. If we shrink this high-mass star's life by the same amount, it would only live for a *month*.

Massive stars are bluish and bright, but they die quickly. When they die out, that leaves only the smaller yellow and red stars. In a star cluster, stars form with a range of masses, but they all form at the same time. This means that astronomers can measure the age of a star cluster by determining which stars are missing. For example, if the most massive stars seen in a cluster are of a size that only last for 100 million years, then that is roughly the age of the cluster, as the more massive stars that last for shorter periods have already died.

Open clusters—which are groups of hundreds to thousands of stars—tend to be younger and therefore contain more massive stars, and so we see more blue stars. We know that the collections of several hundred thousand stars that reside on the outskirts of many galaxies (known as **globular clusters**) are ancient because they lack high-mass stars; therefore, images of these objects reveal more yellow and red stars.

◀ A globular cluster (such as M15 shown here) contains several hundred thousand stars. A close inspection of the stars inside reveals that most are yellowish in color, meaning they are cooler and indicating that the cluster is ancient. Despite its age there are many hot blue stars present as well. These so-called blue stragglers are perhaps created when two stars collide and merge to form a larger star. Alternatively, they might be the result of a binary star system, where one star pulls gas from the other to get bigger. Credit: T. A. Rector (University of Alaska Anchorage) and H. Schweiker (WIYN and NOAO/AURA/NSF).

WHAT'S IN A NAME?

Throughout this book you'll notice most objects have a catalog name that consists of an alphabetic prefix followed by a numeric suffix. The prefix is usually an abbreviation that indicates the name of the catalog. And the suffix indicates which object in the catalog. For example, M8, which is informally known as the Lagoon Nebula, is the eighth object in the Messier catalog. Many objects are listed in more than one catalog; for example, the Andromeda Galaxy is also known as M31 and NGC 224.

Why is it done this way? First, there are too many objects in the night sky for astronomers to come up with clever personalized names for each one. Second, a catalog name reduces the uncertainty about to which object you're referring; for example, the spiral galaxies M33, M83, and M101 have each been called the Pinwheel Galaxy at one time or another.

Here are some of the catalogs you'll see referenced in this book: The granddaddy of them all is the Messier (pronounced "messy-A") catalog, first published in 1771 by French astronomer Charles Messier. Because they were the first to be discovered, these are naturally some of the biggest and brightest objects in the night sky. In 1888, John Louis Emil Dreyer released the *New General Catalogue of Nebulae and Clusters of Stars*, which is abbreviated as NGC. This is a much more thorough catalog of interesting objects in space, many of which are featured in this book. In later years Dreyer released an update to the NGC, known as the *Index Catalogue of Nebulae and Clusters of Stars* (abbreviated as IC). Objects from other catalogs, such as the *Sharpless Catalog* from 1959, the *Lynds' Catalog of Dark Nebulae* (LDN) from 1962, the *Lynds' Catalog of Bright Nebulae* (LBN) from 1965, and the *van den Bergh* (vdB) catalog of reflection nebulae from 1966, can also be found in this book.

DIAMONDS AND DUST

Our Universe is not only filled with stars but also with dust and gas. The gas is a mixture of primarily hydrogen and helium, the two most abundant elements. But other elements are present as well. Most of these heavy elements (that is, everything other than hydrogen and helium) were forged inside previous generations of stars and eventually returned to space through gentle winds from stellar surfaces or giant explosions of the stars known as supernovae.[10] Much of this expelled gas will eventually coalesce into more dense clouds that may produce future stellar descendants. Unless it is heated up, however, the gas itself cannot be seen with visible-light telescopes.

Within the gas is also dust that consists of microscopic grains, ranging from 1 nanometer (1 billionth of a meter) to 1 micron (or micrometer, a millionth of a meter) in size. This is much smaller than what you can see, and much smaller than the dust on your windowsill. While astronomers can't see the individual grains, they can tell it's there because it affects the starlight passing through it. How the light is affected depends on a variety of factors, including the density of the dust, the size of the dust grains, and the location of the star (that is, if the star is in front, embedded within, or behind the gas). Thus astronomers can learn much about the dust in a nebula by looking at the colors.

Reflection nebulae are clouds of gas that reflect the light from nearby stars. Smaller dust grains preferentially scatter blue light, causing the gas to appear blue regardless of the color of the stars providing the light. Larger dust grains reflect all colors of light well, so the color will more closely match the colors of the stars. Larger grains tend to be found in more dense clouds. In contrast, **dark nebulae** are dense clouds of gas that absorb nearly all of the starlight that enters them. Since blue light is scattered and absorbed more easily, the starlight that does make it through the dark nebula will be redder.

THE COLORS OF GALAXIES

Galaxies are often referred to as "island universes" because, when viewed with visible-light telescopes, they usually appear as distinct entities far away from each other, separated by vast distances of empty space. A galaxy is a collection of stars, dust, gas, and dark matter,[11] held together by the force of gravity. Galaxies come in a range of shapes and sizes, and they can range in mass from 10 million to 100 *trillion* times the mass of our Sun.

For comparison, our own Galaxy, the Milky Way, is a **barred spiral**—a spiral galaxy with a bright "bar" stretching across its middle. Astronomers estimate the

▶ The dust in the dark nebula LDN 673 clearly blocks the light from stars behind it. In a few places you can also see the dust illuminated by stars embedded in the nebula. Credit: T. A. Rector (University of Alaska Anchorage) and H. Schweiker (WIYN and NOAO/AURA/NSF).

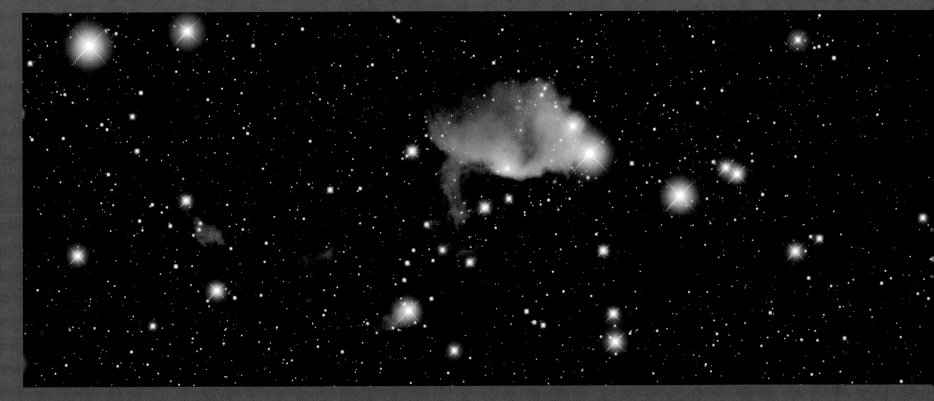

▲ IC 426 is a reflection nebula. It is likely illuminated by the hot, massive star Mintaka, the west-
ernmost star in the belt in the constellation of Orion. It's not yet clear why IC 426 is bluish
in color. It could be blue if the grains are large and it is simply reflecting Mintaka's blue light.
Or it may be blue simply because the dust grains are small. Credit: T. A. Rector (University of
Alaska Anchorage) and H. Schweiker (WIYN and NOAO/AURA/NSF).

◀ Dust not only absorbs and scatters light, it can reflect it as well. In this wide-field image of
the variable star "T Tauri" (at the center of the image) you can see that the dust and gas that
surround it is blocking starlight. The nebulosity closer to the center also reflects light from T
Tauri itself. Credit: T. A. Rector (University of Alaska Anchorage) and H. Schweiker (WIYN and
NOAO/AURA/NSF).

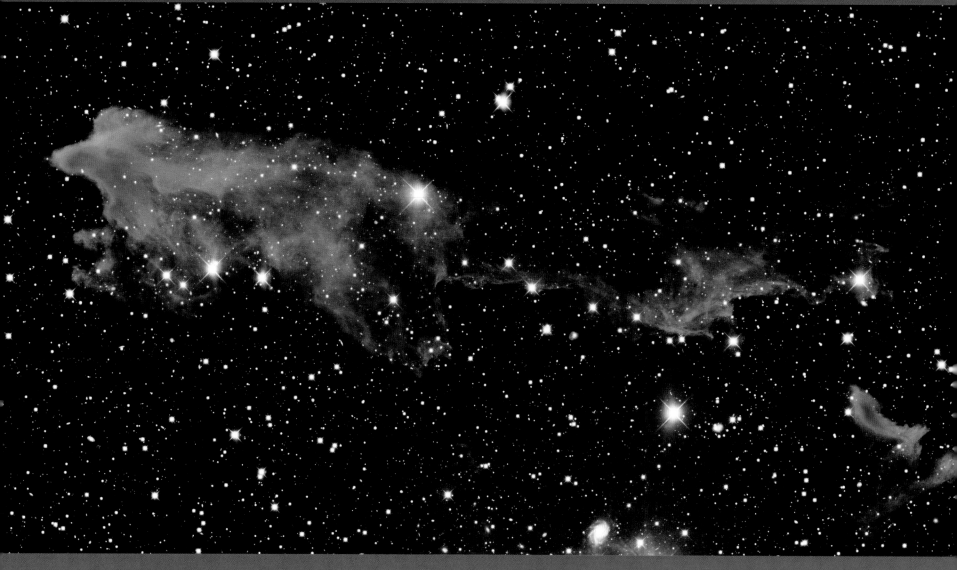

▲ LBN 438 is a **cometary globule**, a reflection nebula whose comet-like shape is caused by evaporation of the nebula by one or more nearby stars. Unlike IC 426 (previous page), this nebula probably contains larger dust grains and is not illuminated by a hot star. Credit: T. A. Rector (University of Alaska Anchorage) and H. Schweiker (WIYN and NOAO/AURA/NSF).

▶ vdB 24 is a reflection nebula with complex colors because it contains small and large dust grains. Credit: T. A. Rector (University of Alaska Anchorage) and H. Schweiker (WIYN and NOAO/AURA/NSF).

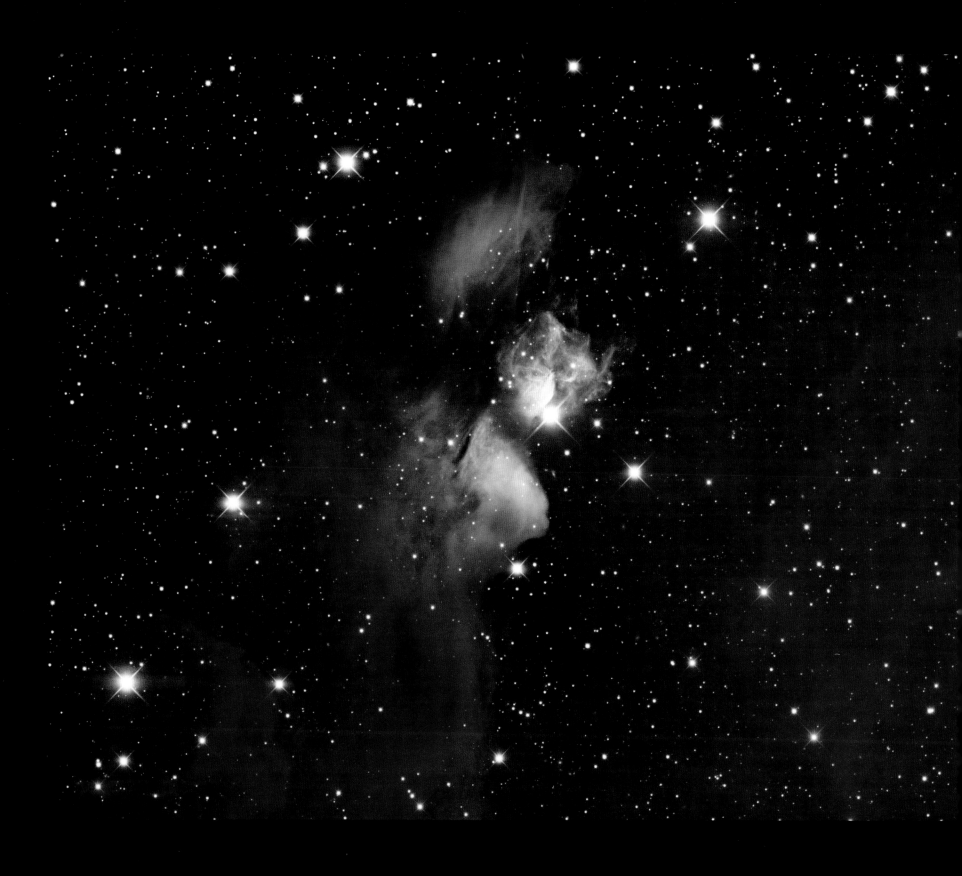

Milky Way has about 400 billion stars and a total mass upwards of more than a trillion times the mass of our Sun. Like most galaxies, most of the mass is in the form of dark matter. Like stars, galaxies come in a wide range of sizes. Our Milky Way is larger than most other galaxies.

When we look at other galaxies with broadband visible-light filters, we primarily see the light from their stars. Just as with clusters of stars, the colors of the different parts give us a rough history of star formation within the galaxy. The bluish areas in the galaxy are places where stars have recently formed. We know this because we can see the blue light from massive but short-lived stars. The yellowish regions are typically where star formation has slowed down or stopped. Here, just about all of the massive stars are dead, and only the low-mass stars remain.

Larger galaxies tend to be either elliptical or spiral in shape. Because most of their star formation has stopped, elliptical galaxies—so called because they are usually round or football shaped—are yellowish. Their light is from older stars. The hot, massive blue stars are long gone.

Spiral galaxies are more complicated. Unlike elliptical galaxies they are largely flat. The inner part of the galaxy, known as the **bulge**, consists primarily of older stars that give it a yellowish color. For many spiral galaxies, including our own, the bulge is in the shape of a bar. The outer parts of the galaxy consist of grand, sweeping spiral arms. The arms tend to be bluer in color from the presence of hot, massive stars, a telltale sign of recent star formation. Also visible in the spiral arms are darker areas, or **dust lanes,** where dust partially obscures starlight.

As you look at these pictures of galaxies, note that nearly all of the stars you see around them are actually within our own Galaxy. They are, in fact, thousands of times closer than the galaxies themselves. They are like bugs on your car's windshield as you gaze out at distant mountains. If you look closely at these images you'll also notice many faint smudges that don't look quite like stars. These are distant galaxies that are ten to a hundred times farther away than the galaxy (or galaxies) that is the focus of the picture.

The color in all of these images not only provides beauty for the viewer, it also delivers valuable information. Astronomers use color from broadband visible-light filters to make measurements about such fundamental qualities as distance, temperature, and age. In later chapters we'll explore how other kinds of filters, and other kinds of light, are used to make images and help us learn about the Universe.

◀ The Toby Jug Nebula (IC 2220) consists of layers of dust and gas being blown off of the red giant star at the center. The large dust grains in the nebula and the color of the star are what give the nebula its distinctive yellow color. Credit: Gemini Observatory/AURA and T. A. Rector (University of Alaska Anchorage).

▲ Most large galaxies are either elliptical or spiral. NGC 5363, the elliptical galaxy in the upper-left corner, is yellowish because older, smaller stars dominate its starlight. A faint dust lane is visible across the center of the galaxy. In stark contrast, the spiral galaxy NGC 5364, in the lower-right corner, shows a rich, complex structure. Its spiral arms are teeming with recently formed hot, massive stars that give it a bluish color. The center of the galaxy lacks hot stars and, like the elliptical galaxy, is yellow. Credit: T. A. Rector (University of Alaska Anchorage) and H. Schweiker (WIYN and NOAO/AURA/NSF).

▶ Since spiral galaxies consist mostly of a flat disk, the orientation of a spiral galaxy to our line of sight will dramatically change its appearance. On the opposite page, NGC 5905 (upper right) is a barred spiral (so named because of the bar across its center). It is seen "face on." This allows us to see the rich detail in the bulge and spiral arms. In contrast, NGC 5908 (lower left) is seen "edge on," making it difficult to see details in the disk. In fact, a dust lane across the disk blocks much of the view. The bright stars between the two galaxies are actually stars inside our own galaxy, meaning they are much closer to us than the galaxies themselves. Credit: T. A. Rector (University of Alaska Anchorage) and H. Schweiker (WIYN and NOAO/AURA/NSF).

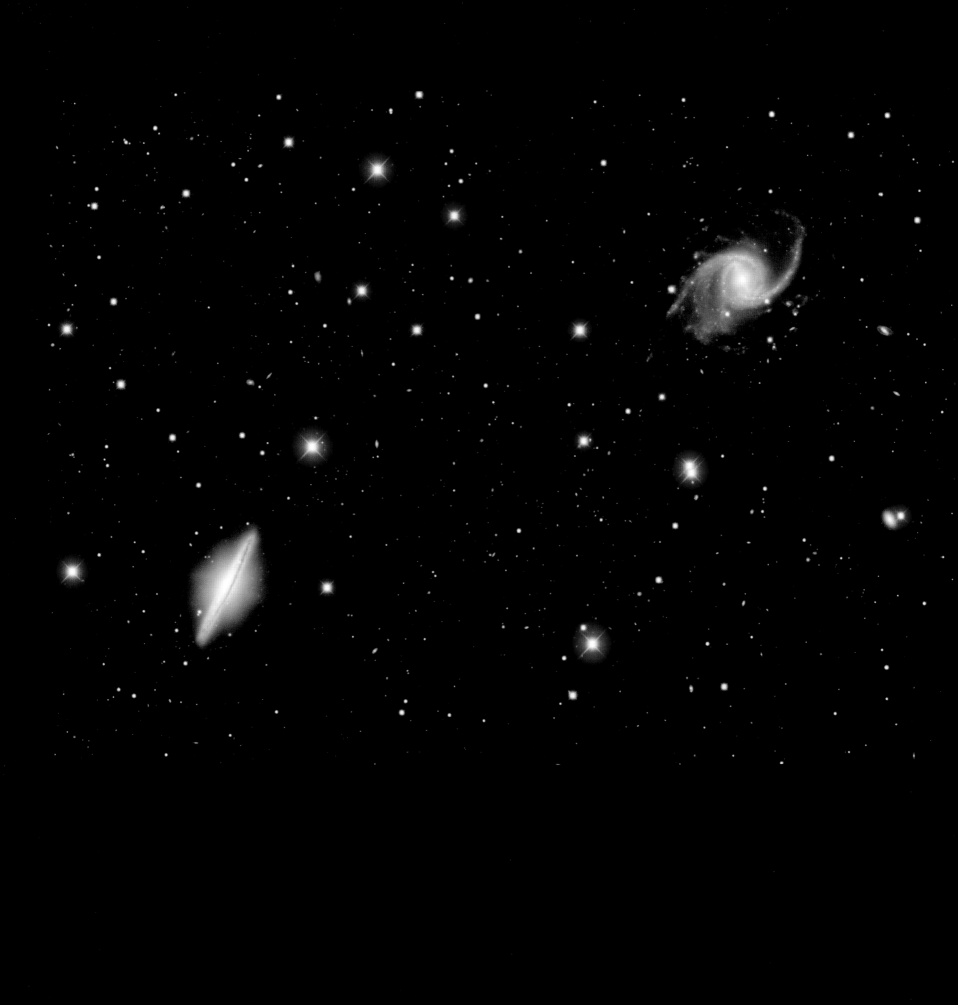

A BRIEF HISTORY OF ASTRONOMICAL IMAGES

The History of How (and Why) Images Are Made

Images from three NASA telescopes were combined to create this spectacular view of the starburst galaxy M82. *Hubble*'s view in visible light (yellow-green) shows the stars in the disk of a modest-sized, apparently normal galaxy. Another *Hubble* observation, designed to image 10,000 degree Celsius hydrogen gas (orange), reveals matter blasting out of the galaxy. An infrared image from *Spitzer* (red) shows that cool gas and dust are also being ejected. *Chandra*'s X-ray image (blue) reveals gas that has been heated to millions of degrees by the violent outflow. This is a good example of a modern astronomical image released to the public to illustrate new scientific results. Credit: X-ray: NASA/CXC/JHU/D. Strickland; visible: NASA/ESA/STScI/AURA/The Hubble Heritage Team; IR: NASA/JPL-Caltech/Univ. of AZ/C. Engelbracht.

People often comment on how many exciting discoveries are happening in astronomy these days. And it's true. There's seemingly a story about space—often accompanied by beautiful images—in the news almost every day. The prodigious rate of new discoveries is driven by several factors, including new technologies that have enabled larger telescopes, much more sensitive electronic detectors, and the development of telescopes both on the ground and in space that can see beyond visible light. Quite literally, scientists are now able to see and study objects in ways never possible before. But there have been other advances over the years as well that have been just as important. These breakthroughs have enabled us to make new kinds of images—and share them—in new ways. So how did we get to the point where we are now?

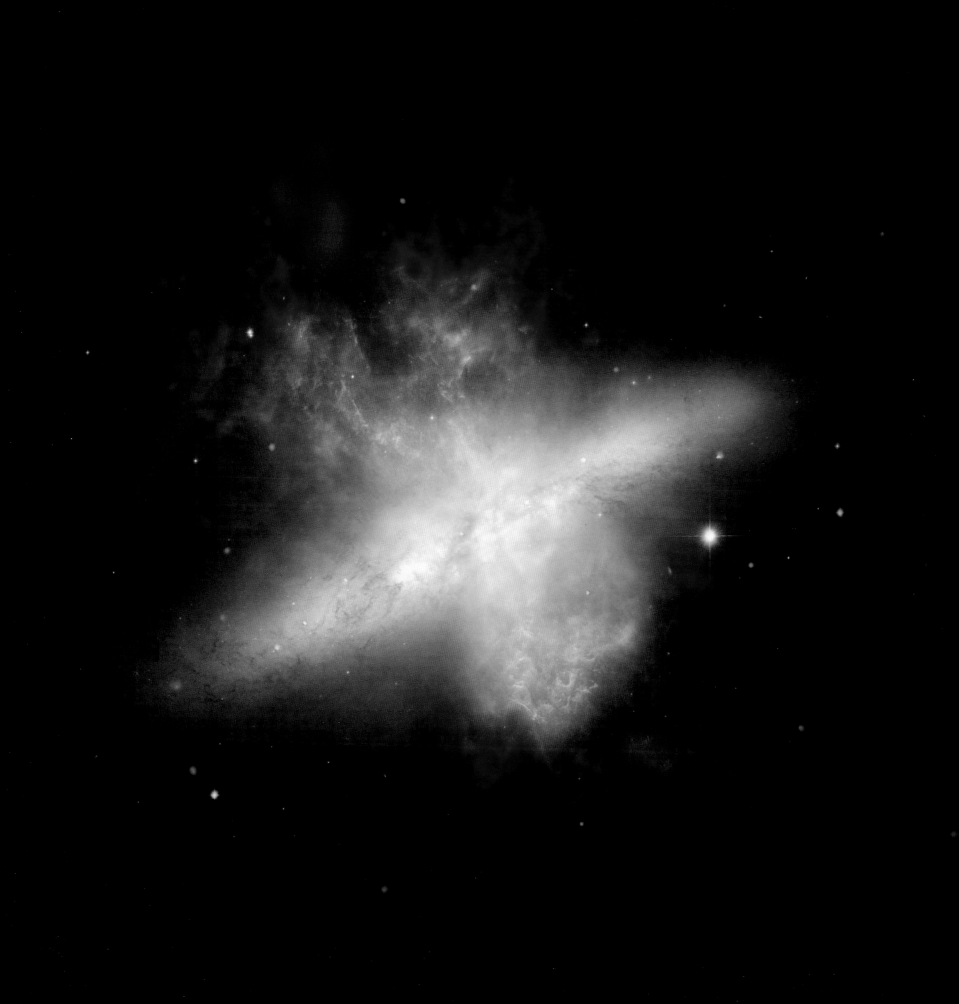

▶ A picture taken in 1977 of the darkroom in the KPNO 4-meter telescope. The darkroom is where photographic plates where prepared before use on the telescope and "developed" afterward. Preparation included **hypersensitization**, a process that made the plates more sensitive to faint light. After the exposure was taken, developing involved soaking the plates in chemicals that "fixed" the image to the photographic plate (so that the plate would not be affected by future exposure to light). The darkroom is so named because many of the steps had to be done with little to no light in the room. Otherwise the light would ruin the plates. Credit: NOAO/AURA/NSF.

THE ERA OF PHOTOGRAPHIC PLATES

Galileo Galilei is famous for first using a telescope for astronomy in 1609. But he and other astronomers were limited to reporting only what they could see by eye, since there were no film or electronic cameras in the seventeenth century. Sketches would have to suffice for more than two hundred years as the only means for recording what they saw.

Photography would eventually change that. In 1840, American chemist John William Draper took the first successful photograph of the Moon. In 1880 his son, Henry Draper, was the first to take an image of the Orion Nebula, a star-forming region just south of Orion's belt.

Henry Draper used something similar to what are now called photographic plates, which consist of a piece of glass coated in a light-sensitive **emulsion**. Exposure to light initiated a chemical reaction that would turn the emulsion dark. At first the emulsions available were relatively insensitive to light, and so it was difficult to capture fainter objects in photographs of space. But over time the technology improved. By the end of the nineteenth century, the development of photographic plates had advanced to the point where they were the primary tools for astronomical research.

Photography allowed a more permanent record of what the telescopes could see. And it helped overcome some of the bias that crept into many an astronomer's

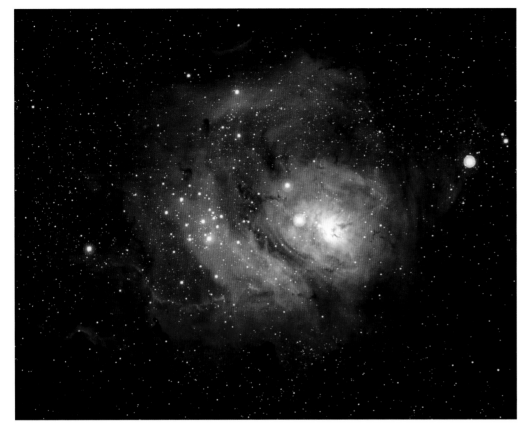
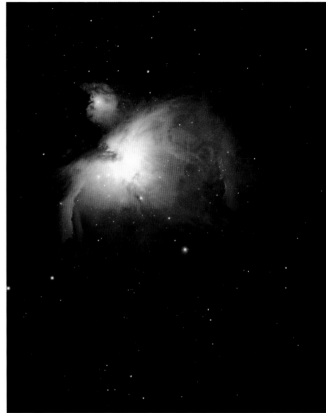

observations by eye and hand. A famous example of this is Percival Lowell. He thought he had seen canals on Mars, which he then interpreted as evidence of alien life. Photography later showed that the canals were not real (and were perhaps seen by Percival as the result of an optical illusion).

Photographic plates, like modern-day electronic cameras, took only black-and-white images. During the second half of the twentieth century, scientists and photographers such as Bill Miller at Palomar Observatory, David Malin at the Anglo Australian Observatory (AAO), and Mark Hanna at NOAO mastered the art of creating color images by using the three-color process of combining red, green, and blue layers as discussed in chapter 3.

These imaging pioneers also developed innovative darkroom techniques to maximize the amount of detail visible in the images, a precursor to the sorts of tools now available in image-processing software such as Adobe Photoshop. Over the span of more than a century, photography with chemically sensitive plates was the primary tool in astronomy.

▲ The Lagoon Nebula (M8; left) and Orion Nebula (M42; right) as seen by the KPNO 4-meter telescope in 1973. These images were made with photographic plates. Left credit: NOAO/AURA/NSF. Right credit: Bill Schoening/NOAO/AURA/NSF.

▼ Technicians inspect the primary mirror for the 4-meter telescope on a grinding table shortly after its arrival at KPNO. Some areas were polished clear for inspection by the Corning Company, which manufactured the mirror. A telescope's mirror is a large piece of glass with a thin metal coating on top that reflects light. The coating is usually replaced every few years. Note the many hexagonal sections of quartz glass that were fused together to form the mirror. Credit: John Lutnes/NOAO/ AURA/NSF.

Photography also greatly expanded what astronomers could see. As we discussed in the first chapter, long exposures made it possible to see objects too faint for the naked eye. Astronomers raced to build larger telescopes to take advantage of photography's potential, such as the *Hooker* 100-inch telescope at Mount Wilson Observatory, completed in 1917, and the *Hale* 200-inch telescope at Palomar Observatory that became operational in 1949. Because of their size, these two telescopes in particular dominated astronomical research in the first half of the twentieth century. However, only a relatively small group of astronomers had access to these telescopes, making the science these big telescopes made possible available to an elite few.

ASTRONOMY FOR EVERYONE

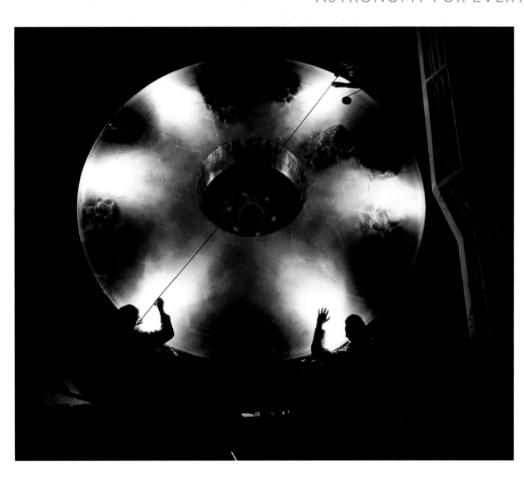

After World War II, it became clear to many that science and technology played an important role in winning the war. In 1950, the United States federal government formed the National Science Foundation (NSF) to fund research in all fields of science and engineering, including astronomy. To address the problem of limited access to large telescopes, in 1953 it was proposed that a National Observatory be built that would enable astronomers from any university or institution to have access to cutting-edge research facilities. Kitt Peak, a mountain in southern Arizona, was selected as the site for the National Observatory. Many telescopes have since been built on Kitt Peak, including the 84-inch telescope (later renamed the 2.1-meter), completed in 1964, the *Mayall* 158-inch telescope (now called the 4-meter), completed in 1973, and the WIYN 138-inch (3.5-meter) telescope, completed in 1994. Today, twenty-six telescopes in total reside on the mountain.

To provide astronomers access to the nighttime sky in the southern hemisphere, starting in 1960 the NSF led the development of the Cerro Tololo Interamerican Observatory (CTIO) high in the Andes Mountains of Chile. CTIO now hosts twenty-one telescopes, including the *Blanco* 4-meter telescope, completed in 1976, and the SOAR[12] 4.1-meter telescope, completed in 2003. KPNO and CTIO are both operated by NOAO. The NSF is also a partner in the international collaboration that built and operates the twin Gemini 319-inch (8.1-meter) North and South telescopes in Hawai'i and Chile, completed in 1999 and 2001 respectively. The NSF also funds the operation of other ground-based telescopes, including the National Radio Astronomy Observatory (NRAO), the National Astronomy and Ionosphere Center and Arecibo Observatory, and the National Solar Observatory. Space-based telescopes, such as *Hubble*, *Chandra*, and *Spitzer*, are NASA facilities that we talk about in more detail later in this chapter. Telescopes funded by NASA and the NSF all operate on the guiding principle that access should be unrestricted. That is, any scientist with a good idea should have an opportunity to use them.

THE RISE OF THE ELECTRONIC CAMERA

Around the same time that the United States was developing its vision for science (including astronomy) on the national scale, camera technology was also advancing. Photographic plates were the primary tool in astronomy until midway through the twentieth century. As the technology of electronic cameras progressed in the early age of television, astronomers took advantage. For example, they attached so-called Vidicons—an early generation of a camera tube first used in the 1950s—to their telescopes.

A particular invention in 1975, however, would fundamentally change the way astronomy was done: the **charged coupled device** (CCD). The CCD offered several advantages over Vidicons, including superior image quality and lower electricity demands. Today, we find CCDs everywhere—from the cameras on our phones to the scanners hooked up to our computers.[13]

By the 1980s the technology had advanced to the point where electronic (CCD) cameras were being used in earnest on many professional telescopes because they offered several advantages to photographic plates. First of all, electronic cameras are much more sensitive. Even the most sensitive photographic plates only absorb about 5 percent of the light that hits them, whereas electronic cameras absorb 50 to 95 percent. This means that electronic cameras made the telescope ten to twenty times more powerful than before because it could collect and store more of the light that the telescope captured. Electronic cameras also have the big advan-

tage of creating an inherently digital image. This enables astronomers to use much more complex (and precise) methods of analysis using computers.

Finally, they are simply much easier to use. Working with photographic plates required a team of astronomers to be present at the telescope during observations. Among the many tasks that astronomers had to perform were preparing new photographic plates for exposure, developing the plates that had been exposed, and working inside the telescope while taking the exposures.

To use photographic plates in large telescopes (such as the KPNO 4-meter, CTIO 4-meter, and Palomar 200-inch), an astronomer had to ride in the telescope, either at the top in the **prime focus cage** or at the bottom in the **Cassegrain cage** (so named after Laurent Cassegrain, who invented the design). After each picture was taken, the astronomer would remove the plate exposed to light and replace it with a new one. As many as four or five astronomers in total were needed at the telescope, whereas nowadays only one is needed. And, in many cases they don't even have to be at the telescope (or can't, in the case of space-based observatories).

Despite all of their advantages, electronic cameras did not fully replace photographic plates for several decades. At first using electronic cameras was challenging, because the computer software that astronomers needed to extract and analyze the data from the CCD was rather rudimentary. Storage of the digital images was also difficult, as they were large compared to the size of disk storage at that time. (In the early 1980s, a PC hard drive had about 5 MB of storage, a *million* times smaller than what is readily available today for a fraction of the cost.)

Another reason why astronomers continued to use photographic plates was the tiny field of view that CCDs offered. Until recently, cameras with CCDs were no match for photographic plates in this regard. Photographic plates were about 8 by 10 inches, or roughly the size of a sheet of paper. The first electronic cameras, on the other hand, were smaller than a postage stamp. When they first came out, CCDs greatly reduced the amount of the sky astronomers could capture through a telescope—something astronomers rarely want to have happen.

Modern CCD detectors are still much smaller than a photographic plate, but scientists and engineers found a solution for this problem. By combining multiple detectors in a single camera, astronomers can now build electronic cameras that are larger than a photographic plate. Interestingly, it is the older telescopes with prime focus cages, such as the KPNO and CTIO 4-meter telescopes, that are ideal for housing these giant cameras. Because these telescopes were built during the photographic era of astronomy, they were designed to be able to carry people and heavy equipment at the prime focus. Now they carry large digital cameras, such as Mosaic at the KPNO 4-meter and the Dark Energy Camera (DECam) at the CTIO

57

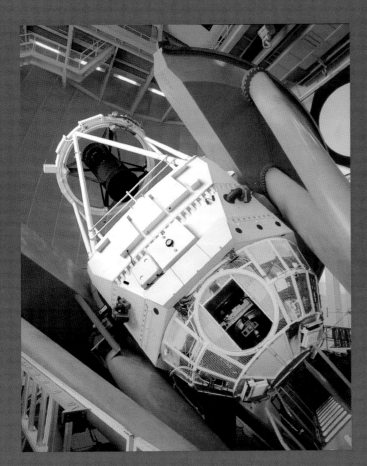
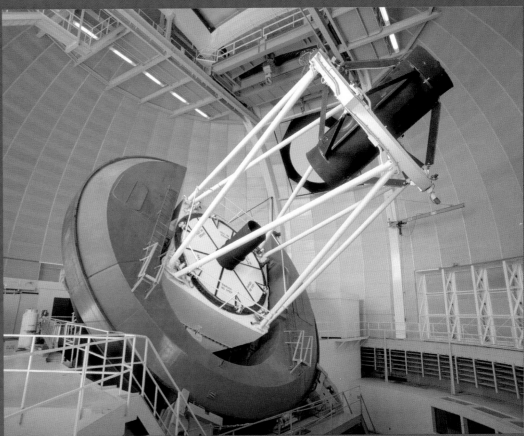

▲ When the KPNO 4-meter telescope was completed in 1972, it was designed to use photographic plates at two locations. The prime focus, located in the giant black cylinder on top (visible in the upper-right corner of the right image), gives a wide-field image. The Cassegrain cage, located on the bottom of the telescope (as seen in the image on the left), gives a "zoom in" view of a smaller region of the sky. In the photographic era, an astronomer would ride along in the telescope at one of these two locations. To get into the prime focus, the telescope would be tipped over on its side. A set of steps leads down to the Cassegrain cage. Both credits: NOAO/AURA/NSF.

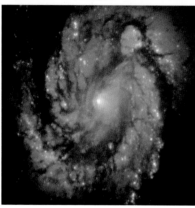

▲ The center of the spiral galaxy M100 as seen by *Hubble* before astronauts installed corrective optics (top) and after (bottom). Credit: NASA, STScI.

4-meter. DECam has several times the field of view of a photographic plate, and it weighs 7,500 pounds.

Newer observatories, such as the Gemini telescopes, were designed for electronic cameras that have a smaller field of view than photographic plates. Because they were designed for smaller electronic cameras, they were built without a prime focus cage. With the combination of advances in electronic cameras, the use of photographic plates waned in the 1990s. And by 2000, photographic plates met their ultimate end when their production was discontinued.

THE YEAR THAT WAS 1994

Electronic cameras were essential for another development in astronomy: putting telescopes into space. Of course, it's not easy to get photographic plates from an orbiting observatory hundreds or thousands of miles from Earth. (Although some, like the Soviet Union's *Luna 3* mission, did use film that was developed and scanned on board the spacecraft.) The CCD in particular was essential for the development—and ultimate success—of space telescopes such as *Hubble*.

First proposed in 1946 by astronomer Lyman Spitzer, the design, funding, and construction of *Hubble* took almost half a century. Finally, the space shuttle *Discovery* carried *Hubble* into orbit in 1990.[14] Soon after, astronomers—who had been waiting decades for this telescope—knew there was a problem. It turned out that *Hubble*'s primary mirror had the wrong shape, which caused everything to be out of focus. Stars looked fuzzy, and galaxies and nebulae looked blurred.

The images were deeply disappointing for scientists because they were counting on *Hubble*'s sharp vision to lead to new discoveries. The flawed multi-billion-dollar telescope was also seen as a public relations disaster for NASA. Fortunately the problem with the mirror was a relatively simple one that could be fixed. Scientists and engineers went to work to figure out how to build corrective optics that, once installed on the telescope, would restore *Hubble*'s vision. But NASA also had to address the issue of public opinion.

In December 1993, astronauts on a servicing mission with the space shuttle *Endeavor* successfully installed new cameras and optics onto *Hubble*. These new "eyes" precisely corrected for the errant shape of the primary mirror (think of how eyeglasses correct for imperfections in the human eye). Finally, three years after it was launched, *Hubble* was ready to perform as promised. To show off *Hubble*'s capabilities, NASA released images from the newly installed Wide Field Planetary Camera 2 (WFPC2).

The new images helped to awaken our collective imaginations. It's hard to over-state how important and popular the images from the "new" *Hubble* were to the scientific community and to NASA. While not quite to the level of quality that we are accustomed to from *Hubble* today (since that time newer, more powerful cameras have been installed on *Hubble*, and better image-processing tools and techniques have been developed), they were nonetheless sensational. They showed stars and galaxies with a sharpness never seen by Earth-bound telescopes. The images also worked to breathe new life into NASA's relationship with taxpayers, politicians, and others who felt invested in the telescope. *Hubble* helped lay the groundwork for creating and sharing images of our Universe that were not only beautiful but also accessible.

The repair of *Hubble* could not have been more timely. Just a few months after it was fixed, *Hubble* was ready to watch one of the most dramatic astronomical events ever to occur in our Solar System. In July 1992, the comet Shoemaker-Levy 9 passed by Jupiter so closely that the planet's intense gravity ripped the comet into pieces. Calculations showed that the fragments would later collide with Jupiter in July 1994. It would be the first time we could witness the collision of large objects in our Solar System. *Hubble*, with its new clear vision, was poised to watch, as were other telescopes.

Meanwhile, other developments had recently occurred that would also prove to be important for this event. The World Wide Web, the standard for Internet communication today, began in 1991. At first its use was rather limited, but that changed in 1993 with the introduction of the Mosaic[15] web browser from the National Center for Supercomputing Applications (NCSA). While we might take these things for granted today, Mosaic provided an easy-to-use interface that combined text, graphics, and hypertext links. In fact, many people credit Mosaic for launching the popularity of the web.

Despite such advances, the World Wide Web was still in its infancy as the fragments of Shoemaker-Levy 9 approached Jupiter. NASA and other agencies and observatories had only rudimentary websites, primarily intended to disseminate documents to scientists. When Shoemaker-Levy 9 hit Jupiter, the demand for images of the event was huge. The web was a new and an ideal way to distribute these images; however, web servers of the time were woefully inadequate to keep up with the demand. People had to wait hours for a single image to download. Often, the download would fail altogether. Despite the problems, the comet's impact demonstrated the power of the web for rapidly distributing astronomical images and information. It also helped show that there was tremendous interest in them.

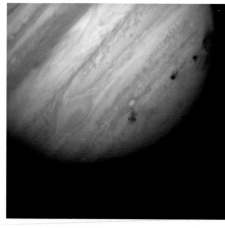

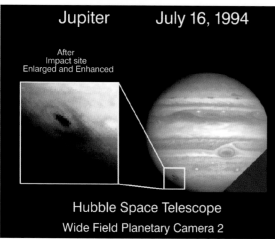

▲ Images of the comet Shoemaker-Levy 9 collision with Jupiter taken by *Hubble*. The impacts from cometary fragments temporarily gave Jupiter a "bruised'" appearance, caused by black debris that was tossed high above the giant planet's cloud tops. The bruises disappeard after several days. Both credits: NASA/ Hubble Space Telescope Comet Team.

A third development was also important. At the same time that electronic camera hardware was improving, so was the software. Image-processing software, such as Photoshop, quickly became an essential tool for creating and modifying electronic images. Released in September 1994, Photoshop version 3.0 had a new feature that would prove invaluable for the creation of complex color composite images. While not the first program to do so, Photoshop 3.0 had the important ability to use **layers**.

In the layering metaphor, multiple images can be stacked on top of one another and then combined to form a single image. Recall that in the traditional three-color method, three **grayscale** (black and white) images were colorized red, green, and blue and then combined to form the color image. The technique, first developed in photography and then used in electronic images, was powerful. But it was limited in that it could use only three images and those three colors.

With the new layering capabilities available in Photoshop, astronomers could combine any number of images and use any colors they wanted. This enabled them to make images much more complex than before. (In chapter 11, we'll show examples that use as many as thirteen images layered together.) The ability to put different layers of astronomical data together with different colors was a critical technological development for creating the spectacular images we have today. Photoshop also has important tools necessary to fine-tune the color balance as well as fix cosmetic defects (which we'll also discuss in chapter 11).

ONWARD TO THE FUTURE

Shortly after the Shoemaker-Levy 9 impact, another event would play an important role in the development of astronomical imaging. In November 1995, NASA released an image of a star-forming region, officially called M16, that would become known as the "Pillars of Creation." The striking nature of the image, combined with the evolving Internet's ability to deliver it directly to individuals, helped make it hugely popular. The *New York Times* described it as a "remarkable view of a kind of fantasyland of powerful cosmic forces." Many people regard it as one of the greatest astronomical images ever made (more on this in chapter 12). The Pillars of Creation went on to become a cultural icon, appearing on items from postage stamps to billboards. Its popularity was another hint that there was a tremendous response to beautiful images of our Universe.

The popularity of the Pillars of Creation and other astronomical images served as the inspiration to start a program where *Hubble* data, collected primarily for scientific purposes, would also be used to create beautiful astronomical pictures

to help connect the public with the cosmos. Since 1998, the Hubble Heritage program has released a new color image every month. The project has produced some of *Hubble*'s most popular images.

At the time, the Hubble Heritage program was somewhat controversial in the astronomical community. While most *Hubble* images are generated from data obtained for scientific purposes, a meager amount of telescope time is also sometimes allocated only for making color images. Telescope time is a precious commodity, especially for a telescope as in-demand as *Hubble*. So some astronomers considered using even a small amount of *Hubble*'s observing time for nonscientific purposes to be a waste. Many scientists labeled the Pillars of Creation, and other images like it, as "pretty pictures"—and not in a complimentary way. Ultimately, the success of the Hubble Heritage program has won over many astronomers. Today, more scientists see these appealing images as an effective way to share scientific discoveries beyond the expert audience, as well as to help increase interest in astronomy and science in general. The idea that "truth and beauty" do not have to be mutually exclusive is becoming more acceptable.

As NASA ramped up its public relations efforts with the use of high-quality color images, other observatories began to do the same. Since 1998, scientists at KPNO and CTIO (including Dr. Rector) have used the giant Mosaic cameras to produce color images for the public. In 2002, the Canada-France-Hawai'i Telescope started their "Hawaiian Starlight" program, where a new image is released every month. And in 2004, Gemini Observatory started its "Gemini Legacy" image project. Others have done so as well.

Most space telescopes launched since *Hubble* have integrated color image creation and dissemination into their programs as well. NASA's *Chandra* X-ray Observatory, launched in 1999, has the most advanced optics of any X-ray telescope today. *Chandra*'s superb resolution and sensitivity have enabled scientists to make images of objects emitting X-rays that were never possible before. The *Chandra* team uses the unique capabilities of the science instruments and spacecraft to release two or more images per month, aligning the image releases with notable scientific results on those objects. The *Chandra* team has also made a particular study of how images are connected with their meaning, and how experts and nonexperts perceive astronomical imagery (which will be discussed in chapter 7). NASA's three remaining "Great Observatories,"[16] *Hubble*, *Chandra*, and the infrared *Spitzer* Space Telescope, also frequently work together to make images of objects that show detail over a wide portion of the electromagnetic spectrum.

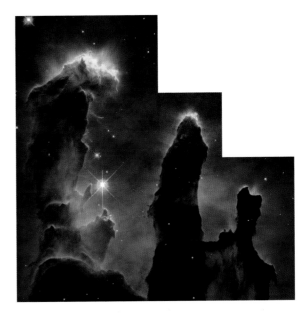

▲ The iconic "Pillars of Creation" image from *Hubble*. In chapter 12, we'll talk about what helps make this image so successful. Credit: NASA, ESA, STScI, J. Hester, and P. Scowen (Arizona State University).

▲ These images of the Moon and the Rosette Nebula (NGC 2237) were released to show off the capabilities of the new Mosaic camera which, when placed on the KPNO 0.9-meter telescope, has a field of view that is one square degree. This is about five times the size of the Moon. These two images are to the same scale, so you can see that the Rosette is actually much larger than the Moon. It is just too faint to see with your naked eye. Left credit: T. A. Rector and I. P. Dell'Antonio (NOAO/AURA/NSF). Right credit: T. A. Rector, B. A. Wolpa, and M. Hanna (NOAO/AURA/NSF).

THE TIME IS NOW

Virtually all publicly funded observatories now have communications programs that release color astronomical images. Where do all these images come from, since we know that telescope time is hard to come by? They come primarily from three sources. One source is "engineering" testing time. The vast majority of time scheduled on professional telescopes is allocated for scientific research. However, the teams of scientists and engineers that operate and maintain telescopes set aside blocks of time for certain technical and engineering purposes; for example, to perform repairs and maintenance on the telescope and cameras, to test new modes of observing, to test upgrades to existing cameras, and to commission new ones.

Since most repairs cannot be anticipated in advance, small blocks of time are allocated regularly throughout the year. For major upgrades, scientists and engineers may request larger amounts of time. For these engineering tests, the telescope staff often selects targets that can both serve as a good test of the camera and, if it is performing well, generate good data for a color image. These images are often used to demonstrate the capabilities of the camera and telescope.

Another source is, of course, data obtained for scientific purposes through a proposal process described in chapter 9. However, these data are not always suitable for making a quality color image. Some observatories, such as *Hubble*, keep an eye out for scientific data that also have potential for a high-quality color image. These images are often used in press releases associated with the scientific discoveries made from the data. Some might assume the press release image itself was used to make the reported discovery, but often the image is intended to help illustrate the scientific result obtained through various analysis techniques not related to the image itself.

Finally, on some telescopes, small blocks of time are set aside specifically for the purpose of creating color images similar to the *Hubble* Heritage program. Targets are selected primarily on their aesthetic value and are usually assigned a short amount of time. For example, the Gemini Legacy program allows for only a few hours per telescope per semester. Fortunately, with large apertures and high-sensitivity visible and near-infrared instruments, it is possible to make a high-quality image with this modest investment of telescope time.

These communications programs have helped share with citizens the important discoveries being made with these telescopes as well as the beauty of the Universe in which we all live. Research has shown that these images have helped to increase enthusiasm about astronomy and science in general. They also have become embedded in our public culture. They've appeared in countless magazines and

▲ This image demonstrates the capabilities of the Gemini Multi-Conjugate Adaptive Optics System (GeMS) on the Gemini South telescope. It is a near-infrared image of the outskirts of the Orion Nebula. The blue spots are clouds of gaseous iron "bullets" being propelled at supersonic speeds from a region of massive star formation outside, and below, this image's field-of-view. The image quality rivals that possible with *Hubble*. Credit: Gemini Observatory/AURA and T. A. Rector (University of Alaska Anchorage).

▶ An example of an image intended to illustrate a scientific result. This picture shows the spiral galaxy NGC 7424 as observed by the Gemini South telescope for the purpose of studying the remains of the unusual supernova SN2001ig that exploded inside a spiral arm of this galaxy (in the upper-left corner of this image). Using this data astronomers found a predicted "companion" star that was left behind after the explosion. The presence of the companion explains why the supernova, which started off looking like one kind of exploding star, seemed to change its appearance after a few weeks. Credit: Gemini Observatory/ AURA, Stuart Ryder (Anglo-Australian Observatory) and T.A. Rector (University of Alaska Anchorage).

newspapers. They've been on album covers, including Pearl Jam's *Binaural* in 2000 and Styx's *Big Bang Theory* in 2005. And then there's the skit character, "Milky J" on *Late Night with Jimmy Fallon*, who expressed his love of *Hubble* images with the catch phrase "Hubble gotchu."

The art and science of making astronomical images has certainly come a long way since the days of hand-drawn sketches and early photographs taken through small telescopes. In fact, some say today's flotilla of space-based telescopes and the myriad of observatories on the ground have us in the midst of a "golden age" of astronomy. True or not, it's clear that the invention of electronic cameras, Photoshop, and the Internet have enabled scientists and educators to make stunning astronomical images a regular part of our daily lives.

▲ In 2009, the "From Earth to the Universe" (FETTU) project brought astronomy to millions of people around the world, from locations as diverse as Central Park in New York City (top) to Iran (bottom). Both credits: The FETTU project.

◄ Sharpless 71 is a complex planetary nebula with an unclear origin. It was imaged for the Gemini Legacy imaging project. Credit: Gemini Observatory/AURA and T. A. Rector (University of Alaska Anchorage).

THE MARVEL OF HYDROGEN

The Most Important Element and How We See It

ELEMENT NUMBER ONE

There are ninety-eight elements that occur naturally in the Universe, but one in particular stands out. Hydrogen is the lightest element on the periodic table. It is also the most abundant element in space. *By far.* Hydrogen makes up about three-quarters of all of the "normal" matter in the Universe. (Note that this doesn't include dark matter or dark energy. These are exotic forms of mass and energy that differ from the elements from which we are made. Astronomers and physicists have labeled everything that's not dark matter or dark energy to be normal, or **baryonic,** matter.) Needless to say, hydrogen is essential. It is the basic building block of stars. It is also the primary fuel in the nuclear reactions that power the stars. And it's *everywhere*—in stars, between stars, throughout and even between galaxies.

Hydrogen is the "dirt" that allows the seedlings of star formation to grow. If astronomers couldn't find this cosmic compost, they would be missing much of the information about what is happening in our Galaxy and beyond. For these

▶ The giant nebula IC 1805 glows red because of the warm hydrogen gas inside. The bright, hot, and blue stars embedded within the nebula are energizing the gas. Credit: T.A. Rector (University of Alaska Anchorage) and H. Schweiker (WIYN and NOAO/AURA/NSF).

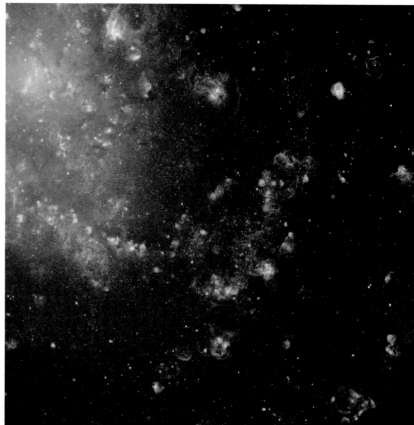

▲ The image on the left shows the nearby spiral galaxy M33 as seen through the broadband B filter. The image on the right shows the same portion of the galaxy as seen through the narrowband H-alpha filter. The B filter allows blue light to pass through, so it is useful for finding the hot, massive blue stars within the galaxy. The image on the right shows structures not visible in the left. These structures, known as HII regions, are giant clouds of hydrogen gas that glow from the energy of the stars forming inside them. Notice that many of the clusters of blue stars seen in the left image are located within hydrogen clouds seen in the right. Astronomers can use images like these to study the formation of stars within a galaxy. Credit: Local Group Survey Team and T. A. Rector (University of Alaska Anchorage).

reasons, astronomers have taken special care to develop technologies to detect hydrogen gas.

Cold gas is largely invisible to visible-light telescopes. But that changes as soon as you start to heat it up. This is true for hydrogen as well. When energized by, say, a nearby star, hydrogen starts to glow. When it glows, hydrogen produces several specific colors of light. And astronomers use special filters to see that light. These filters are called **narrowband filters**, because they only allow a select portion of light to pass through.

The **hydrogen alpha** filter (also known as "H-alpha") is particularly crucial for astronomical research. It allows only a specific color of red light produced by hydrogen gas to pass through. H-alpha is therefore a handy tool for detecting warm hydrogen gas. Because the narrowband filter blocks out other kinds of light, it allows astronomers to better see the location and distribution of this gas in whatever object they observe.

THE BIRTH OF STARS

Most galaxies—including the Milky Way—are filled with interstellar clouds of gas. These clouds, made primarily of hydrogen, are where new stars form. Stars come in a range of sizes. The more massive stars are bigger, hotter, and bluer. They also produce more of a high-energy light known as ultraviolet. This ultraviolet light—similar to what causes a sunburn—energizes the surrounding gas, causing it to glow. Astronomers call these glowing clouds **HII regions** (pronounced "H two" since the "II" are Roman numerals). HII regions are seen inside our Galaxy as well as in others. The H-alpha filter is an effective way to find and study them.

Hydrogen alpha emission is often seen when hot, massive blue stars are embedded in an interstellar cloud of gas. Sharpless 54 is an example of an HII region inside our galaxy. Credit: Gemini Observatory, Paul Fitz-Gerald (Ivanhoe Girls School) and T. A. Rector (University of Alaska Anchorage).

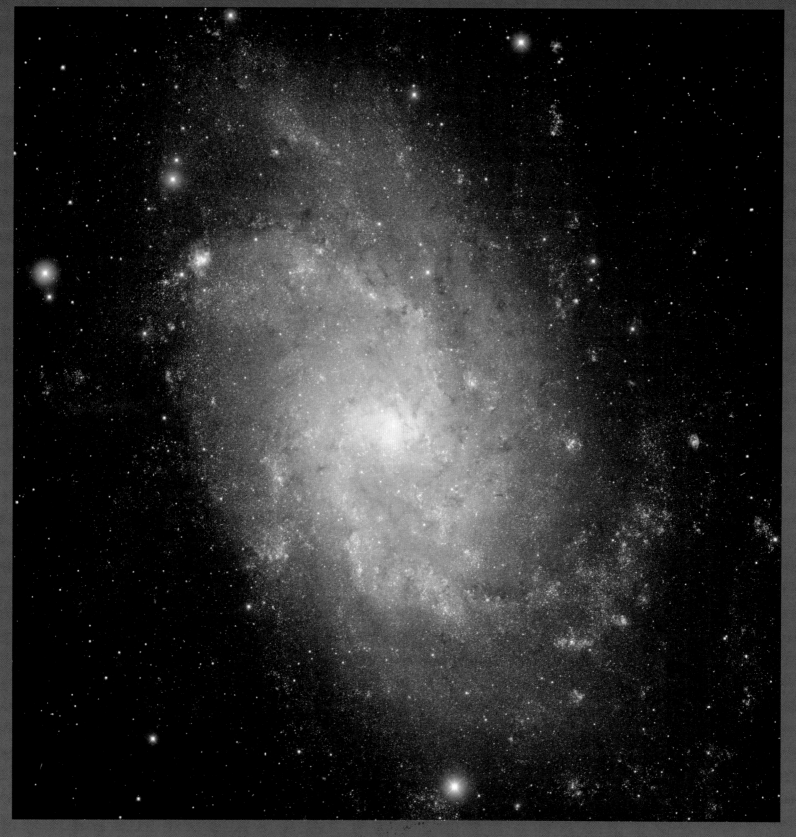

▲ ▶ Here's another example of the different things we see through broadband and narrowband filters. The image of M33 above was made using only broadband filters, whereas for the image on the opposite page the broadband R filter was replaced with H-alpha. By using H-alpha, we can better see the warm clouds of hydrogen gas (HII regions) in which new stars are forming. Credit: Local Group Survey Team and T. A. Rector (University of Alaska Anchorage).

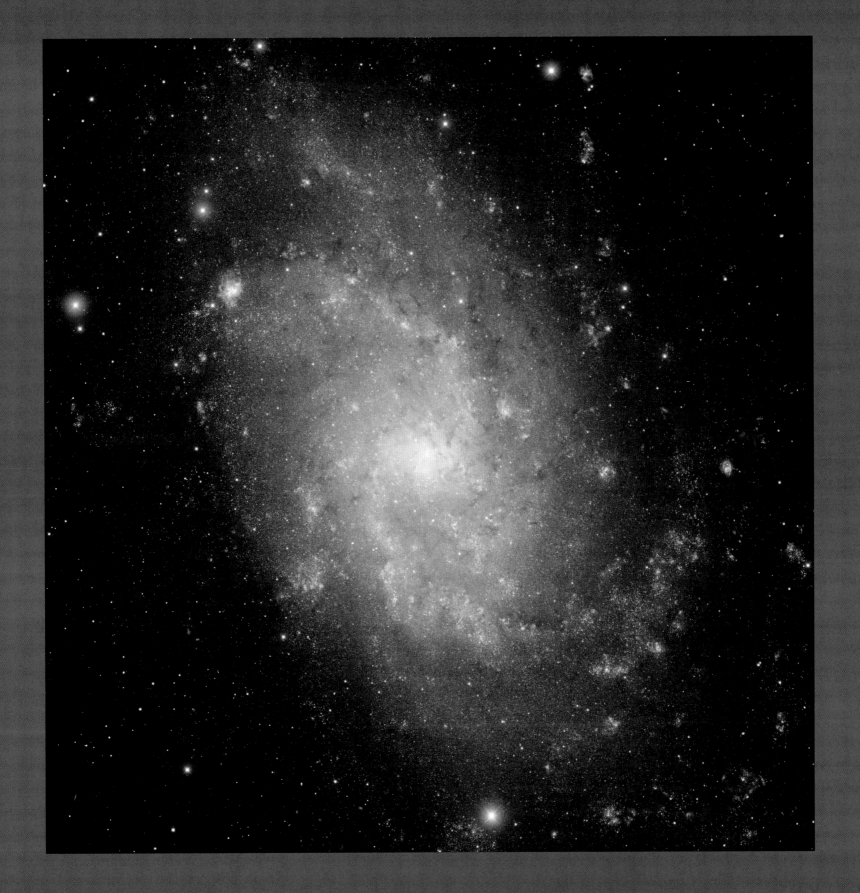

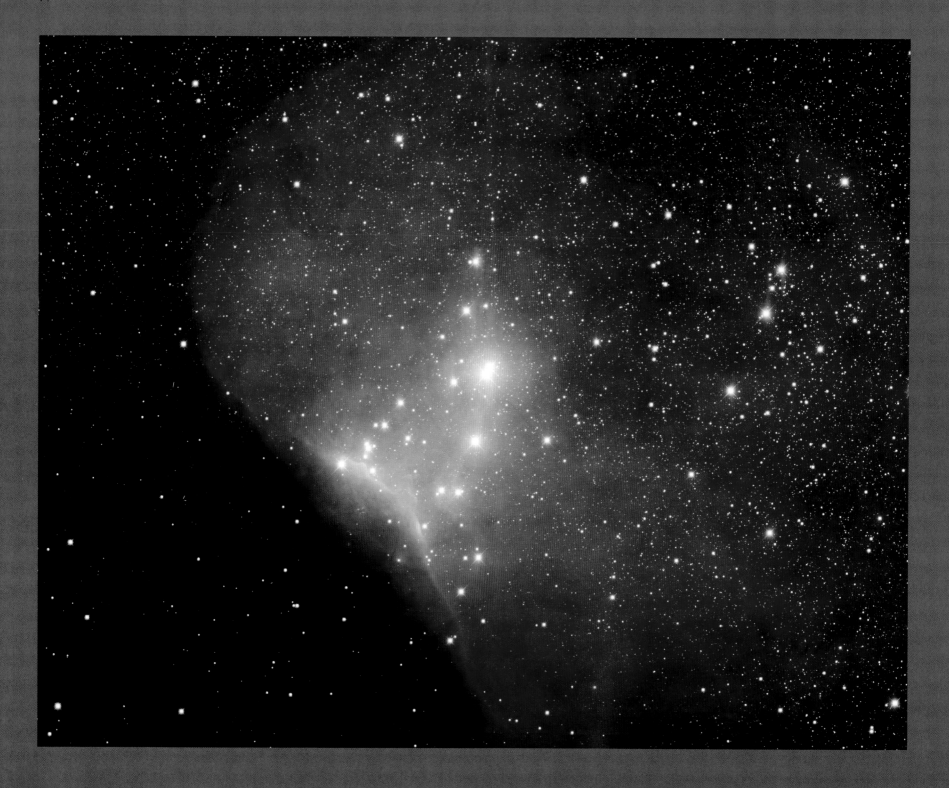

▲ ▶ The rich glow of H-alpha emission in red can be seen throughout the giant HII regions Sharpless 140 (above) and Sharpless 155 (opposite page). The bright stars within the nebulae are energizing the gas. Both credits: T. A. Rector (University of Alaska Anchorage) and H. Schweiker (WIYN and NOAO/AURA/NSF).

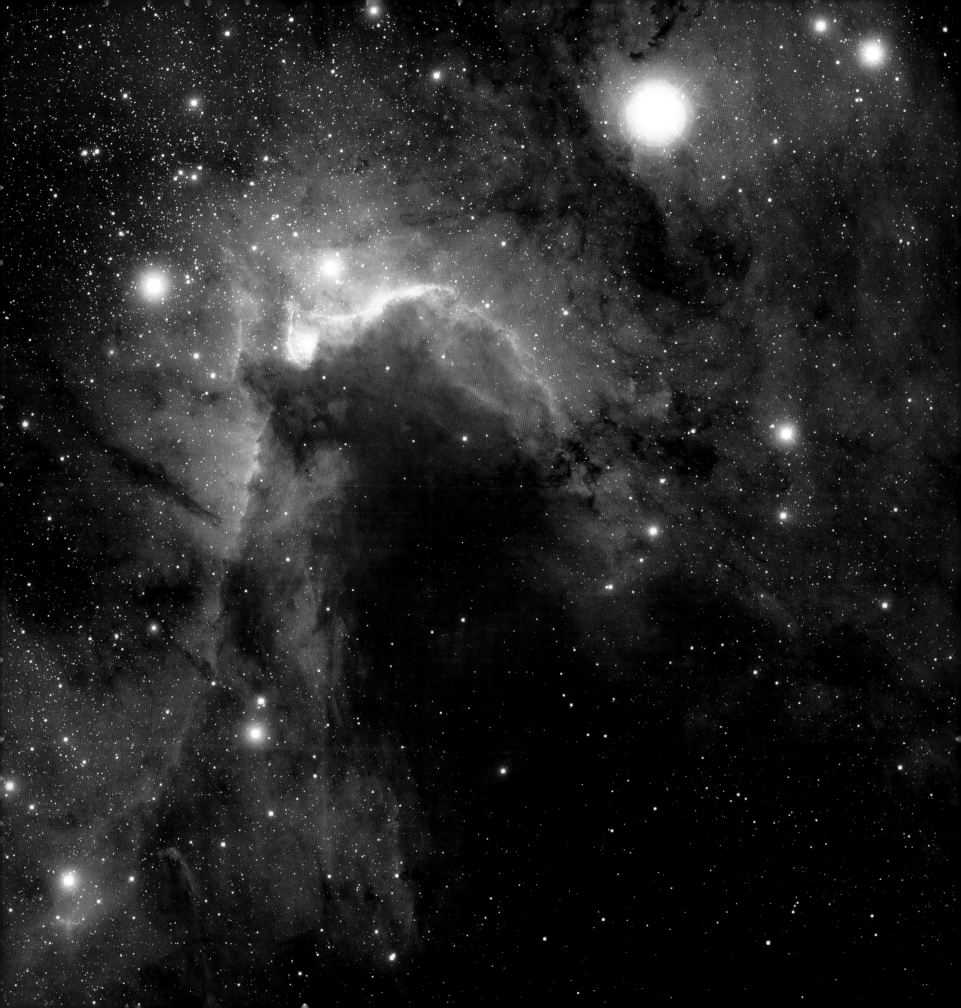

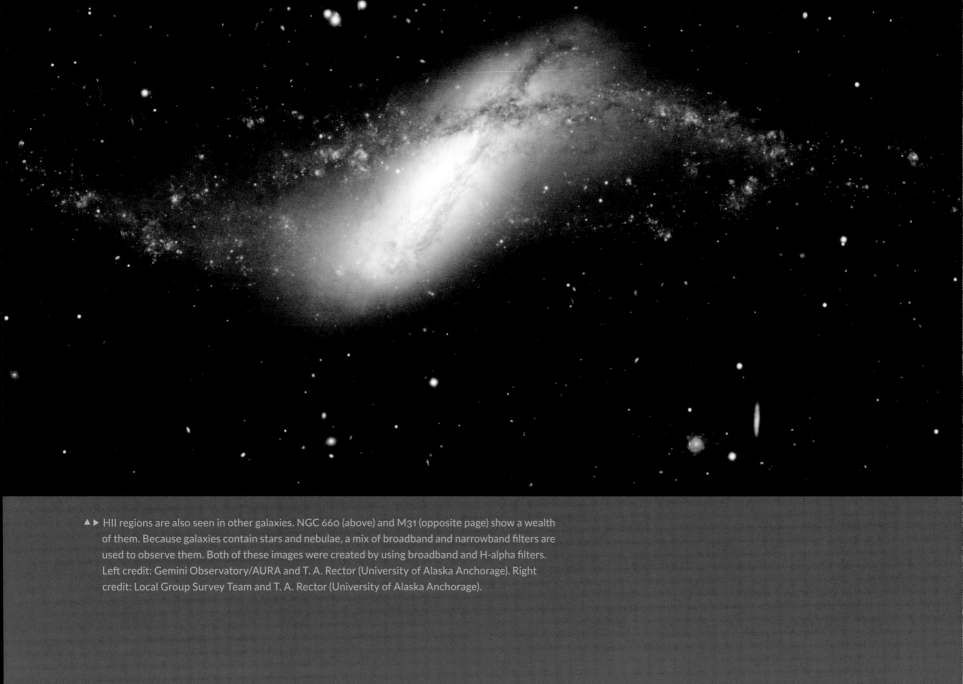

▲ ▶ HII regions are also seen in other galaxies. NGC 660 (above) and M31 (opposite page) show a wealth of them. Because galaxies contain stars and nebulae, a mix of broadband and narrowband filters are used to observe them. Both of these images were created by using broadband and H-alpha filters. Left credit: Gemini Observatory/AURA and T. A. Rector (University of Alaska Anchorage). Right credit: Local Group Survey Team and T. A. Rector (University of Alaska Anchorage).

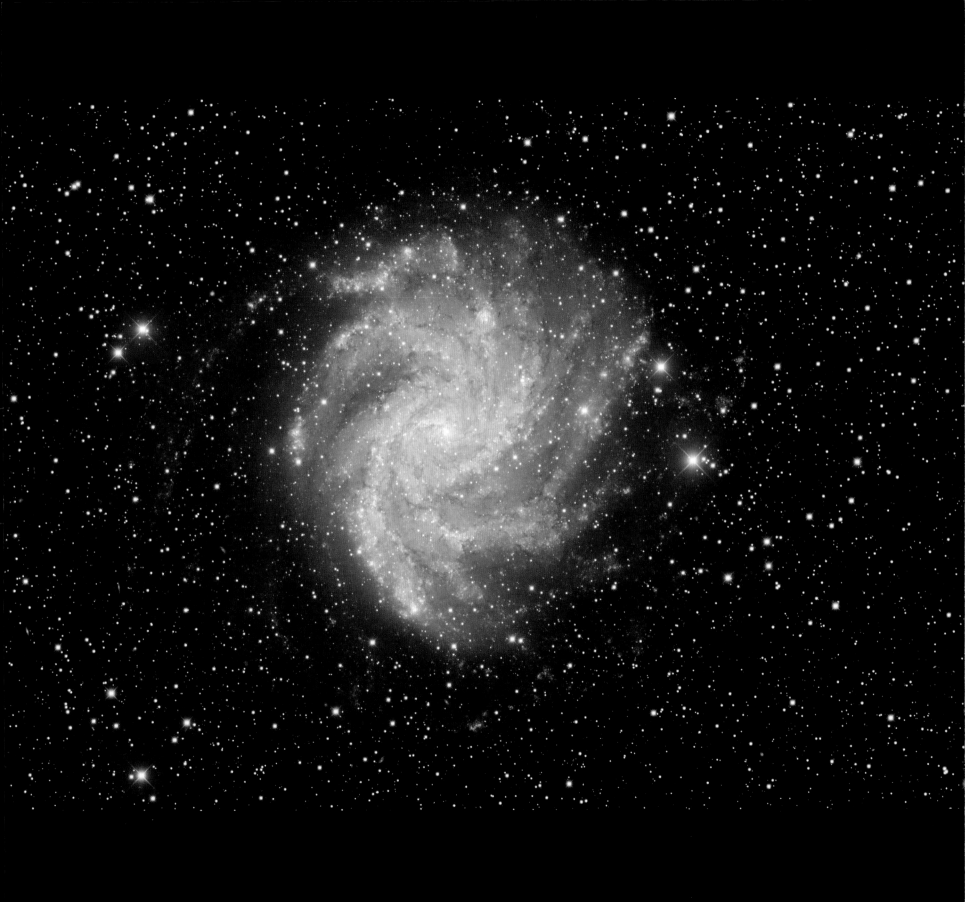

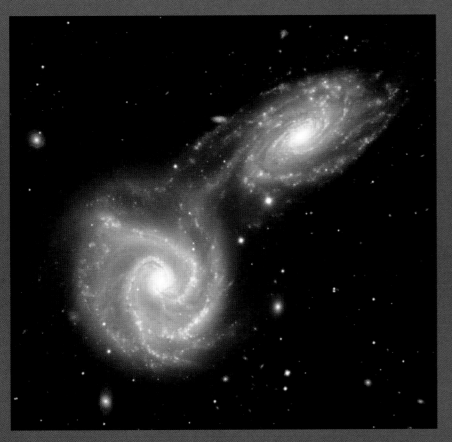 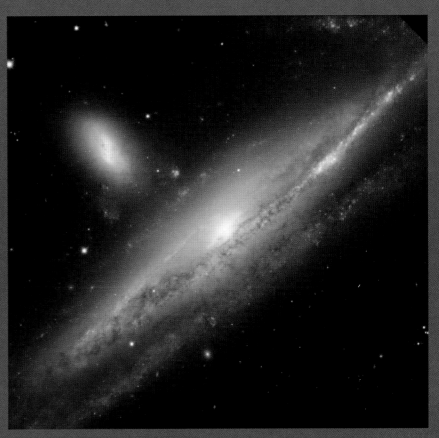

▲ Interactions with other galaxies can also trigger stars to form in a galaxy, as seen here in the galaxies NGC 5426 and NGC 5427 (left) and NGC 1531 and NGC 1532 (right). Both credits: Gemini Observatory/ AURA and T. A. Rector (University of Alaska Anchorage).

◄ Nearly all spiral galaxies have ongoing star formation, so if hydrogen alpha data are included when making images of them it tends to cause a "chicken pox effect" of red dots sprinkled within the galaxy. HII regions are seen throughout most spiral galaxies, such as NGC 6946 shown here, but are rarely seen in elliptical galaxies. Credit: T. A. Rector (University of Alaska Anchorage) and H. Schweiker (WIYN and NOAO/AURA/NSF).

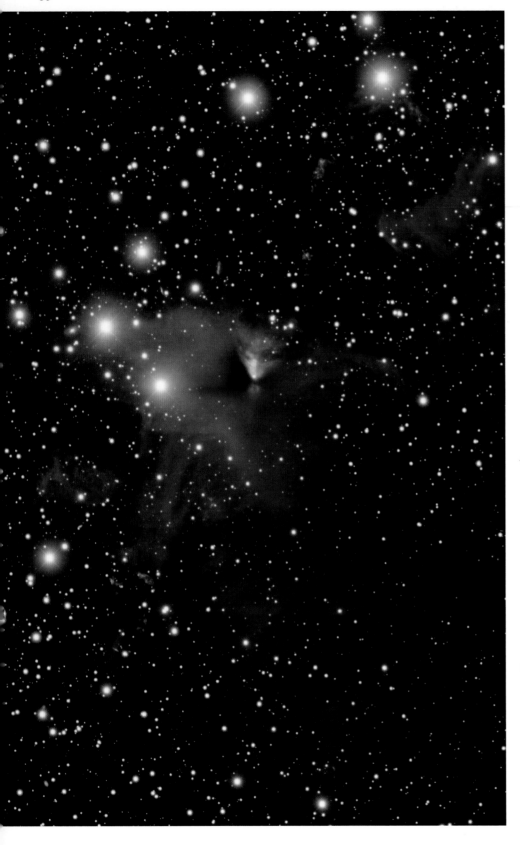

JETS FROM FORMING STARS

Hydrogen-alpha light is seen from objects in our Milky Way other than HII regions. For example, when young stars are forming they can emit narrow jets of gas. The jets are aligned with the star's axis of rotation, coming out of the top and bottom of the star. When these jets collide with the ambient gas near the star, the gas will be energized and will start to glow. These glowing areas in the jet are known as **Herbig-Haro objects** (or "HH objects" for short). They are named after George Herbig and Guillermo Haro, two astronomers who began to study them in earnest more than fifty years ago.

◀ This image shows a newly forming star called PV Cep (so named because it is located in the constellation of Cepheus, the King). The star itself is embedded in the cloud of gas near the center of the image. The red blobs are Herbig-Haro (HH) objects, caused by high-speed jets of material colliding with gas surrounding the star. A long chain of HH objects is seen coming from the top and bottom of the star, curving to make a gentle "S" shape that runs from the upper-right to the lower-left corners of the image. Credit: T. A. Rector (University of Alaska Anchorage) and H. Schweiker (WIYN and NOAO/AURA/NSF).

▶ A wealth of HH objects can be seen in the dark nebula Sharpless 239. The jets from many young stars are punching holes in the dense cloud of gas and dust in which these stars are forming. Credit: T. A. Rector (University of Alaska Anchorage) and H. Schweiker (WIYN and NOAO/AURA/NSF).

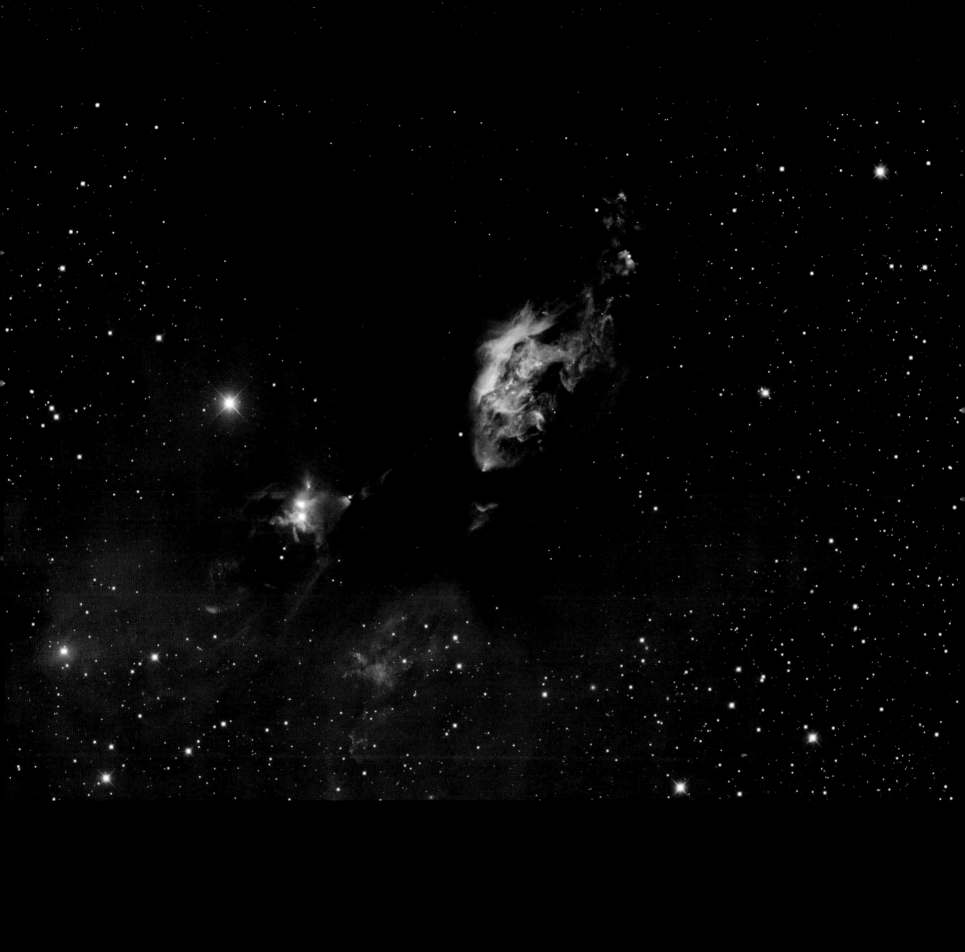

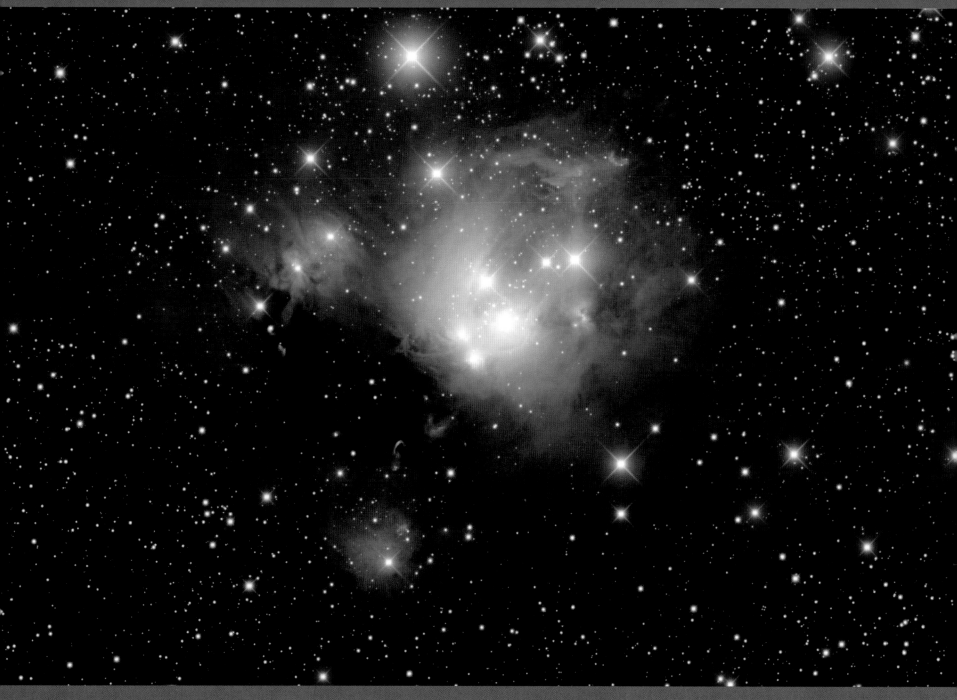

▲ ▶ Many HH objects can be seen embedded in the reflection nebulae NGC 7129 (above) and NGC 1333 (opposite page). HH objects are often found in reflection nebulae because the gas that is forming new stars may also contain dust that reflects light. Both credits: T. A. Rector (University of Alaska Anchorage) and H. Schweiker (WIYN and NOAO/AURA/NSF).

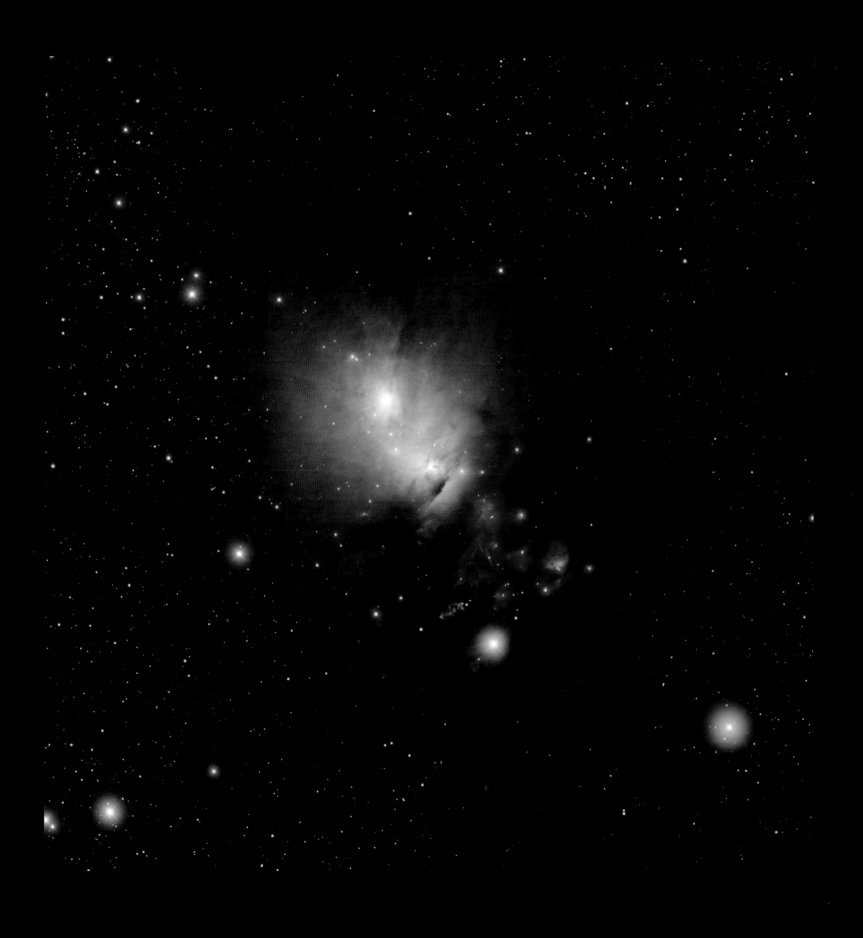

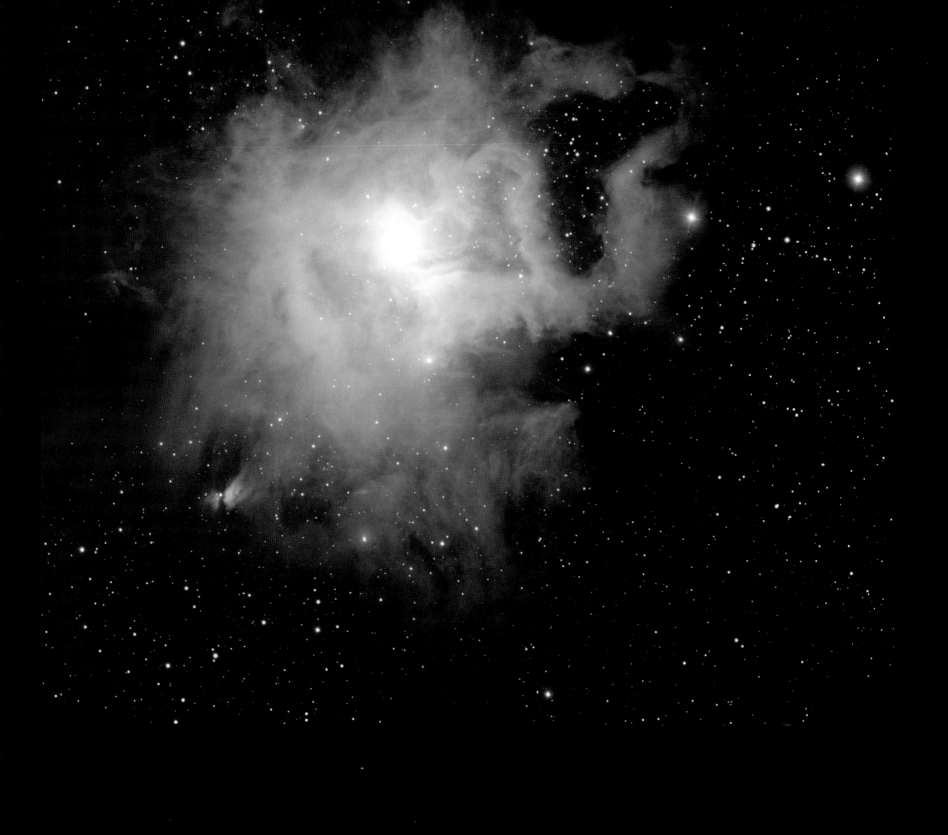

◀▲ The H-alpha filter is an effective tool for finding HH objects, which are often obscured by gas and dust. For example, the use of this filter enabled the discovery of several HH objects in the reflection nebula NGC 7023 (opposite page). They appear as faint red smudges in several locations in the zoomed-in image above. Can you find them? Credit: T. A. Rector (University of Alaska Anchorage) and H. Schweiker (WIYN and NOAO/AURA/NSF).

▲ ▶ These images show a portion of the giant star-forming region Cepheus OB3 (above) and the reflection and emission nebula Sharpless 82 (opposite page). In both images, the hydrogen alpha image is red and the "I" broadband image is orange. By using different colors we can distinguish between the reflection nebulae seen in the I band (for example, at the bottom of the image above and at the center of the opposite image) and hydrogen emission. Above credit: T. S. Allen (University of Toledo), T. A. Rector (University of Alaska Anchorage), and WIYN. Opposite page credit: T. A. Rector (University of Alaska Anchorage) and H. Schweiker (WIYN and NOAO/AURA/NSF).

CHOOSING THE COLORS

As mentioned before, the primary colors—red, green, and blue—are the building blocks of all color. They can be combined, in various ratios, to make all of the other possible colors our eyes can see. The images shown in chapter 3 were made with three broadband filters colored red, green, and blue. And they were assigned these primary colors because they *roughly* matched the colors that the cones in your eyes see.

But most of the images in this chapter have been made with four filters: three broadband filters *and* the narrowband filter hydrogen alpha. So what colors should be used? Since H-alpha is a red light, it is usually made red. In this case, the reddest broadband filter (for example, R or I) is often made with a different color, such as yellow or orange, so that it stands out from the hydrogen alpha. The different colors help distinguish the different kinds of objects in the image. It also makes the image more colorful and rich in detail.

There are no fixed rules when it comes to choosing colors for astronomical images. As we'll explore more in later chapters, the choice of color is somewhat subjective. It is based upon both the scientific points to be illustrated and the aesthetic value hoping to be achieved. When possible, color choices are made in a "commonsense" way as described for the images in this chapter. In the next chapter we'll explore how we see and interpret light, and how that guides the colors used.

SEEING RED

How We See Color, and How We Use It

In this picture of the spiral galaxy IC 342, the colors give the image a sense of depth. The orange stars appear to hang as glowing orbs in front of the galaxy. (Which is actually true as these are foreground stars in our galaxy. The galaxy itself is much more distant.) Why do the colors do this? Credit: T. A. Rector (University of Alaska Anchorage) and H. Schweiker (WIYN and NOAO/AURA/NSF).

With so many fantastic astronomical images, you might be wondering exactly how we see and interpret a picture from space (or from anywhere for that matter). We are going to pause on our journey around the cosmos and delve into an equally fascinating environment: ourselves. What is going on inside our eyes, and our brain, when we look at an image?

HOW OUR EYES SEE COLOR

Imagine you're in a dark room. It's dark enough so that you can see things, but barely. Out of the edge of your eye you think you see something, so you turn to face it. But you see nothing. You look away, and again you see it on the periphery. Are you going crazy? Not really. It's just that your peripheral vision is more sensitive to faint light. Why is that?

There are two types of cells in our eyes that detect light: rods and cones. The rods outnumber the cones by a wide margin. There are about 125 million rods in

▶ The constellation of Orion is visible above and to the left of the KPNO 4-meter telescope dome. Betelgeuse is the bright red star near the top-left edge of the picture. Credit: J. Glaspey and NOAO/AURA/NSF.

▼ The top plot below shows the sensitivity of the three types of cones in the human eye. On the bottom is the sensitivity of the five broadband filters in the Johnson-Cousins UBVRI system. Each plot shows the sensitivity (along the vertical axis) for different wavelengths (colors) of visible light (the horizontal axis). Note that the B, V, and R filters fairly closely match the S, M, and L cones. Top credit: Vanessaezekowitz at en.wikipedia. Bottom credit: Leibniz-Institut für Astrophysik Potsdam.

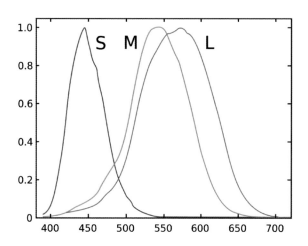

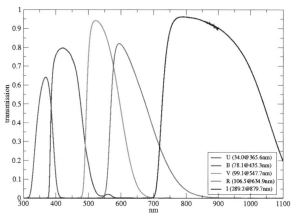

the human eye, compared to only about seven million cones. Rods are sensitive to faint light, so that's what we use to see when it's dark outside. The rods are concentrated along the outer edges of the retina, which is why our peripheral vision is better at night. The rods, however, don't perceive color.

To see color we have to use the cones. They aren't as sensitive as the rods, so they only work in brighter light. You can try this for yourself. Go outside on a clear night and look at the stars. If there's not too much light pollution, you'll probably notice that only a few stars are actually bright enough for you to see their colors. Betelgeuse, a brilliant red giant star in the constellation of Orion, is one example.

Three kinds of cones are at work in our eyes: S-cones, M-cones, and L-cones. The names are to remind us that these different cones are sensitive to short-, medium-, and long-wavelength visible light respectively. The ROY G. BIV colors of the rainbow correspond to a range of **wavelengths**, with red being at the longest wavelengths and blue light at the shorter wavelengths. One way to think about it is that longer wavelength light is lower energy, and shorter wavelength light is higher energy. Therefore, the S-cones are primarily sensitive to the shorter wavelength, higher energy blue light. The M and L cones are both sensitive to green light. And the L cones are more sensitive to red light.

The brain interprets and combines the signals from these three types of cones to determine perceived color. There are physiological variations in some people, however. **Color blindness** is the condition of missing one of these types of cones;

for example, **protanopia** is when a person's eyes lack L cones and cannot see red. Color blindness affects less than 1 percent of the population, and it primarily affects males.

Because the human eye's sensitivity to color varies with intensity of light, "true color" is complex when discussing faint objects. For example, the famous Orion Nebula is one of the brightest nebulae in the night sky. However, it is still too faint for you to see with the naked eye. If you look at it through a telescope the nebula becomes visible. But it will look blue-green because our eyes are much more sensitive to these colors of light even though most of the light coming from the nebula is hydrogen alpha. (As we talked about in the previous chapter, H-alpha is a specific color of red light. However, it is just on the edge of our eye's sensitivity, meaning that we don't see it very well.)

INTERPRETATION OF COLOR

In general, people will agree upon the basic colors. What is red to one person will be red to many people. There are some cultural variations on the names of colors, and to what range of colors the name applies (for example, there are eleven primary color words in the English language. Other languages have more or fewer. Some cultures don't distinguish between blue and green in their language, for example).

When we look at an image, our brain will attempt to derive information from the colors. This too will depend somewhat on the culture from which we come (for example, red is considered a sign of happiness and prosperity in China, whereas in Western cultures it is often associated with danger). We also use color to discern physical properties of an object. Let's go over some examples.

PERCEPTION OF TEMPERATURE

We often associate color with temperature. Because of fire, we naturally think of red as hot. You likely have heard the phrase "red hot." There are spicy cinnamon candies known as Red Hots. And of course the band the Red Hot Chili Peppers. Maybe you've even heard the phrase "white hot." We're not referring to the hot dog or the terrible 1989 action movie (you might need to Google either or both of those).

In fact, there is something that is even hotter than red or white hot. Have you ever heard of blue hot? Surprisingly enough, dense objects that are blue are the hottest of them all. So why don't we talk about things that are "blue hot"?

▲ When you turn an electric stove on low, it feels warm but still looks black (left). Turn it up to high and it starts to glow red (right). Credits: freefoodphotos.com.

Think of an electric stovetop. If we turn on one of the burners to the low setting it will feel warm but still look black. That's because the coils on the stove are warm enough to emit a low-energy form of light known as infrared. (Here on Earth we frequently experience infrared light as heat. It is a type of light that is too low energy for our eyes to see.) When we turn the burner up to the high setting, the coil radiates even more infrared radiation (it gets hotter) *and* it starts to emit low-energy visible light that we can see—in other words, it glows red. The coils are now about 1,500°F. Fortunately our stoves do not allow us to heat the coils any higher or we'd likely burn down the house.

But if we could, the coils would get brighter and eventually become white hot when the temperature reached 3,000 to 5,000°F. At this point, the coils are hot enough to emit all the different colors of the visible spectrum, which add up to appear white. This is the temperature range for the metal filament inside a typical incandescent light bulb. (Note that the metal is still emitting tremendous amounts of infrared light, which is wasteful if you only want to light your room. For this reason, incandescent bulbs are not energy efficient.)

What if we heated the metal further? Unfortunately it would melt. But if we could somehow keep it from melting, the metal would become hot enough that it would emit more and more high-energy light, getting up into the ultraviolet. (Ultraviolet is a high-energy form of light our eyes cannot see.) The object would start to look whitish blue because it is now emitting more blue light than the other

▲ Liquid water and ice (as seen here in Portage Glacier, Alaska) are light blue because the water molecules absorb some of the red light that hits them. The reflected light is therefore slightly bluer. Credit: S. Gramse (APUNSC).

colors in the visible spectrum. This can't happen here on Earth, but some stars in space get hot enough to be blue.

Keep in mind that the color of a hot object is connected to its temperature *only* if it is dense, such as a solid, a liquid, or the dense gas inside a star. The color of a low-density gas (such as that inside a nebula) depends primarily on the *type* of gas; for example, hydrogen produces different colors than does helium. Clouds of low-density gas must be hot to emit light, but their colors do not necessarily reflect the temperature.

Of course we Earth-dwellers tend to associate the color blue with cold. This is because liquid water and ice are blue. The H_2O molecules in water and ice preferentially absorb red light, allowing blue light to pass through and reflect back to our eyes. It is indeed ironic that blue stars are the hottest. It is worth noting that whether or not you associate blue as cold often depends somewhat on your knowledge of physics and astronomy. Experts are much more likely to picture blue as hot than are novices; about 80 percent of novices see red as hot compared to 60 percent of experts.

HERE AND FAR

Another way we use color is to perceive depth. Here on Earth, we often interpret color to estimate the relative distance to objects far away—even though we may not be aware that we're doing it. During the daytime our skies are blue from scattered sunlight. It's not noticeable nearby, but distant objects such as mountains will look bluish because of the air between us. More distant objects will have more intervening air and will therefore look bluer. We interpret the blue as an indica-

▼ When interpreting images we use many clues to perceive depth. Looking at the Wrangell Mountains in Alaska (top), for example, we can perceive that the mountain range is quite distant. The size of the trees and the shrinking of the road in the distance serve as important visual cues. The mountains appear to be bluer because of foreground air. On the airless Moon (bottom), it was unclear to Apollo astronauts if geographic features were large mountains in the distance or just nearby hills. Stare closely at the "mountain" just to the left of the Apollo lander and you'll see it is possible to convince yourself of either scenario. Top credit: T.A. Rector (University of Alaska Anchorage). Bottom credit: Lunar and Planetary Institute.

Some might think that *Hubble* produces its spectacular images by flying closer to the nebulae and galaxies it observes. Such a journey is impossible because of the tremendous distances to these objects. *Hubble* stays happily in its orbit close to the Earth, about 350 miles up. It's easy to see how people might think that it flies, as its solar panels do look like wings. Credit: NASA.

Colors in this Hubble image of the Lagoon Nebula (M8) give the picture a three-dimensional feel. The blue gas naturally appears to be in the background whereas yellows and reds in the top half of the image seem closer. Credit: A. Caulet (ST-ECF, ESA) and NASA.

tion of distance. Without this effect, distances are harder for us to visualize. For example, Apollo astronauts commented that they had difficulty visually estimating the distance to mountains and hills because there is no atmosphere on the Moon.

Our brains have become wired to interpret blues and greens (collectively known as **cool colors**) as being more distant to yellows and reds (known as **warm colors**). We naturally infer depth in images based upon this optical illusion. We do this when we look at astronomical pictures too. This has led many to ask how telescopes are able to see in 3D. Images from *Hubble* often invite this remark. The reality is that telescopes such as *Hubble* don't have three-dimensional (**stereoscopic**) vision.[17] The distances to astronomical objects are just too large for that to work. However, astronomical images can *appear* to be 3D because of the colors in them.

NOT PAINT BY NUMBERS

It might sound like astronomers deliberately color parts of their images with different colors to make them seem hotter or colder, closer or more distant, and such. Unquestionably, astronomers don't do "color by numbers." Going back to

▶ A comparison of color and "black-and-white" versions of the *Hubble* image of the Keyhole Nebula (NGC 3324) shows how color gives depth to the image. Credit: NASA and the Hubble Heritage Team (AURA/STScl). Acknowledgment: N. Walborn (STScl) and R. Barbá (La Plata Observatory, Argentina).

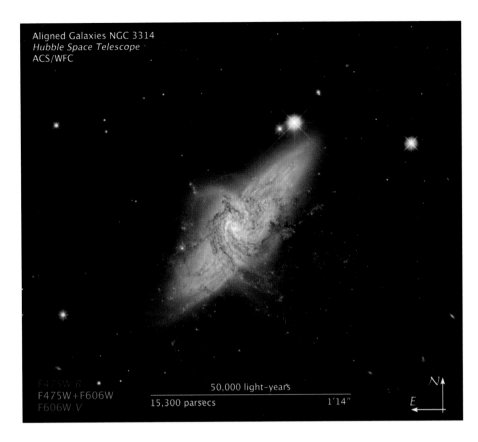

Aligned Galaxies NGC 3314
Hubble Space Telescope
ACS/WFC

F475W B
F475W+F606W
F606W V

50,000 light-years

15,300 parsecs

1'14"

N
E

◄ For many *Hubble* images, there is a version with graphic overlays that contain important information such as the camera used and the orientation of the telescope (shown here in the lower-right corner). They also cleverly list the filters in the actual colors they were assigned (in the lower left). Credit: NASA, ESA, the Hubble Heritage Team (STScI/AURA)–ESA/Hubble Collaboration, and W. Keel (University of Alabama).

▼ Astronomers use colors in ways that can be confusing at first. But not like this! Credit: S. Harris/Cartoonstock.com.

our discussion of how these images are put together, colors are assigned to each grayscale image from each filter. If a portion of an image looks, for example, blue, it's because that area is brighter in the filter assigned to blue (at least compared to the other filters used). It is not because the astronomer chose to make it blue.

Fortunately, most professional observatories are explicit on how their images are made. For each image, its caption usually describes which filters were used and what color was assigned to each.

When reading the caption for an image you might also encounter some terms that you haven't heard before. The image might be described as "true color," "false color," or maybe even "pseudocolor." What do these terms mean?

True color sounds simple enough. It seems to mean that what you're seeing is an accurate representation of the object's actual appearance. Astronomers can make color images using filters that are reasonably close to the sensitivities of the three cones in our eyes. These images are often labeled as "true color" even though, as we discussed before, color has an ambiguous meaning for objects too faint for our eyes to naturally see. This is the case for most of the objects in space—everything from nebulae to galaxies.

▶ Glaciologist Kimberly Casey took this photo of Mount Everest (left peak) lit by the sunset while she was in the field at Khumbu Glacier in the Nepali Himalayas. The snow atop the mountains is intrinsically white, but it appears orange because it is reflecting light from the setting Sun. Credit: NASA/GSFC/ Kimberly Casey.

▼ A calibration target in the form of a sundial is mounted on the Mars *Spirit* and *Opportunity* rovers. Note the four colors in the corners. Pictures taken of the Martian landscape that have the sundial in the image are used to calibrate the color in images taken by the rover cameras. The shadow cast by the sundial also helps to measure the difference in lighting effects from the Sun and atmosphere, allowing the intrinsic color of objects to be determined. Credit: NASA/JPL/Cornell.

However, true color is a realistic goal for bright, sunlit objects such as planets and their moons. When we send spacecraft to land on other planets, on board are additional tools for color calibration to account for the effects of the atmosphere. Just as our blue skies (or orange skies at sunset) can change the apparent color of an object, the same effect occurs on other planets with atmospheres. The thick yellow atmosphere of Venus and the dusty brown air on Mars affect the apparent color of the planets' surfaces. To take this into account, swatches of known color are placed on the spacecraft. By taking pictures of these color swatches with the onboard cameras, the color images from those cameras can be calibrated to show what you would see if you were there. Color-corrected images can also be made to show the "intrinsic" colors of the surface—that is, as it would appear if the Sun and sky were white. Scientists use these intrinsic colors to help identify the kinds of rocks and minerals that are on these distant worlds.

What does it mean if the colors aren't "true?" The terms "false color" and "pseudocolor" sound like they're synonymous, but they refer to different ways of using color. These terms aren't always used consistently, but they do have distinct meanings.

▲ The top image shows a valley on Mars as you might see it if you were standing there. The dusty haze of the Martian atmosphere makes the ground appear more brown than it really is. The bottom image is "white balance" color corrected to remove this effect and show the inherent colors of the rocks and sand. Credit: NASA/JPL/Cornell.

▲ The image on the left shows Jupiter's moon Io (pronounced "eye-oh") in true color, where the colors have been balanced to best match what your eye might see if you were in a spacecraft nearby. The image on the right is in **enhanced color**, where the differences in color are amplified so that subtle details can be better seen. Credit: NASA/JPL/University of Arizona.

The term **false color** is often used when referring to an image that was made with two or more filters, but the colors assigned to the filters are not close to the intrinsic color of the filter (if it is a filter that is on a visible-light telescope). An example of this would be if you assigned a blue color to a filter that looks orange to your eyes. Astronomers sometimes do this to better show details in an object. As we'll discuss in the next chapter, astronomers commonly do this with so-called narrowband filters. It is, in a sense, *always* used when making images with nonvisible light. Since these are kinds of light that we cannot see with our unaided eye, the meaning of color can get complicated.

False color might seem to imply that what you're seeing isn't real, but that's not the case. It's a real object in space that we can see because it emits light that the telescope's camera can detect. It isn't from a graphic artist's imagination—that's something completely different, known as **space art**. The most important point

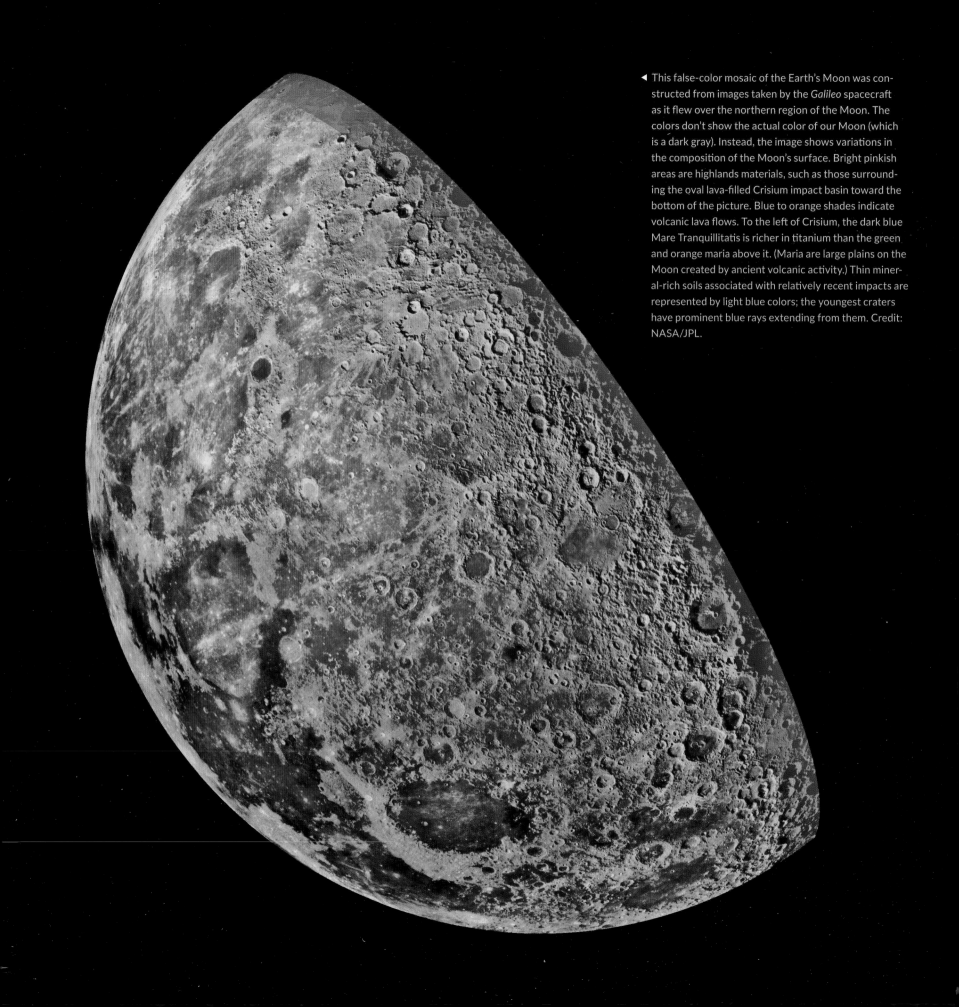

◄ This false-color mosaic of the Earth's Moon was constructed from images taken by the *Galileo* spacecraft as it flew over the northern region of the Moon. The colors don't show the actual color of our Moon (which is a dark gray). Instead, the image shows variations in the composition of the Moon's surface. Bright pinkish areas are highlands materials, such as those surrounding the oval lava-filled Crisium impact basin toward the bottom of the picture. Blue to orange shades indicate volcanic lava flows. To the left of Crisium, the dark blue Mare Tranquillitatis is richer in titanium than the green and orange maria above it. (Maria are large plains on the Moon created by ancient volcanic activity.) Thin mineral-rich soils associated with relatively recent impacts are represented by light blue colors; the youngest craters have prominent blue rays extending from them. Credit: NASA/JPL.

▶ Sometimes an actual image of an object is impossible to obtain with current technologies, but we can discover what it looks like by other means. Space art is often used to help provide the reader with a better understanding of the discovery when there is not a picture to help tell the story. For example, this artist's concept illustrates an asteroid belt around the bright star Vega. Evidence for this warm ring of debris was found using *Spitzer* and the European Space Agency's *Herschel* Space Observatory. Credit: NASA/ JPL-Caltech.

to remember is that false color isn't "paint by numbers." That is, the astronomer doesn't say, "Let's make that object over there red, and this one green," and so on. Rather, false color means one subset of the light collected is assigned one color, another subset is assigned another, and so on. In fact, the term "false color" is so misleading that many people in the field avoid using it altogether.

Think back to our discussion about how color works for our eyes and brain. When we see someone wearing a red sweater, it looks red because it is reflecting more red light than blue and green. The L cones in our eyes therefore detect a strong signal, the M cones detect a weaker signal, and the S cones detect little signal at all. Our brain knows that in this scenario we should interpret the object to be red. In other words, our brain says something is red because it detects *more* red light than the other colors. Color is therefore a measurement of the relative amounts of light coming from an object.

In a false-color image this is true as well. Something will appear to be red because the object is emitting more light that corresponds to the red filter, whatever that filter may be. For this reason, astronomers often instead use the phrase **representative color** because the colors represent the science being shown in the image.

◄ ▲ The pseudocolor astronomical image (left) of the radio source 3C 75 in the cluster of galaxies Abell 400 shows the intensity of a specific energy of radio waves. Red and yellow show regions of intense radio emission, while blue and green show regions of fainter emission. Similarly, a pseudocolor image of the United States (right) shows the population density, with red and yellow areas showing the highest density of people. Left credit: Image courtesy of NRAO/AUI and F. N. Owen, C. P. O'Dea, M. Inoue, and J. Eilek. Right credit: User JimIrwin on en.wikipedia.

Since in false color the assigned colors don't match the intrinsic color of the filter, most astronomers think carefully about the colors they use. The colors are chosen primarily to best illustrate what's interesting scientifically. A common method is akin to the three-color process we talked about before. **Chromatic ordering** is where the filter that corresponds to the lowest-energy light is made red, the filter that corresponds to the highest energy is blue, and the filter of intermediate energy is made green. If more than three filters are used, other colors might be chosen; for example, the filter between the red and green ones may be assigned yellow, since that is an energy of light between these two colors. Astronomers almost always employ chromatic ordering for broadband filters, and you can find many examples in chapter 3. But they often use a nonchromatic (sometimes called a **composite**) color scheme with narrowband filters for a variety of reasons. In the next chapter we'll cover several examples.

An unrelated color scheme is that of **pseudocolor**. In a pseudocolor image, the color is coded to reflect the relative amounts of something. For example, the color may indicate the relative brightness of an object in a single filter. Or the color might indicate its velocity toward or away from us. Again, normally color tells us about the relative amounts (or ratios) of different kinds of light. Here, color tells

▶ A pseudocolor image of the spiral galaxy M33 reveals the relative velocities of hydrogen gas. Red gas is moving away from us and blue is moving toward us. Credit: Image courtesy of NRAO /AUI.

us something entirely different. Pseudocolor images can convey important information in a compelling and visual way, but it is important to pay close attention to understand what the colors represent.

Unfortunately, there is no set of strict rules that dictate how colors are used in scientific images. It's not possible to do so because there are an infinite number of ways to combine filters and data from different telescopes. (KPNO alone has over one hundred filters, for example.) So to understand what the colors mean in an astronomical image, a good place to start is to read the caption.

No matter what scheme, color in astronomical images can tell scientists a great deal about objects within our Solar System, across our Galaxy, or on the other side of the Universe. Knowing some basics about how our eyes and brains work will help you better understand what you're seeing.

▶ In this image of the "Boomerang Nebula" (ESO 172-7), the colors show the polarization of light reflecting off of dust grains embedded in the nebula. Credit: NASA, ESA, and the Hubble Heritage Team (STScI/AURA).

NARROWBAND IMAGING

Addition by Subtraction

In chapter 6, we explored how astronomers use particular filters, for example, the hydrogen alpha filter, to isolate the light produced by warm hydrogen gas. While hydrogen is the most abundant, there are many other types of gases in space. And, when heated, they too produce distinct colors.

Luckily for those who study the cosmos, each type of gas glows with different, distinct colors. This enables astronomers to identify and map out the distribution of various types of gases in space. It's a powerful tool. It allows us to know what's inside a nebula without actually flying out to it, collecting, and analyzing the gas directly (a trip that would be impossible anyway because of the enormous distances to these cosmic objects).

Astronomers use many different kinds of narrowband filters, not just H-alpha, to learn not only where gas is in outer space but also what kinds of gas are present. We can also use these filters to determine important physical characteristics such as the temperature and density of the gas. Somewhat ironically, by using narrowband filters to exclude light we can sometimes learn more. Or, as the French composer Claude Debussy once said, "Music is the space between the notes."

▶ This wide-field image of M16, the Eagle Nebula, was created using only narrowband filters, creating vibrant colors within the nebula. Why is that? Credit: T.A. Rector and B.A. Wolpa (NRAO/AUI/NSF).

These images show a portion of the North America Nebula (NGC 7000), a giant HII emission nebula. The image on the left was created with the broadband filters B (blue) and I (orange) plus the narrowband H-alpha (red) filter. The image on the right was created with only the narrowband filters H-alpha (red), Oxygen [OIII] (pronounced "oxygen three"; green), and Sulfur [SII] ("sulfur two"; blue). In the left image the stars are more visible, and their colors are more accurate. In the right, the narrowband filters block much of the starlight and show more detail in the nebula. Left credit: T. A. Rector (University of Alaska Anchorage) and H. Schweiker (WIYN and NOAO/AURA/NSF). Right credit: T. A. Rector (University of Alaska Anchorage).

THE SPACES BETWEEN THE NOTES

Broadband filters allow relatively large portions of the light spectrum to pass through them. Some of these filters (for example, the Harris B, V, and R filters) roughly match up to the range of colors seen by the short-, medium-, and long-wavelength (S, M, and L) cones in our eyes. So, in a sense, these filters can be used to roughly mimic what our eyes could see (that is, if our eyes were a million or so times more sensitive than they are now).

Narrowband filters, by design, allow only a sliver of light to pass through. Each filter lets through a specific color of light produced by a certain type of atom inside the warm gas. All of the other colors are blocked out. We can then study only the

light these elements make. For this reason, narrowband filters "see" light differently than your eyes do.

Try thinking of broadband images as listening to one of Debussy's most famous works, *Prelude to the Afternoon of a Faun*, by a full orchestra—strings, woodwinds, percussion, the works. These various sections of the orchestra are akin to the different types of light we can select with our astronomical filters. When listening to Debussy's orchestral work, we might choose to listen just to the violin section of the orchestra. This would allow us to really home in on the nuances and details of how this one instrument contributes to the whole piece. We can do something similar with narrowband filters on our telescopes. Sometimes we can learn more by seeing (or, in the case of our analogy, hearing) less.

▷ NGC 1313 is known as a **starburst galaxy** because the gas inside of it is undergoing unusually rapid star formation. The image on top shows how the galaxy appears with the broadband B (blue), V (green), and I (orange) filters, as well as the narrowband hydrogen alpha (red) filter. The image on the bottom shows how it appears in narrowband only: H-alpha (red), Oxygen [OIII] (green), and Helium HeII ("helium two"; blue). The narrowband filters suppress most of the starlight and help show the star-forming gas within the galaxy. The HeII filter shows the locations of massive stars that are hot enough to ionize helium. Top credit: T. A. Rector (University of Alaska Anchorage) and T. Abbott (NOAO/AURA/NSF). Bottom credit: Gemini Observatory/AURA and T. A. Rector (University of Alaska Anchorage).

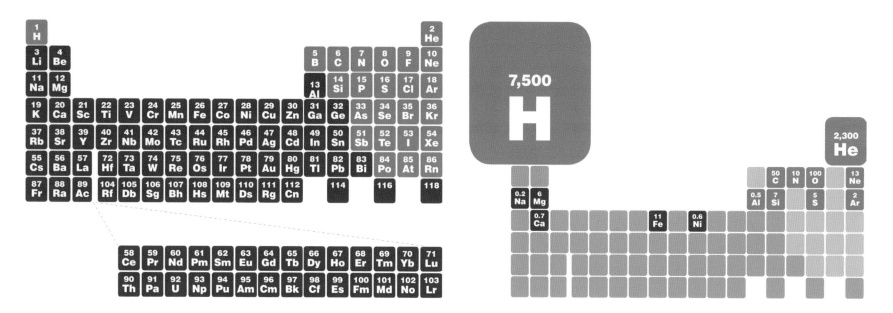

The periodic table (left) lists all of the different kinds of atoms known to exist. The first ninety-eight can be found in nature, whereas the rest have been synthesized in a lab. The modified periodic table (right) shows the relative abundances of the most common elements, given on a scale of parts per ten thousand. Hydrogen and helium are by far the most abundant, representing 75 percent and 23 percent of all of the elements in the Universe. Oxygen, the third most abundant, is only 1 percent. All of the other elements combined make up the last 1 percent. Even though elements like oxygen, nitrogen, and neon are relatively rare, they can glow brilliantly when energized. Thus they can be found by using narrowband filters that select the distinct colors they produce. Credit: NASA/CXC/M. Weiss.

When making images with narrowband filters, astronomers use color in a different way. Color can be used to show detail in the object that would not normally be visible. The selection of colors can also help distinguish different physical processes in the nebula or galaxy in question. Astronomers can look at these images and deduce great stories invisible to the untrained eye. So how do astronomers use narrowband filters? And how are color images made with them?

GIVE ME OXYGEN

Let's look at the unusual names of narrowband filters, using oxygen as our first example. Oxygen is the most abundant element in our body (and what keeps us alive through breathing). But it is only the third most abundant element in the Universe, after hydrogen and helium. It is a distant third too, consisting of only about 1 percent of the total elemental mass (again, we're ignoring dark matter and dark energy here). Even though it is rare, relative to hydrogen and helium at least, it is seen in many places. That's because, when heated up, it can be luminous. However, oxygen is complicated. Unlike hydrogen, oxygen atoms produce different colors depending on physical characteristics such as temperature and density.

To better understand this, it is helpful to look at what goes on inside an atom. All atoms are made up of protons, neutrons, and electrons. The protons and neu-

trons sit in the nucleus of the atom. And the electrons zip around in orbits circling the nucleus. The movement of the electrons from one orbit to another produces light.

Most of the time, atoms will be **neutral**, meaning they have the same number of protons and electrons. But if an atom is heated up enough, it can lose one or more of its electrons. This can happen if the atom absorbs high-energy light, such as ultraviolet. It can also happen if an atom is hit at high speed by an electron or another atom. This happens all the time in space for many different reasons. When an atom loses an electron, it is no longer neutral. It's what scientists call **ionized**.

How do we keep track of all of these flavors of atoms and their various numbers of electrons? Through a confusing labeling system, of course! Atoms that have all of their electrons are labeled with the Roman numeral I; for example, an oxygen atom with all of its electrons is called **OI**, or "oxygen one." If an atom loses electrons, it will be labeled with higher Roman numerals; for example, **OII**, pronounced "oxygen two," has lost one electron. **OIII** (yep, "oxygen three") has lost two electrons. And so on. In general, hotter gas will have more ionized atoms, and they will be more likely to have lost more than one electron. As you can now guess, the HII regions described in chapter 6 are clouds filled with singularly ionized hydrogen gas; that is, hydrogen atoms that have each lost their electron. (Hydrogen only has one electron, so it can only be neutral or singularly ionized. There's no such thing as HIII.)

Just when you think you might have a handle on the whole Roman numeral situation, you will notice that the element's name might be in brackets. This indicates that the element with its particular electron count is **forbidden**. As ominous as that sounds, what it really means is that the atom produces forbidden colors of light only where the density of gas is so low that collisions with other particles won't interfere. In other words, in outer space.

Like hydrogen, neutral oxygen (that is, [OI]) produces several distinct colors when heated. And [OII] produces different colors than [OI], as does [OIII]. [OIII] is of particular interest because it produces a specific color of green light that is bright and easy to see. Astronomers therefore use a special filter designed to see this light. And where do they look? Astronomers find oxygen in a host of hot places across the cosmos, such as the stellar nurseries where stars are born, the violent explosions where giant stars die, and many more. Let's tour some of the best places in the Universe to study using narrowband filters.

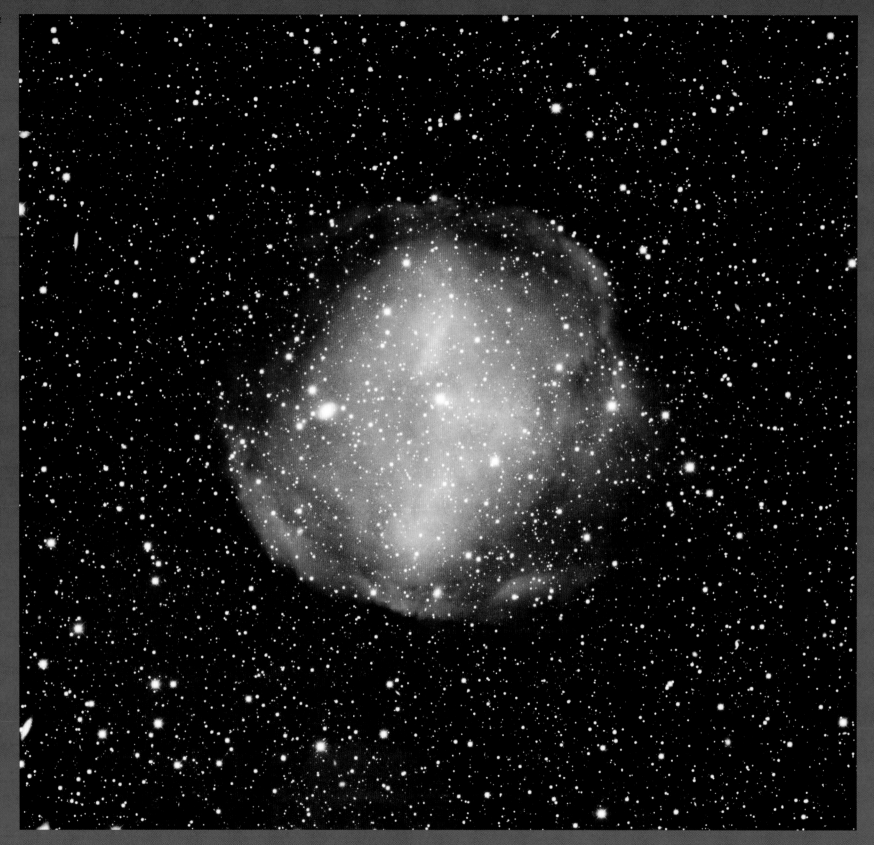

▲ ▶ Abell 74 (above) is a fairly typical planetary nebula. Its round shape looks similar to a planet (hence the name), although planetary nebulae are not at all related to planets. The image was made with hydrogen alpha (red) and [OIII] (cyan) filters. The gas at the center of the nebula is hotter, which is why it produces more [OIII] light. The image of Jones 1 (opposite page) was made with the same filters but looks different—it has a more uniform color. The shape and colors of a planetary nebula depend on many factors, including its age, the gas surrounding it, and more. Both credits: T. A. Rector (University of Alaska Anchorage) and H. Schweiker (WIYN and NOAO/AURA/NSF).

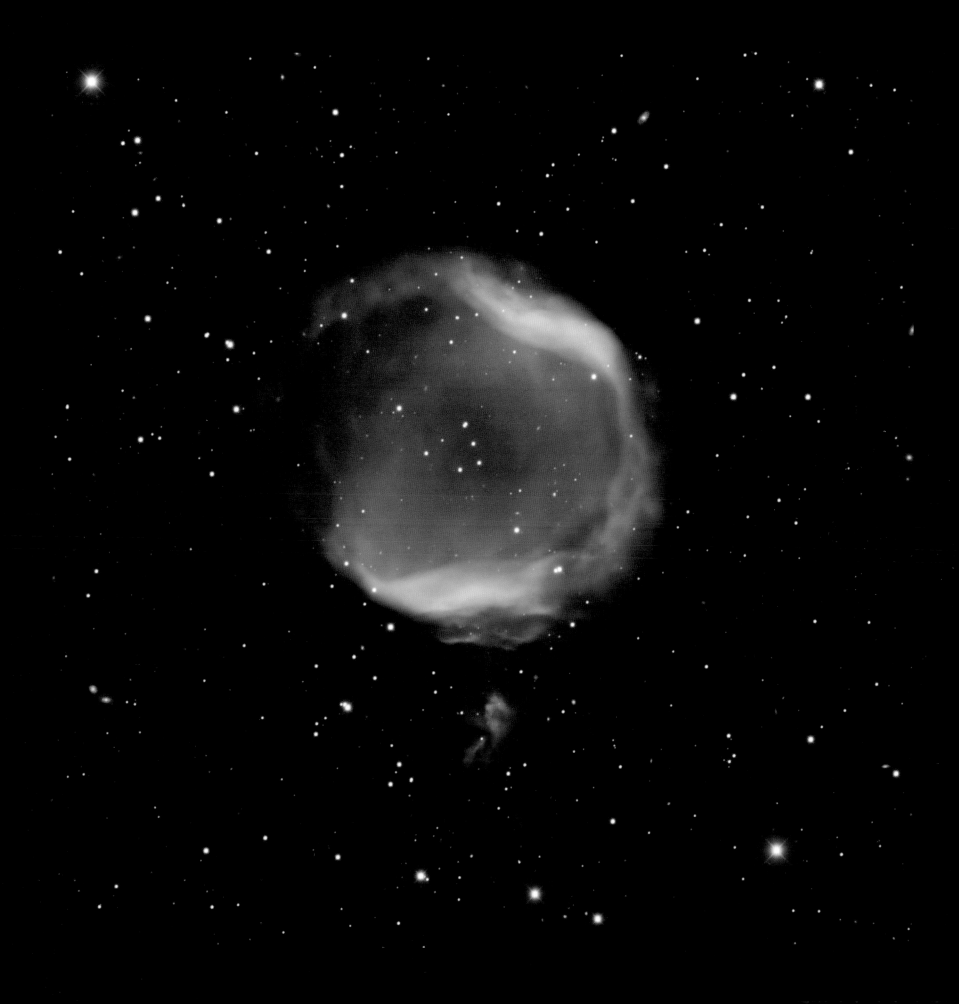

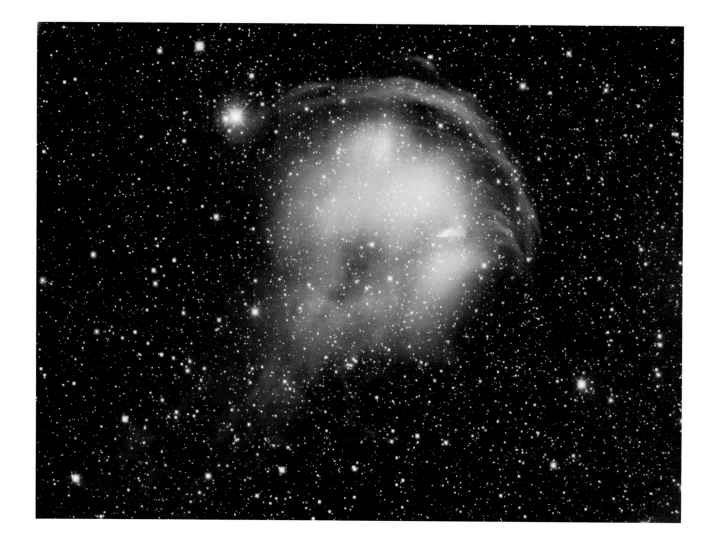

WHEN A STAR HITS EMPTY

▲ ▶ The shape of a planetary nebula can also be affected by its motion through the interstellar gas that surrounds it. In both HFG1 (above) and HDW3 (opposite), a ring of [OIII] around the nebula glows brighter in the direction of motion because the planetary nebula is colliding with the ambient gas, causing it to glow hotter. Both credits: T. A. Rector (University of Alaska Anchorage) and H. Schweiker (WIYN and NOAO/AURA/NSF).

Stars spend about 90 percent of their lives producing energy by turning hydrogen into helium through nuclear reactions. During this time it is called a **main-sequence star**. Our own Sun is about halfway through its life, meaning it is a middle-aged main-sequence star. When the hydrogen gas in the center of a star starts to run out, it will become bigger and cool off, turning into what's called a **red giant**. For lower-mass stars like our Sun, the outer layers of the star will eventually be blown off. The gas will be heated by the hot core of the star that remains, which itself will eventually become a **white dwarf** star (so named because it is

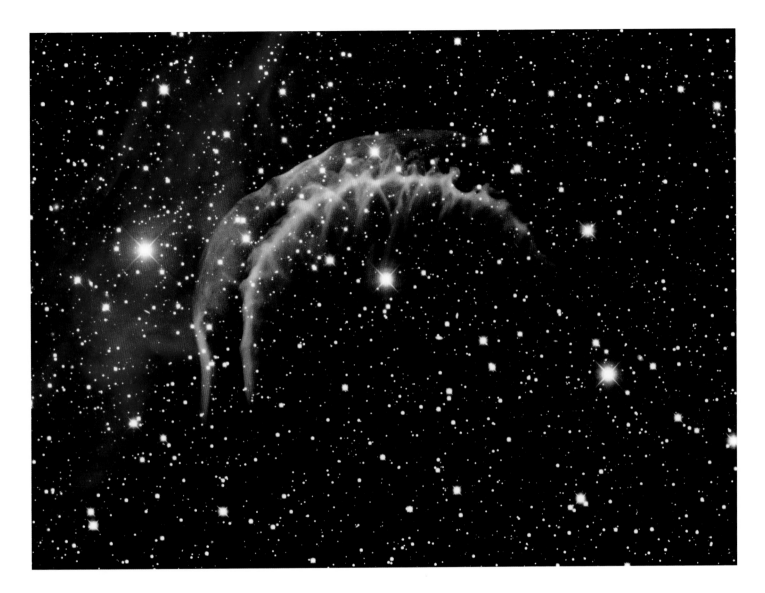

small and white hot). When this occurs, the outer layers will turn into a **plane-tary nebula** for a brief period of time before fading away. (This term is rather con-fusing. Planetary nebulae have nothing to do with planets, as we've just described. The name is a historical remnant, left over from when these objects were first found with small telescopes and incorrectly interpreted to be planets because of their circular shape.) While rare, planetary nebulae are some of the most stun-ningly beautiful objects in our Galaxy. And because they are hot, astronomers often find hydrogen alpha and [OIII] filters to be valuable tools for studying them.

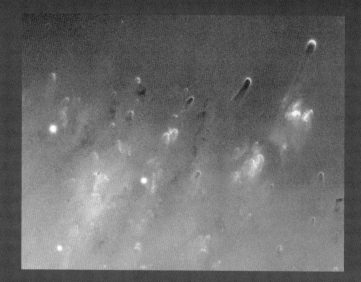

▶ ▶ The Helix Nebula (NGC 7293) is one of the nearest large planetary nebulae, meaning that it can be studied in great detail. This image is a combination of high-resolution data from *Hubble* and wide-field data from the KPNO 0.9-meter telescope. In November 2002 there was an unusually strong Leonid meteor storm. To protect *Hubble*, controllers turned the back of the telescope into the direction of the meteor stream for about half a day. Fortunately, the Helix Nebula was almost exactly in the opposite direction of the meteor stream, so *Hubble* observed parts of the nebula while it waited out the storm. Data from the KPNO 0.9-meter telescope was then used to fill in the parts not seen by *Hubble*. A tremendous amount of structure is visible in the nebula, as shown in the insets on this page. Credit: NASA, NOAO, ESA, the Hubble Helix Nebula Team, M. Meixner (STScI), and T. A. Rector (NRAO).

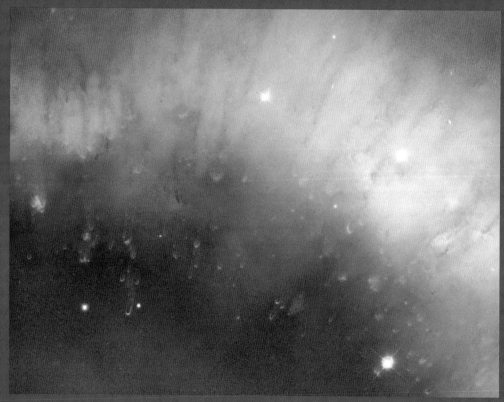

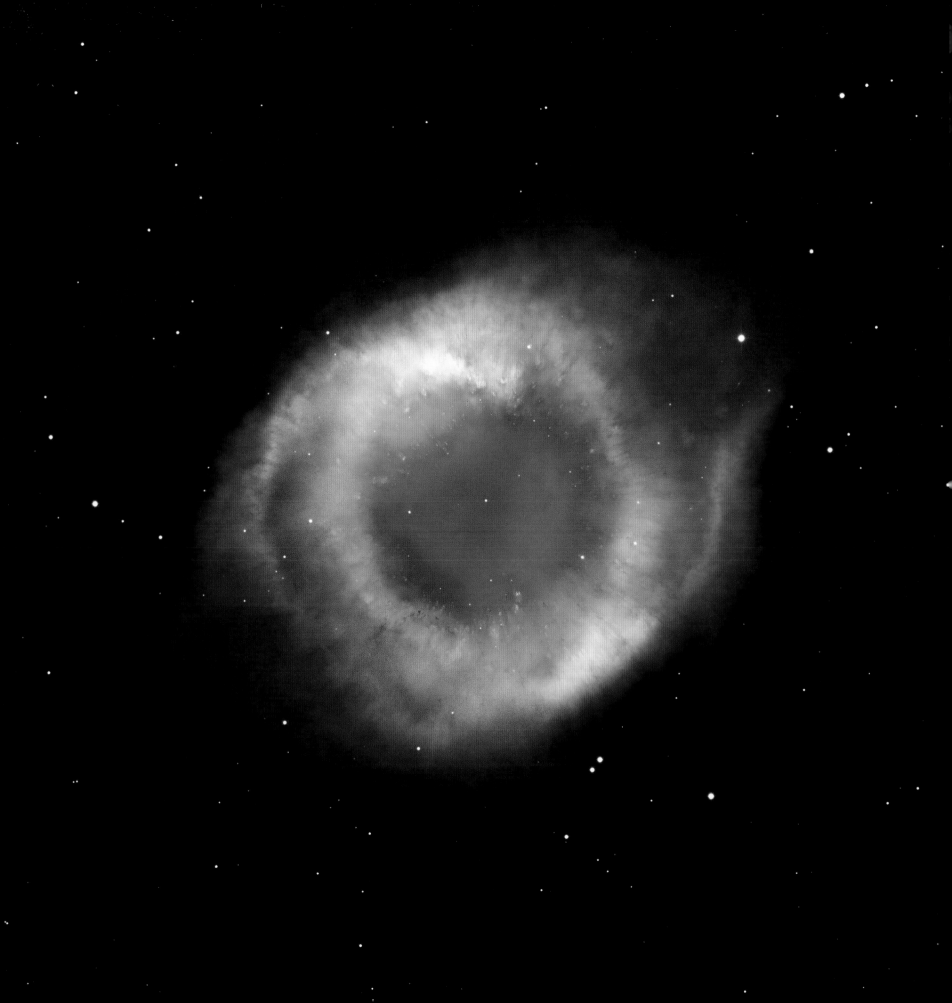

118

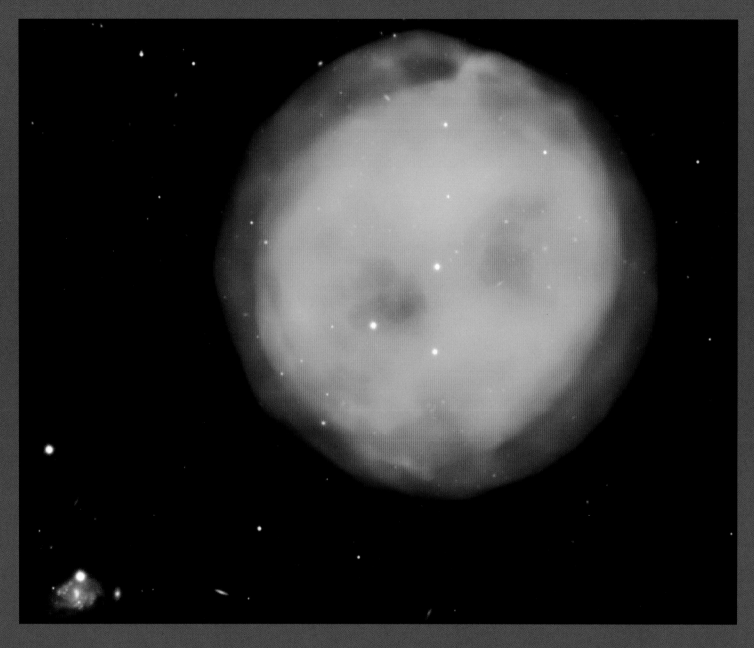

▲ This true-color image of the Owl Nebula (M97) planetary nebula was made only with broadband fil-
ters. Thus these colors are reasonably close to what you might see with superamplified eyes. (Notice
that the colors of the galaxy in the lower-left corner closely match other visible-light broadband
images of galaxies in this book.) The color of M97 is remarkably close to the colors of other planetary
nebulae observed with narrowband filters, showing that the colors aren't simply the fantasies of
imaginative scientists. Credit: Gemini Observatory/AURA, É. Storer (Collège Charlemagne, Quebec),
A.-N. Chené (HIA/NRC of Canada), and T. A. Rector (University of Alaska Anchorage).

The preceding images of planetary nebulae were all made from just the two narrowband filters of hydrogen alpha and [OIII]. This was done because planetary nebulae are usually bright in these two filters. How were the colors chosen? Since hydrogen alpha is red it is an easy decision to choose that color. For [OIII] the decision was a little more complicated. The color of this light is green, but this choice would make the colors unbalanced. They would look like garish Christmas decorations. Instead, we chose cyan, which is a mix of green and blue. It is the complementary color to red, so the colors will be balanced (which we will talk about more in chapter 12). Most important, by choosing these colors, astronomers enable detail in the [OIII] image to stand out in contrast to the hydrogen alpha. It is also a reasonable choice because [OII], also present in the nebula, emits a bright color of blue. So the [OII] and [OIII] emission combined would look close to cyan if your eyes could see it. But these aren't the only narrowband filters used to look at nebulae.

FIFTY SHADES OF RED

Much like a carpenter with a box full of tools to choose from, an astronomer has many other narrowband filters that he or she can select for a variety of reasons. Three of the most commonly used are [OI], [NII], and [SII], which show specific colors of red light produced by (you guessed it!) neutral oxygen, singly ionized nitrogen, and singly ionized sulfur atoms. These colors of red light are similar to hydrogen alpha. In fact, they so closely resemble each other that our eyes cannot tell the difference. Fortunately, with the use of narrowband filters, our cameras can.

A good question to ask then is: What colors should be used for each filter? If all of these filters—hydrogen alpha, [OI], [NII], and [SII]—were shown as red then we'd lose valuable information. If we are to use colors other than red, which ones? There is no single answer for this question. Instead, it depends on the filters used, the object observed, the science to be illustrated, and the aesthetic goals.

THE "HUBBLE PALETTE" AND BEYOND

Telescopes have a wide range of filters available, broadband and narrowband. When scheduling their observations, astronomers choose the filters that will most help them to learn about the objects to be studied. Like broadband filters, narrowband filters can be used to learn specific things. Since they block most colors of light, narrowband filters are effective for finding or studying objects that only emit the specific colors of light the filters let pass through. For example, if an

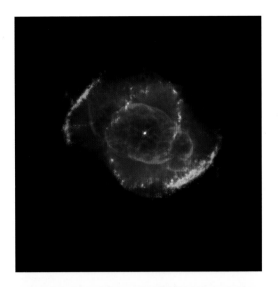

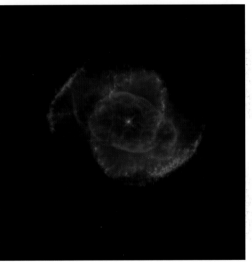

▲ The Cat's Eye Nebula (NGC 6543) is a complex planetary nebula. In the *Hubble* image on the top, hydrogen alpha is shown as red, [NII] is green, and [OI] is blue, although in reality all three filters transmit different colors of red. The hydrogen gas is energized by ultraviolet light from the white dwarf at the center. In contrast, we see bright [NII] along the edges of the nebula. This gas is glowing because it is energized by collisions with the gas surrounding the planetary nebula. The [OI] filter nicely shows the white dwarf at the center. The different colors help show distinct detail in the nebula that are the result of different causes. The image on the bottom shows what it would look like if all three filters were assigned to their **intrinsic colors** (that is, the color of the filter if held up to a bright white light). Since they are essentially the same, the information we see in the top image would be lost. Credit for original image on top: J. P. Harrington and K. J. Borkowski (University of Maryland), and NASA. Bottom image modified by T. A. Rector.

▶ This image of HH24 shows high-speed jets known as Herbig-Haro (HH) objects. Bright narrowband light of H-alpha (red) and [SII] (blue) is produced when these jets collide with gas surrounding the star. Credit: Gemini Observatory/AURA and T. A. Rector (University of Alaska Anchorage).

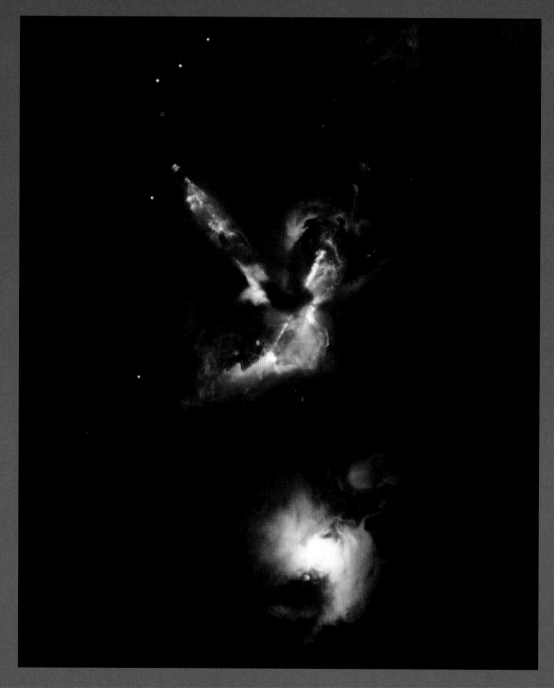

▶ This wide-field view of a star-forming region in the Orion A molecular cloud was made using the *Hubble* palette. [SII] light, in red in this image, is a telltale sign of HH objects. They are seen as distinct red blobs, often in a line. Look just to the right of the image center and you'll see several HH objects associated with a protostar, as well as a distinctive "waterfall" like object called HH 222. A close look will reveal dozens of HH objects. How many can you find? Credit: Z. Levay (STScI/AURA/NASA), T.A. Rector (University of Alaska Anchorage) and H. Schweiker (NOAO/AURA/NSF).

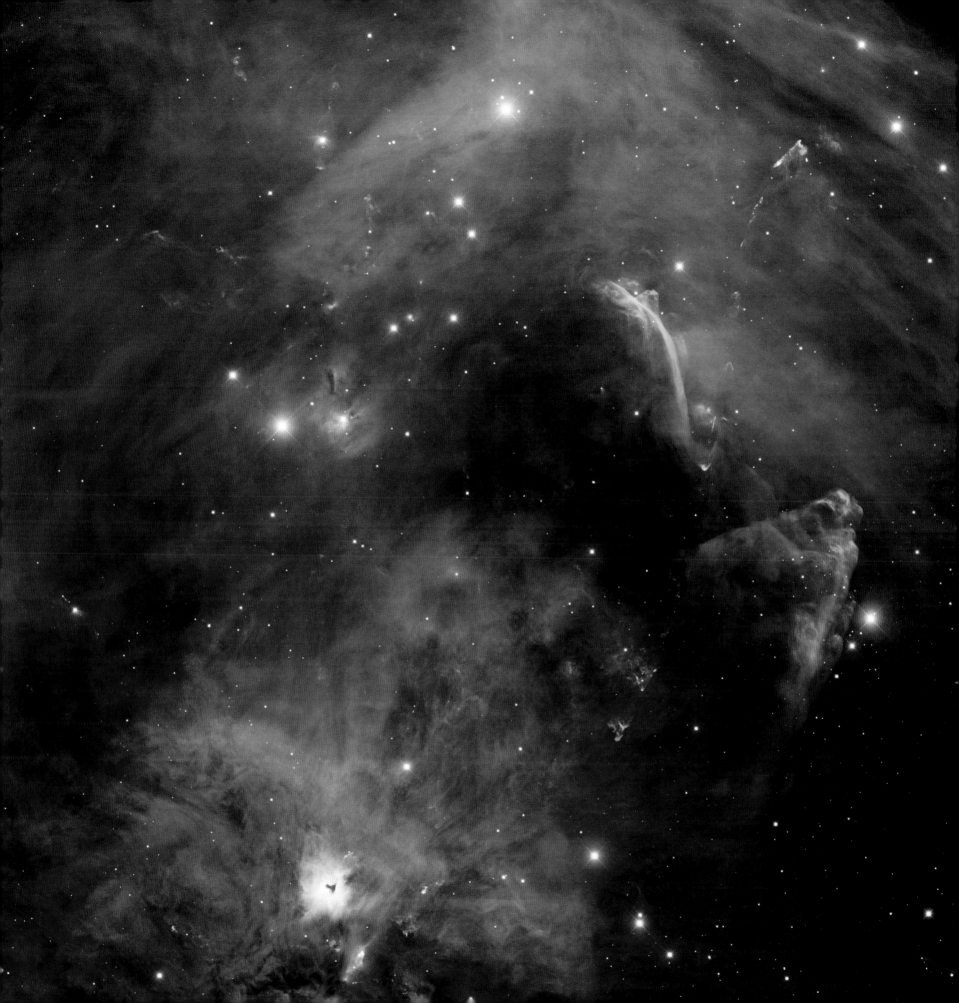

astronomer is searching for planetary nebulae in a nearby galaxy, he or she might choose to observe the galaxy with an [OIII] filter because it would *block* most of the starlight from the galaxy while *allowing* most of the light from the nebula to pass through to the camera. It therefore helps a faint nebula stand out from the billions of stars in the galaxy. Narrowband filters are also used to identify different kinds of objects. For example, the HeII filter is effective for finding hot, massive **Wolf-Rayet** stars. And the [SII] filter is a powerful tool for discovering Herbig-Haro objects.

Astronomers can also use narrowband filters to determine the physical conditions inside a nebula. By measuring the relative amounts of light from each filter they can measure the temperature and density of the gas at each location within the nebula. When narrowband filters are used to make an image, the relative amounts of light will also determine the color. Thus the colors inside a nebula depend, to a large degree, on its temperature.

Astronomers often look at nebulae with three particular narrowband filters: hydrogen alpha, [OIII], and [SII]. The "intrinsic" colors of these filters are red, green, and red—the colors of Christmas. What's the best way then to assign color to these filters so we may see the most detail? Almost by accident, astronomers started using the color scheme of [OIII] (blue), hydrogen alpha (green), and [SII] (red). This is in chromatic order and is the color scheme used for the Pillars of Creation image of M16. Amateur astronomers often refer to using these three filters with this color scheme as the "*Hubble* palette," although in reality only a small fraction of images from *Hubble* use this scheme.

When creating an image for nonexperts, astronomers try to pick colors for the filters that both show the scientific story and are aesthetically pleasing. Narrowband filters are very useful for showing subtle detail in many objects, such as inside a nebula. Since stars emit a wide range of light, not just specific colors, narrowband filters can sometimes make stars look unusual. They can have colors that sometimes look funky. For example, the *Hubble* palette can make stars look pink! For this reason color schemes other than the *Hubble* palette are often used for narrowband images. Again, there's no set palette. It depends on the filters used, the object observed, and to a certain degree the preferences of the person making the image.

▶ This image of the Rosette Nebula (NGC 2237), another star-forming region, uses the same three narrowband filters but with a different color scheme: hydrogen alpha (red), [OIII] (green), and [SII] (blue). The center of the nebula is being hollowed out by the hot, massive blue stars that recently formed there. Visible near the center are dense clouds of gas that are being sculpted by the intense radiation from these stars. Note that all of the pillars point toward the stars at the center. The colors of the gas indicate the temperature. The blue-green gas is hotter than the yellow, orange, and red. Credit: T. A. Rector, B. A. Wolpa, and M. Hanna (NOAO/AURA/NSF).

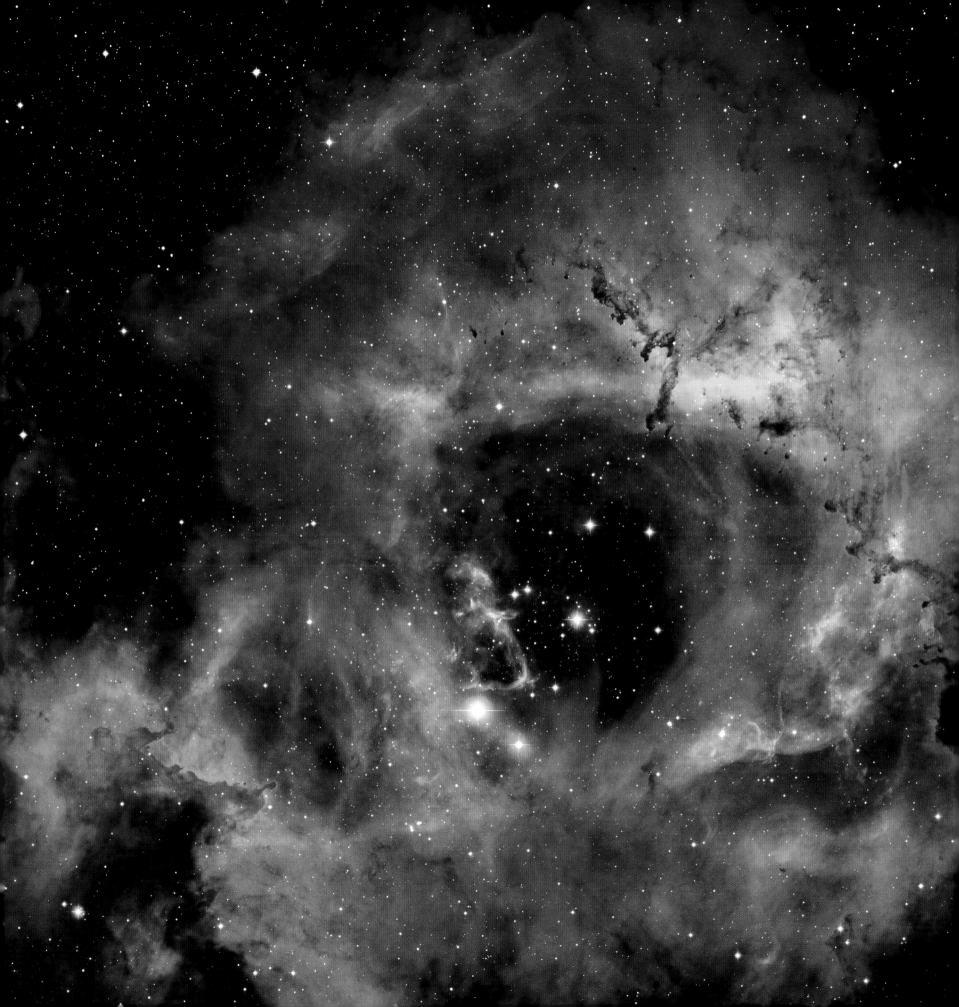

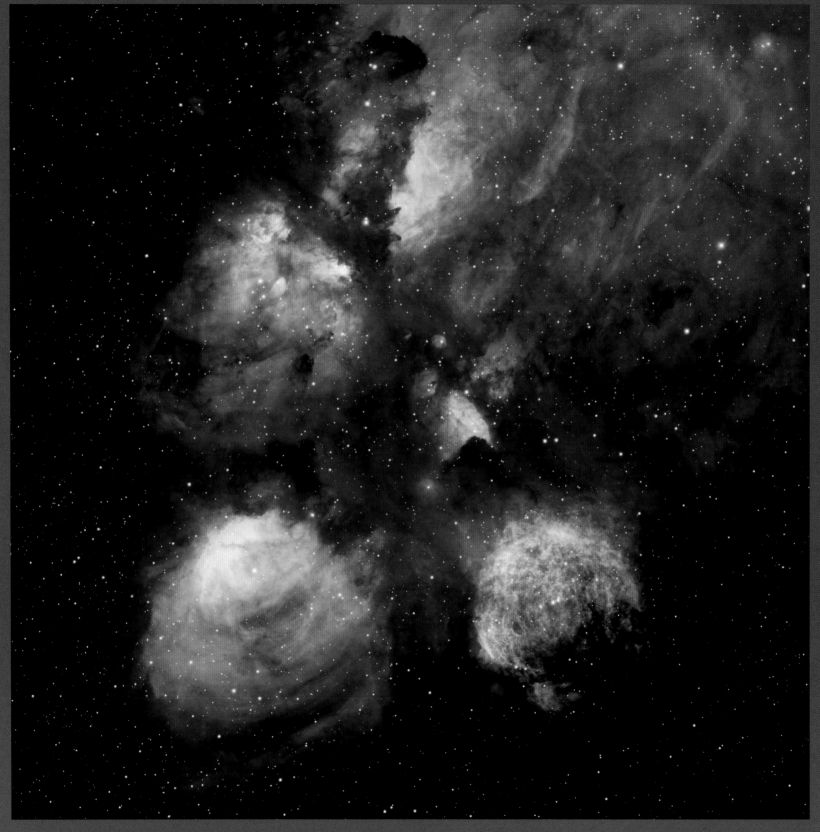

▲▶ NGC 6334 Cat's Paw (above) and NGC 3582 (opposite page) are giant star-forming regions. In both of these images the color scheme is hydrogen alpha (red), [OIII] (cyan), and [SII] (green). The colors were chosen to more closely match what would have been seen with broadband filters. Both credits: T. A. Rector (University of Alaska Anchorage) and T. Abbott (NOAO/AURA/NSF).

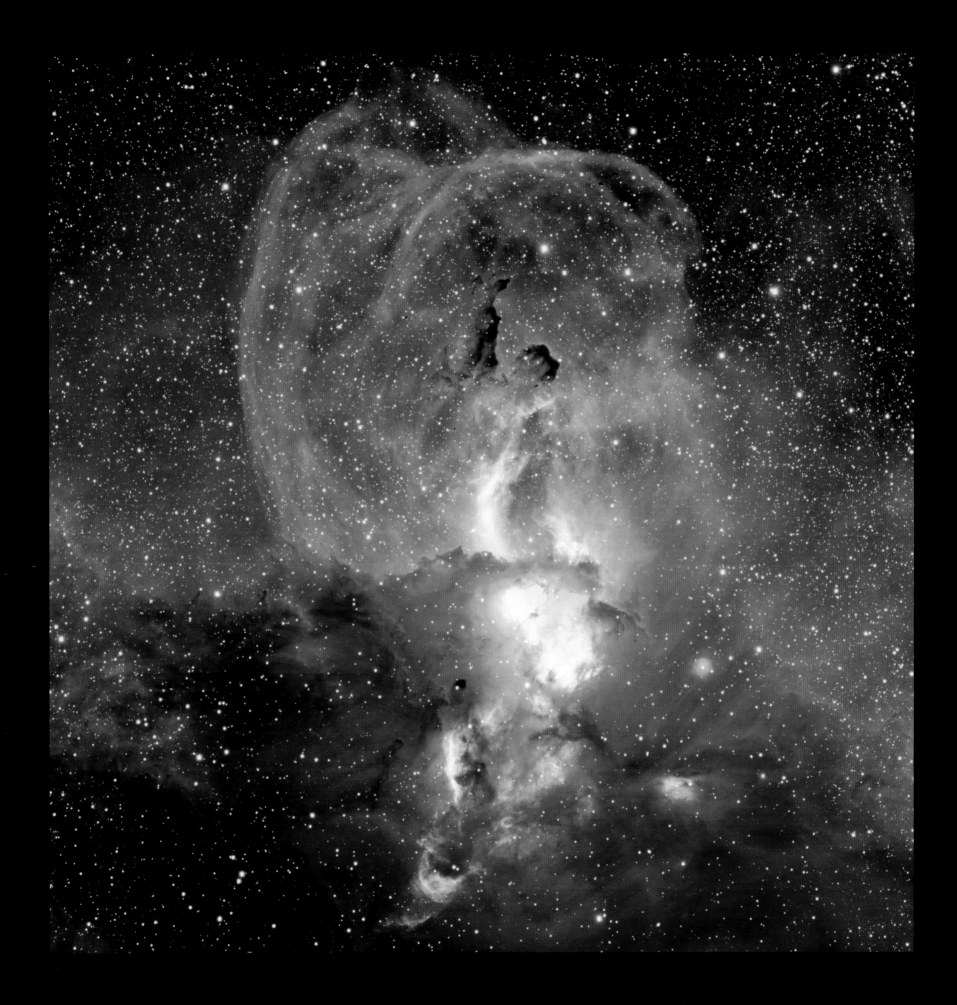

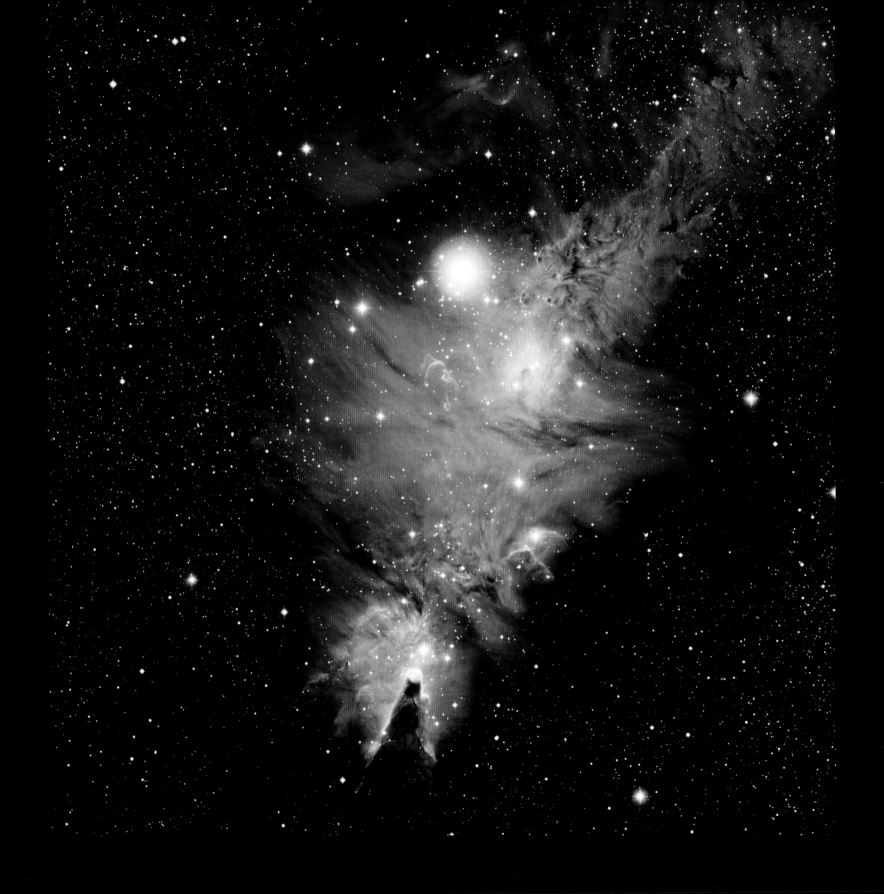

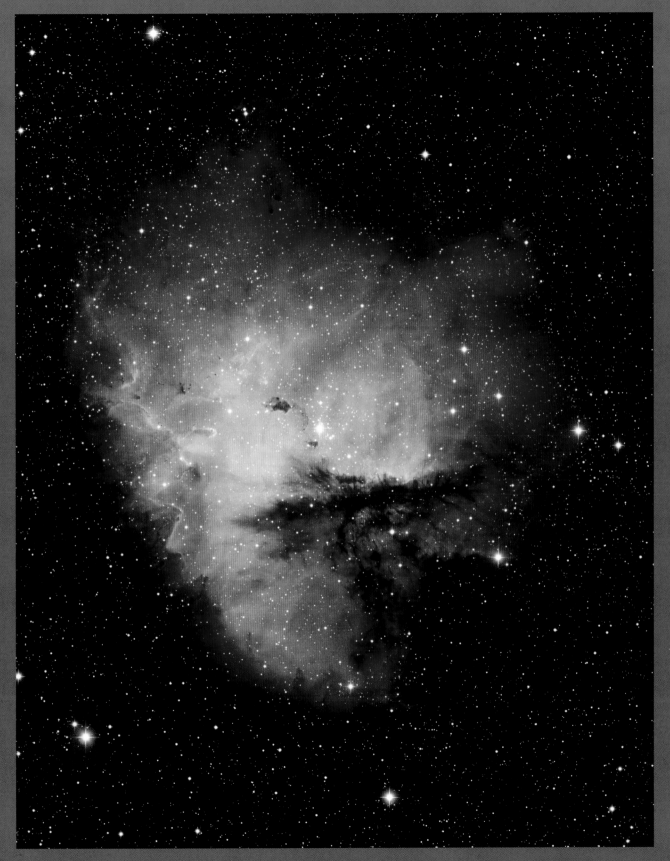

◀ In these images of the HII regions NGC 2264 (opposite page) and NGC 281 (right) the color scheme consists of hydrogen alpha (red), [OIII] (green), and [SII] (blue). This was done because the [SII] filter in these images is showing reflected blue light, in the same manner that the broadband B filter would. Left credit: T. A. Rector and B. A. Wolpa (NOAO/AURA/NSF). Right credit: T. A. Rector (University of Alaska Anchorage).

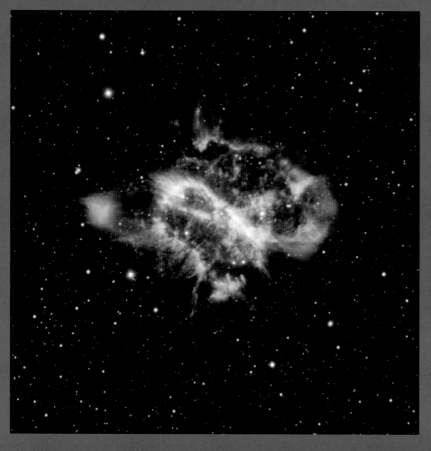 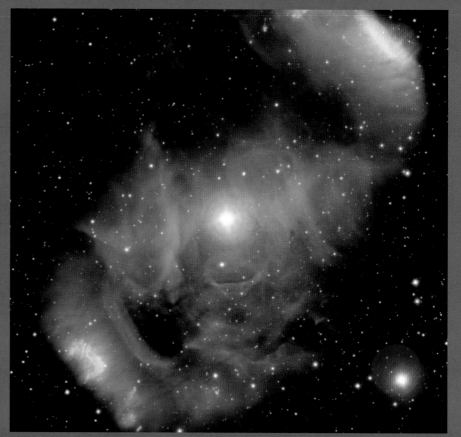

▲ These images use different color schemes to better show the complex structural detail in each object. NGC 5189 (left) is an unusual planetary nebula. The image was made with the filters: hydrogen alpha (yellow), [OIII] (red), and [SII] (blue). NGC 6164 (right) is a Wolf-Rayet star. The same filters were used but colored differently: hydrogen alpha (orange), [OIII] (blue), and [SII] (red). The colors were chosen to best show the detail in the nebula, and, of course, to look good! Both credits: Gemini Observatory/ AURA and T. A. Rector (University of Alaska Anchorage).

BIG STARS GO BANG

Earlier we talked about how a low-mass star will end its life by first cooling off, puffing out, and then becoming a so-called red giant. Eventually, it will shed its outer layers, briefly creating a planetary nebula.[18] Ultimately only the white-hot core of the star will remain, as a white dwarf.

For more massive stars, meaning those that are more than several times the mass of our Sun, their fates will not be so gentle. These bigger stars will also become red giants, but that's where the similarity ends. A giant star ends its life in a stupendous explosion called a **supernova**, blowing off the outer layers of the star with spectacular force. A supernova can be 100 *billion* times brighter than the star prior to its explosion. A supernova can briefly outshine all of the other stars in its galaxy, making it visible on the distant edges of our observable Universe.

It's hard to overstate how important supernovae are. Elements heavier than hydrogen and helium are forged in the furnaces of stars. They are then spread into space when a supernova explodes. All of the elements heavier than iron are produced in the supernova explosion itself. These so-called heavy elements are then swept up into the clouds that form the next generations of stars and planets. For example, one or more supernovae that exploded before our Solar System formed made the nickel and iron inside the Earth. If you're wearing any silver, gold, or platinum jewelry, you're quite lit-

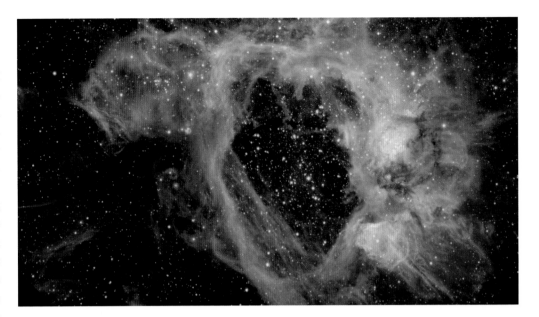

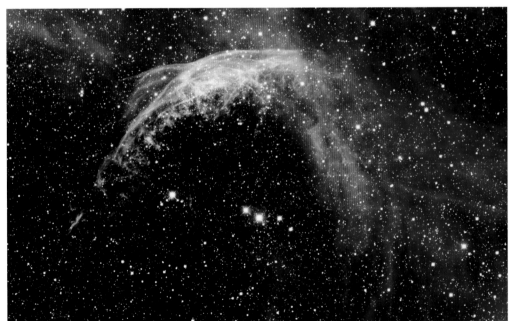

Before they explode as supernovae, high-mass stars blow off copious amounts of material in high-speed **stellar winds**. The massive stars at the center of the N44 (NGC 1929) superbubble in the nearby dwarf galaxy known as the Large Magellanic Cloud (top) have created a giant hole in the nebula from which they formed. Wolf-Rayet stars, such as WR 134 (bottom), are extremely massive stars. They are so massive that they are literally blowing themselves apart. When their outer layers hit nearby clouds of gas the collision causes them to glow in [OIII], which is seen here in blue. Top credit: Gemini Observatory/AURA and T. A. Rector (University of Alaska Anchorage). Bottom credit: T. A. Rector (University of Alaska Anchorage) and H. Schweiker (WIYN and NOAO/AURA/NSF).

▲▶ The "Cygnus Loop" (opposite page) is the remains of a star that exploded as a supernova 5,000 to 10,000 years ago. Despite happening that long ago, the released gas is still several million degrees in temperature. The **shock fronts**, where the supernova remnant collided with the surrounding gas, glow brightly. A zoom-in on a portion of the nebula, called IC 1340, is shown above. The narrowband filters hydrogen alpha (red), [OIII] (blue), and [SII] (green) show spectacularly complex and colorful structure. The entire remnant is enormous in the sky, about forty-five times the angular area of the full Moon. Above credit: T. A. Rector (University of Alaska Anchorage) and H. Schweiker (WIYN and NOAO/AURA/NSF). Opposite page credit: T. A. Rector (University of Alaska Anchorage), Richard Cool (University of Arizona), and WIYN.

erally wearing the remnants of a star that exploded billions of years ago. We have many reasons to be thankful for these high-mass stars that valiantly give their lives to produce some of the elements out of which we are made.

When gas collides with material at high speeds—which happens quite a bit when a supernova explodes—it gives off copious amounts of ionized sulfur light. This means that the [SII] narrowband filter is a particularly good tool for studying supernova explosions and their expanding debris field (what astronomers call a **supernova remnant**). Since the remnant is intensely hot, it also shines brightly in [OIII], so astronomers also frequently employ that filter when looking at these objects in visible light.

◄ NGC 6960 (opposite page), known as the Witch's Broom Nebula, is also part of the Cygnus Loop. The bright star at the center of the image is not associated with the supernova. Credit: T. A. Rector (University of Alaska Anchorage).

▼ DEM L316 consists of two supernova remnant bubbles that are located in the Large Magellanic Cloud. The filters and color scheme are the same as for the Cygnus Loop with hydrogen alpha (red), [OIII] (blue), and [SII] (green). Credit: Gemini Observatory/AURA and T. A. Rector (University of Alaska Anchorage).

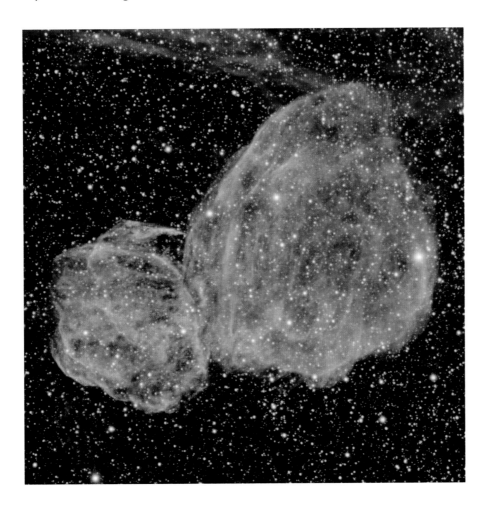

A NIGHT IN THE LIFE

Observing with the World's Largest Telescopes

▶ When preparing for a night of observing, a telescope's dome is opened shortly after sunset. The image quality is best when the telescope is at the same temperature as the ambient air. Usually the telescope and dome are warm at the start of the night from a day's worth of exposure to sunlight. To better cool off the telescope, many domes open along the sides to allow air to flow through. This photo shows the interior of the Gemini North observatory's dome with the shutter and side vents open. Credit: Gemini Observatory/AURA.

It was 2:00 a.m. at the KPNO 2.1-meter telescope and we were finally observing. Summer monsoons had clouded out the first half of the night, but by midnight the skies were clear and the 4-meter telescope operator had given us the go-ahead to open up the dome and get to work. We had just settled into observing when the Klaxon went off, indicating there was a fire. With only one exit from the mountain, a fire on Kitt Peak could become dangerous quickly. Flashing alarms lit up the 4-meter telescope like a Christmas tree. What was going on? A phone call to the staff at the 4-meter gave the answer. It turns out a bagel had gotten stuck in their toaster. Its burning carcass set off the alarm.

It was an amusing episode in an otherwise typical night "on the mountain" (as the astronomers and staff who work there call it). Sometimes people think that astronomers are at the observatory most every night. But usually we get to use a telescope for only a handful of nights every year. So what is it like to use the telescopes at Kitt Peak and other observatories? And how do astronomers get to use them?

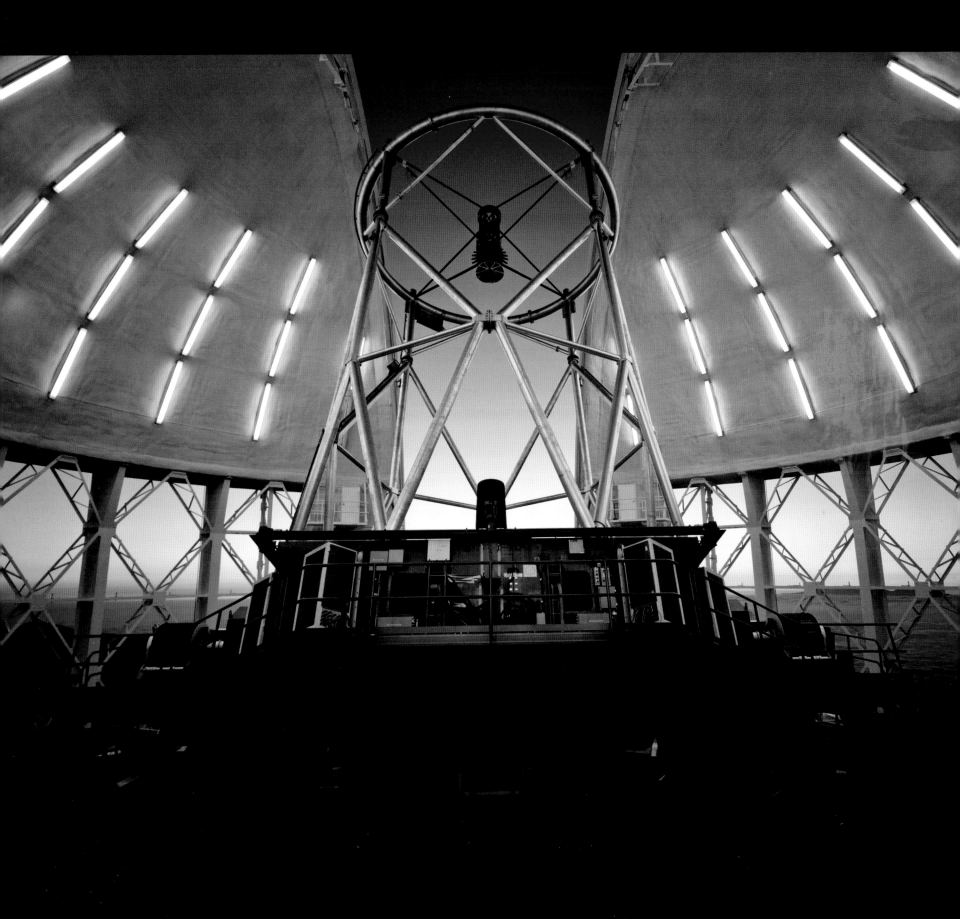

▲ One of the world's most powerful visible-light and infrared telescopes, the *Frederick C. Gillett* Gemini North Telescope, sits atop the summit of Mauna Kea, Hawai'i, at an altitude of 13,800 feet (4,200 m). The dome in which the telescope resides is more than fifteen stories tall. Note the car in the lower-right corner for scale. Credit: Gemini Observatory/AURA.

THESE ARE PROFESSIONAL GRADE

Professional observatories are the telescopes astronomers use for their research. They're used primarily to make scientific discoveries, from topics as diverse as studying volcanoes on Jupiter's moon Io to measuring the rate of expansion of the entire Universe. These telescopes aren't like the one sitting in the corner of your aunt and uncle's living room. They are big. And by big, we mean as big as a building. Telescopes, especially visible-light ones, are often measured by the diameter of their primary mirror. This is the main mirror that gathers and focuses the incoming light. The larger the mirror, the more light the telescope can collect and

◄ The dome protects the telescope from inclement weather. The dome opens to allow the telescope to see the sky through the opening along the top of the dome (called the shutter). The dome rotates so that the telescope is always looking through the shutter. This picture shows the University of Arizona's Bok 90-inch telescope (left) and the KPNO 4-meter telescope (right) atop the summit of Kitt Peak. Like Gemini North, the KPNO 4-meter has vents to increase airflow through the dome. Credit: T.A. Rector (University of Alaska Anchorage).

the fainter of objects you can see. A top-of-the-line amateur telescope may have a mirror that is 24 inches (0.6 meters). That's two feet across. To compare, the primary mirror of the Gemini North telescope is 27 feet (8.2 meters) across.

In addition to their size, these telescopes are also expensive. You can get a low-end amateur telescope for only a few hundred dollars. A top-end amateur telescope can cost hundreds of thousands of dollars. Professional observatories cost in the hundreds of *millions*, not to mention the expense of operating them. For example, once all the costs of staff, maintenance, and expendables (such as electricity and cryogenics) are added up, it costs Gemini Observatory roughly $50,000 *per night* to operate each telescope. That's over a dollar a second. And that's just for the telescopes on the ground. Space-based telescopes like *Hubble* and *Chandra* cost several billion dollars to build and many millions per year to operate.[19]

That brings us to our final point about how different these telescopes are from one you might have at home. Many of them are built to detect the types of light

that you can't see with your eyes—everything from radio waves to X-rays and gamma rays. To detect these "invisible" types of light, scientists and engineers have developed technology and hardware that is much different from what you can buy in a store or online. (Not even Amazon carries them.) In chapter 10 we'll talk about these kinds of light and the telescopes that can detect them. Even those that do detect visible light—including those that are in space[20]—are not as they often are depicted in comics, cartoons, and movies. (Hint: there's no white tube with an eyepiece on the back.)

RESERVATIONS REQUIRED?

So how do you get to use one of these telescopes? Can you make reservations? Is it pay as you go? The process varies some from one observatory to another, but all of them have a procedure in which astronomers submit a proposal requesting to use the telescope. The proposal deadlines are usually once or twice a year. In the proposal, the astronomers describe the telescope and **instruments**[21] they want to use, when they would like to use them, how much time they need and, most important, what scientific discoveries they hope to make. Another group of astronomers, usually called a **time-allocation committee,** or "TAC" for short (pronounced "tack"), will then read and rank the proposals.

Competition is stiff. Only the top proposals are likely to get time on a telescope. For example, in 2014 astronomers asked for three times as much time than is available on the Gemini North telescope. In the same year, *Chandra* and *Hubble* were **oversubscribed** by a factor of five and seven respectively. Fortunately, those who do get time usually don't have to pay for it. For some telescopes the astronomers actually get additional financial support to help cover the costs associated with analyzing the data as well as publishing and presenting their results.

How an astronomer gets to use a telescope depends on how time is scheduled. The traditional method (in what is now known as **classical observing**) is that the astronomer is given specific dates. In the past the astronomer would always go to the telescope for these nights. But in the twenty-first century, astronomers can often control the telescope via the Internet (known as **remote observing**). This method works well unless the weather is bad on your nights, in which case you're out of luck. Many newer observatories now use **queue observing**, where the observations are done in order of priority. In other words, the most interesting proposals are done first. If the weather is bad on one night they'll wait to do the observations the next time the conditions are good. There are also **target of opportunity** observations. For example, let's say you study supernova explo-

sions. You don't know when the next star will explode, so a target of opportunity proposal can ensure that you get time on the telescope when you need it.

Telescopes at older observatories, such as KPNO and CTIO, are mostly scheduled in the classical way with specific dates. That's because most of these telescopes were built long before the Internet, so the astronomer has to be there to operate it. For newer telescopes, such as Gemini Observatory, the astronomer doesn't have to be physically present. Either the telescope can be controlled remotely, or staff astronomers will do the observations for you when it's your project's turn. And for some telescopes, such as *Hubble* and *Chandra*, the astronomer *can't* be there—the telescopes are in space![22]

Classical observing may not be the most efficient or convenient, but it can be the most fun. Observatories are located atop high mountains with pristine clear, dark skies. Astronomers get to travel to some of the highest and driest places on Earth, such as the Sonoran Desert in Arizona, the mountaintops of Hawai'i, and the high deserts of northern Chile. In other words, astronomers get to work in some of the most dramatically beautiful places on Earth.

WORKING DUSK TILL DAWN

What are astronomers doing when they observe with ground-based telescopes? Telescope time is hard to come by, so every second of darkness counts. Astronomers literally observe from dusk to dawn, which in the winter can mean working for over fourteen hours straight. So, in addition to the computers and electronics necessary to run the telescope, most control rooms have extra amenities. Typically this includes a kitchen area (to prepare **night lunch**),[23] a stereo system, and a bathroom. Some telescopes also have a couch for a quick nap, a mini library, and even gaming rooms for entertainment should the weather be bad. Since we're up all night observing, like vampires we sleep during the day. The dormitories have light-tight shades over the windows so we can sleep in darkness. Fortunately, we don't sleep in coffins.

REMOTE CONTROL

How do you use a telescope if you're not there? Most newer telescopes are fully computer controlled, so you can use the telescope by creating a computer "script" that will tell the telescope where to point, what camera to use, how long to make the exposures, and so on. When it is your turn to observe, the script is loaded into the telescope and executed automatically. Assuming all goes well, the data the

▲ Astronomers are often pictured sitting in a dome looking through an eyepiece while wearing a white lab coat. But the reality is pretty different. We don't look through an eyepiece, we use electronic instruments like those discussed in chapter 2. We also, luckily, don't have to sit in a dark dome anymore. Instead, we sit in a warm, well-lit control room away from the telescope (because having the lights on in the dome would ruin the observations). And there's no need for lab coats. Credit: Guy and Rodd/ Cartoonstock.com.

▲ Kitt Peak is an isolated mountain in the Sonoran Desert of southern Arizona, about 40 miles west of Tucson. At an altitude of 6,800 feet, the telescopes are able to get above most of the dust and water vapor in the atmosphere, giving astronomers more than three hundred clear nights a year. It is a tradition for astronomers to watch the sunset before starting to observe. Many telescopes have a raised **catwalk** around the perimeter of the dome for checking the weather. Here Dr. Steve Howell is enjoying the sunset from the KPNO 2.1-meter telescope catwalk on the left. The WIYN 0.9-meter and 3.5-meter telescopes are to the left of center. And the KPNO 4-meter telescope is the tall dome on the opposite page. Credit: T. A. Rector (University of Alaska Anchorage).

▲ Sunset as seen from the summit of Mauna Kea, Hawai'i. The Gemini North telescope is the large one on the opposite page. Just below the Sun (on this page) is the 8.2-meter Subaru Telescope. To its right are the two 10-meter Keck Telescopes and the NASA Infrared Telescope Facility. On the far left, a group of tourists have come to the summit to enjoy the sunset. Credit: T. A. Rector (University of Alaska Anchorage).

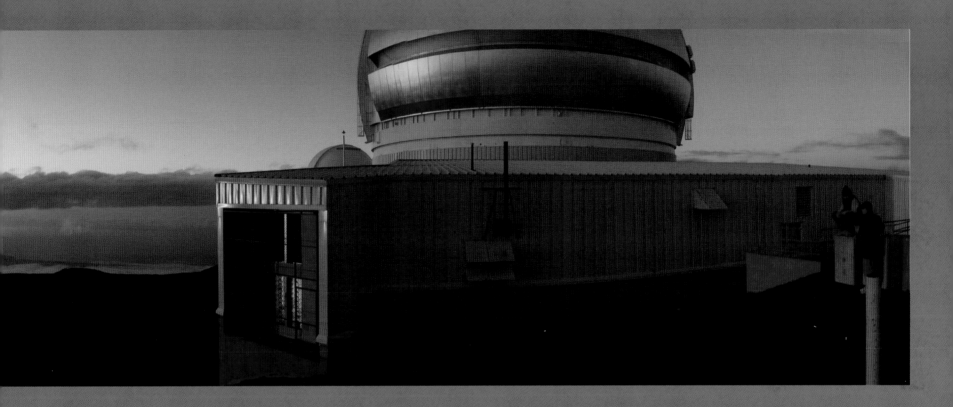

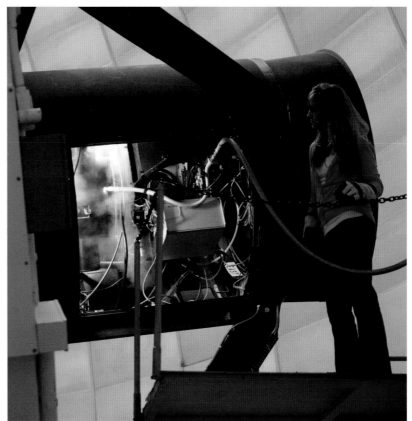

▲ Many different skills are required to run an observatory. Among other duties, the observatory staff keep the telescopes in good working order and the astronomers and staff well fed. Credit: NOAO/AURA/NSF.

▶ Most astronomical cameras are kept extremely cold because it makes them more sensitive to faint light. The Mosaic camera on the KPNO 4-meter telescope is kept at a temperature of −100°C (−150°F) by filling the camera with liquid nitrogen. The camera needs to be filled twice a day to stay cold, which is what Mosaic instrument scientist Heidi Schweiker is doing here. This is usually done just before sunset and just after sunrise. Credit: Pete Marenfeld/NOAO/AURA/NSF.

telescope collected will be uploaded to a website from where you can download it. It's like an unexpected birthday gift when you get the e-mail telling you that your observations are done and your data are ready to be downloaded.

So far we've just been talking about visible-light telescopes, which detect mostly the same kinds of light our eyes can see. In the next chapter we'll describe other kinds of light and the different kinds of telescopes that see them.

◄ These giant machines are complicated to use, not to mention expensive, so observatory staff often help astronomers with the observing. Usually a **telescope operator** will control the telescope (for example, open and close the dome, move the telescope to the next target) while the astronomers control the instruments. The operator also makes the decision as to whether the weather permits opening the telescope dome. At the Gemini Observatory, the telescopes are primarily used for queue observing. Gemini staff astronomers (shown here working in the control room) complete the observations scheduled by other astronomers. Credit: Gemini Observatory/AURA.

▼ Known as the **observing tool**, this is the software used to program observations for the Gemini Observatory telescopes. The window on the left is where you set up the coordinates to which the telescope will point and where you choose the instrument settings, such as number of exposures, filters to use, and the length of each exposure. The window on the right shows as a blue box the portion of the sky that the telescope will see, so that the observations can be further refined. The small red box is placed on a **guide star**, which is used to control the movement of the telescope as well as improve the image quality. Credit: Gemini Observatory/AURA and T. A. Rector (University of Alaska Anchorage).

OUTSIDE THE RAINBOW

The Electromagnetic Spectrum, Different Kinds of Light

▶ The giant star Zeta Ophiuchi is having a "shocking" effect on the surrounding dust clouds in this far-infrared image from *Spitzer*. Stellar winds flowing out from this fast-moving star are making ripples in the dust as it approaches, creating a bow shock. The bow shock is seen as glowing gossamer threads, which, for this star, are only detected in far-infrared light because the star is shrouded in dust. The shock cannot be seen with a visible-light telescope. In this image, the dust glows in infrared light and is seen as green. Credit: NASA/JPL-Caltech.

We often think of "light" as what we can see with our eyes, but there are other kinds of light that we *can't* see. Maybe you've heard of some of them before: infrared, ultraviolet, X-rays—what are these? And how do astronomers use them to learn more about how our Universe works?

THE ELECTROMAGNETIC SPECTRUM

For most of human history, we have relied on a pair of exquisite tools to explore the skies: our eyes. As described in chapter 7, our eyes are remarkably complex and versatile, if somewhat limited, light-collecting devices. When the Italian scientist Galileo Galilei first turned his telescope to the sky more than four hundred years ago, he was using it to enhance his natural vision much in the way that binoculars do.

We now know, however, that the light our eyes can detect—even when bolstered by powerful telescopes—represents a mere fraction of the total light that exists. What we call light is the same thing that scientists call **electromagnetic**

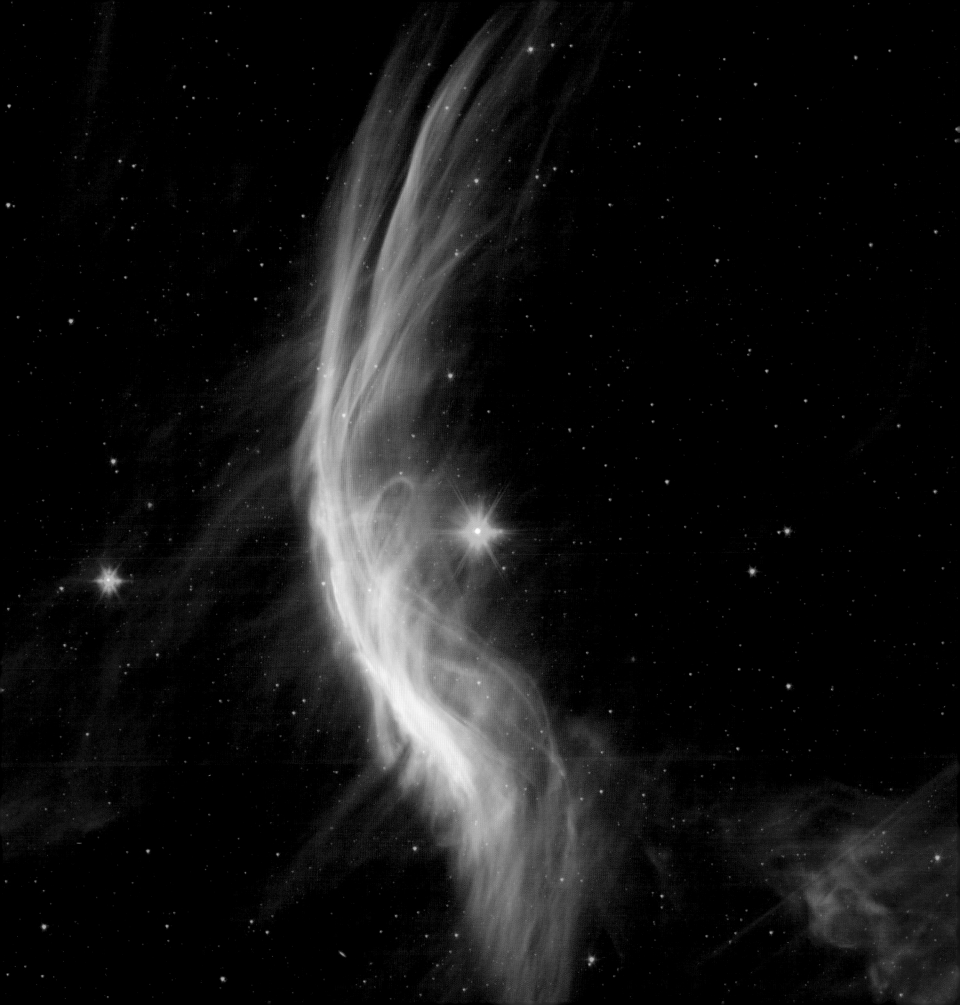

radiation, which can carry energy through the vacuum of space. Because of this, it can deliver information to us from the farthest corners of the Universe. Astronomical objects produce all the different kinds of light. In order to explore and comprehend the Universe, astronomers use different kinds of telescopes to collect and analyze light.

Electromagnetic (EM) radiation—a.k.a. light—exists in an enormous range of energies. Scientists call the full gamut of EM radiation the **electromagnetic spectrum**, or EM spectrum. The spectrum has been historically divided into seven groups: radio waves, microwaves, infrared, visible, ultraviolet, X-rays, and gamma rays. You've probably heard of them, but you may not know they are all essentially the same thing. The only difference between the groups is the amount of energy. Radio waves have the lowest energy, and gamma rays have the highest.

▶ This illustration shows the electromagnetic spectrum, the range of light from radio waves to gamma rays. Credit: NASA/CXC/S. Lee.

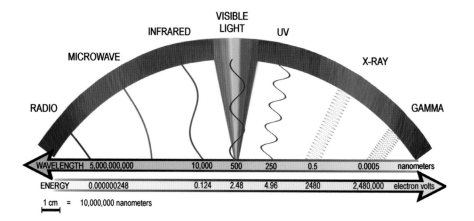

The vast range of the EM spectrum is why there are many different telescopes in astronomy. In order to understand the cosmos and our place in it, we need access to telescopes that can look at all of the different kinds of light. Each slice of the EM spectrum usually requires its own technology to observe it. In other words, we can't build a single telescope or observatory to see all the different types of light. For example, because radio waves are so low in energy, the telescopes designed to detect them require enormous dishes. Other types of light—such as ultraviolet, X-rays, and gamma rays—are mostly absorbed by the Earth's atmosphere. So the telescopes that observe these types of light must be in space. In fact, gamma rays are so energetic that they cannot be focused onto a detector and thus demand a radically different telescope design. Let's explore the different kinds of light, the telescopes used to "see" them, and what kinds of information astronomers learn from them.

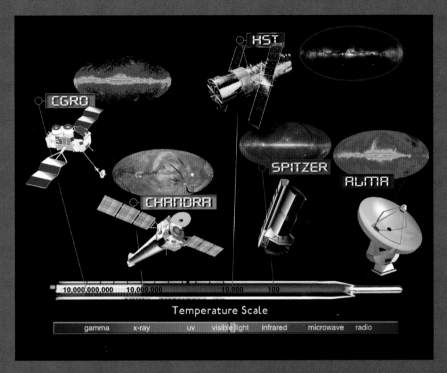

In order to get a more complete picture of our Universe, we need different kinds of telescopes to observe different slices of the EM spectrum. Pictured here are five different kinds of telescopes and the portions of the EM spectrum they detect. Credit: NASA/CXC/M. Weiss.

The antenna in the upper right picture is designed to send and receive radio waves in all directions, whereas the one in the lower right picture sends and receives them only in the direction it is pointed. Top image: By Chetvorno. Bottom image: GNU license, Credit: Yann, Wikipedia.

▲▲ The Very Large Array[3] (VLA) telescope in New Mexico (top) has twenty-seven antennas, each of which is 85 feet across. The signals from each antenna are combined to simulate a single large telescope. Credit: T. A. Rector.

▲ Two of the antennas of the VLA. Credit: Copyright 2014 Michael Mauldin.

RADIO, RADIO

Most of us will be familiar with a small subset of radio waves that we scan to find our favorite radio station. Here on Earth we use radio waves for communication because they readily go through anything that isn't made of metal. They are used for radio, television, cellular phones, WiFi, and more. Radio waves are sometimes confused with sound waves. Radio waves are the electromagnetic signals that your stereo receives from an antenna. The electronics inside your stereo then convert them into a sound wave that travels from the speaker to your ear. (Sound waves are caused by the compression of air.)

Radio astronomy is the field of studying the radio waves that come from objects in space. Astronomers detect radio waves from a host of objects—everything from planets and comets to giant clouds of gas and dust to stars and galaxies. To do this they use, naturally, what are called **radio telescopes**. These telescopes look completely different from a traditional visible-light telescope. Most of them look like one or more giant satellite dishes. Each dish has one or more **receivers** that are designed to pick up a range of radio wave energies (known as a **waveband**).

MICROWAVES: MORE THAN THE OVEN

Moving to radiation with slightly higher energy than radio brings us to microwaves. This can be confusing because some scientists regard this range of light to be part of radio waves, while others purposefully separate them into their own category.

Upon hearing the word "microwaves" many people think of cooking. And that's because a specific energy of microwaves is used in microwave ovens to energize water molecules and heat food. Other energies of microwave radiation are not absorbed by water, so they are used for communication. Like radio waves, they are also useful for sending information from one location to another because their energy can pass through walls as well as rain, snow, clouds, and smoke (which is why they are often used by satellites to observe the Earth). Weather forecasters employ higher-energy forms of microwaves for Doppler radar.

In astronomy, microwaves are perhaps most famous for their role in providing clues to the origin of the Universe. In 1965, Bell Laboratories scientists Arno Penzias and Robert Wilson accidentally discovered microwave radiation coming from all directions in the sky. This "noise" was not coming from anywhere on our planet. Rather, it was the **Cosmic Microwave Background** (CMB). The CMB is the oldest light in the Universe. That is, it is the leftover radiation from the Big Bang itself.

▷ A map of the CMB, the "leftover energy" from the origin of the Universe 13.8 billion years ago. This is a pseudocolor image, where blue areas are slightly colder (by just a fraction of a degree) than the red areas. The tiny perturbations in this image eventually turned into the stars, galaxies, and other large structures we see in the Universe today. This is one of the most important scientific images ever made. Credit: Plank/ESA.

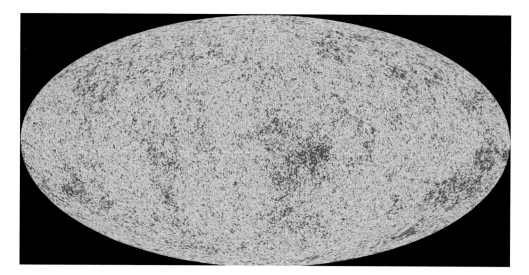

▷ Observations using the Atacama Large Millimeter/submillimeter Array (ALMA), a telescope with sixty-six antennas in northern Chile, have revealed an unexpected spiral structure in the material around the old star R Sculptoris. Millimeter and submillimeter corresponds to light between microwaves and the far infrared. Credit: ALMA (ESO/NAOJ/NRAO).

By studying the CMB, scientists have been able to answer with precision some of the most fundamental questions about the Universe. They've been able to determine, among other things, its size, shape, and age. Astronomers have also taken what they've learned about the CMB to help establish the relative amounts of normal matter, dark matter, and dark energy in the Universe.

INFRARED: CAN YOU FEEL THE HEAT?

Infrared light lies between the microwave and visible portions of the electromagnetic spectrum. The word "infrared" literally means "below red," so named because it is the range of energies below red light in the visible spectrum. On Earth, we experience infrared light every day as heat. All objects, including people, give off heat from their bodies in the form of infrared light. Warmer objects emit more infrared. Some night vision goggles work by seeing this light. "Heat-seeking" missiles search for their targets by looking for infrared light as well. Like radio waves and microwaves, we use infrared light for communications in devices such as remote controls and computers. But since infrared doesn't go through material as easily, it is used primarily for short-distance communication.

Astronomers have built telescopes and cameras capable of seeing infrared light. Higher-energy infrared light, called **near infrared** because it is closer to visible light, can travel through the Earth's atmosphere but is partially absorbed by water vapor. Visible-light telescopes at high altitudes and dry locations can detect this light when using special cameras designed to see it. Many visible-light telescopes, such as those at Gemini and KPNO, have such cameras. Lower-energy infrared light, called **far infrared**, is completely absorbed by the Earth's atmosphere. So telescopes for this kind of light must be put in airplanes that fly at high altitudes, or in spacecraft beyond Earth's atmosphere.

A man holding a plastic bag as seen in visible light (left) and infrared (right). Infrared can pass right through some objects that stop visible light entirely. In the image on the left, you can't see the man's hands at all—the plastic bag stops the visible light from passing through. In the infrared image on the right, the bag looks transparent, and his hands are visible. Just as infrared light can get through some things that visible light can't, infrared can also be blocked by some things that let visible light through. Notice the eyeglasses in both images. In infrared light, they're opaque. Credit: NASA/JPL-Caltech/R. Hurt (SSC).

To see the far infrared, telescopes must be above all of the water vapor in the Earth's atmosphere. Several telescopes, including the *Spitzer* Space Telescope launched in 2003 (as shown in an artist's conception on the left) observe infrared light from space. A novel alternate solution is to put the telescope in an airplane. NASA's Stratospheric Observatory for Infrared Astronomy (*SOFIA*) is a 2.5-meter telescope that peers out of the side of a modified 747 (right image). *SOFIA* flies at altitudes up to 45,000 feet. Left credit: NASA/JPL-Caltech/R. Hurt (SSC). Right credit: NASA photo/Jim Ross. Image: ED10-0182-01.

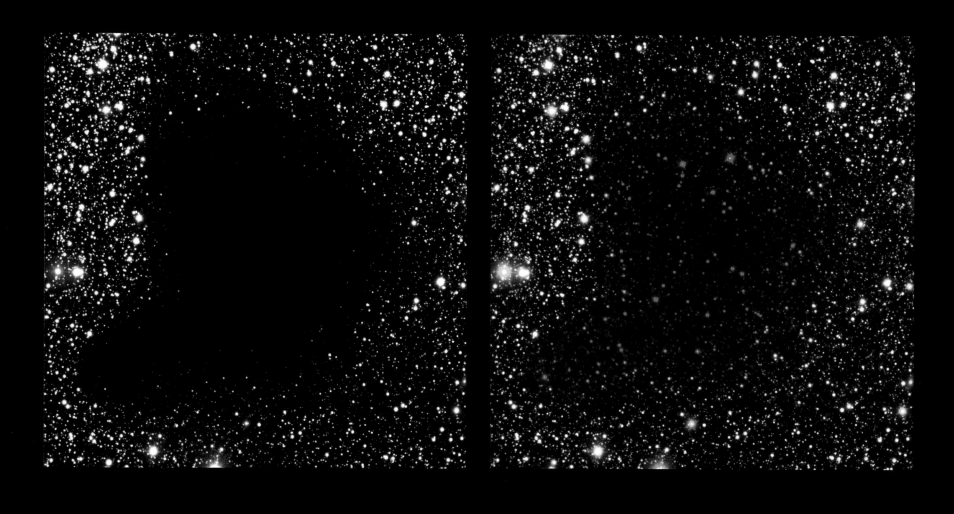

▲ Near-infrared images of the barred spiral galaxy NGC 6300 (top left), the Rotten Egg Nebula QX Puppis (top right), the giant star cluster RMC 136 (bottom left), and dust and gas from the young star AFGL 2591 (bottom right). These images reveal detail and information that cannot be seen in visible-light images. In the case of AFGL 2591, the star and nebula aren't visible at all to a visible-light telescope. Credit: Gemini Observatory/ AURA and T. A. Rector (University of Alaska Anchorage).

◄ This dark cloud of gas, known as Barnard 68, is completely opaque to visible light (left). Dust in the nebula absorbs visible light, but allows near-infrared light to pass through (right). Both credits: ESO.

There are some really exciting areas of research involving the infrared in modern astronomy—from studying planets beyond our Solar System (called exoplanets) to looking at distant exploded stars in order to measure the fate of the Universe. Telescopes and cameras that can see near-infrared light are also useful for examining dusty clouds of gas where new stars are forming. The dust is transparent to near-infrared light, allowing us to see inside. In the far infrared the dust actually *emits* light, so we can see it directly.

VISIBLE: THE TINY SLICE YOU CAN SEE

The next stop on our tour is visible light. Despite its important presence in our lives on Earth, visible light is just a mere fraction of the entire EM spectrum. Think of it as just a couple of keys on a full-length piano and you'll have an idea of just how little of the EM spectrum our eyes can detect. That said, it's an important range of energy, as much of the material in this book demonstrates. It's no accident that humans have the ability to detect this particular band of radiation—the Sun produces more visible light than any other kind.

As we noted before, the colors correspond to the energy of the light. Red light is the lowest energy of light we can see. The other colors of the rainbow—orange, yellow, green, blue, indigo, and violet—each represent an additional step up the energy scale.

ULTRAVIOLET: LIGHT MY WAY

If violet is the highest energy light in the visible segment of the EM spectrum, you might guess that ultraviolet light is next. And you would be right. Ultraviolet literally means "above violet." Many of us are familiar with UV light because it can cause your skin to get suntanned (or sunburned if you're not careful). Sometimes people think the Sun produces primarily UV light, but in reality it produces more visible light. UV light is used for a variety of purposes on Earth, including (somewhat obviously) tanning beds.[24] It is also used for "black lights" and anticounterfeiting measures.

Most of the UV from the Sun is blocked by gases in the Earth's atmosphere, as are X-rays and gamma rays. This is a good thing, as all of these high-energy forms of light are dangerous to life on Earth. But it's not so great for astronomers, because it means we have to put our high-energy telescopes into space. *Hubble* can see UV light, as can spacecraft such as NASA's *GALEX*, *Swift*, and the Solar Dynamics Observatory. There are many different objects in the cosmos that emit

▶ The visible portion of the EM spectrum spread out into its different colors in an optical phenomenon known as a circumhorizontal arc, seen here behind the KPNO 0.9-meter telescope. Although it's not a rainbow, it shows much the same effect of the dispersion of light. Credit: T. A. Rector (NOAO/AURA/NSF).

▲ The Solar Dynamics Observatory has given us spectacular views of the Sun in the UV, revealing loops of hot gas, magnetic fields, and a turbulent surface (as seen in the image on the left). This is a monochromatic image of the Sun through only one filter, which was then made red. The image on the right shows the Andromeda Galaxy (M31) as seen by *GALEX*. The blue light is from hot, massive stars in the galaxy. This is an image made through two filters, with low-energy UV light assigned yellow and high-energy UV assigned blue. Left credit: Solar Dynamics Observatory/NASA. Right credit: NASA/ JPL-Caltech.

copious amounts of ultraviolet light. For example, hot, massive stars glow brightly in ultraviolet radiation.

X-RAYS: BEYOND THE DENTIST'S OFFICE

As the energies of light get higher, the phenomena they reveal also change. It takes extremely high temperatures (millions of degrees) to produce X-rays. The energy of an X-ray is hundreds to thousands of times higher than that of visible light. Here on Earth, we tend to associate X-rays with a visit to the doctor or dentist. X-rays easily go through low-density material, including skin and muscle, so they are useful for seeing what's going on inside your teeth and bones. Security officers also use them to see what's inside your luggage or handbag when you go to the airport.

As with UV, the field of X-ray astronomy had to wait until the advent of the Space Age. While scientists discovered that the Sun gave off X-rays in 1949, it wasn't until 1962 that detectors revealed that there were X-ray sources outside of our Solar Sys-

tem. Since then, the technology in this field has improved by leaps and bounds in just a handful of decades. Both NASA and the European Space Agency launched major X-ray astronomy missions in 1999—the *Chandra* X-ray Observatory and *XMM-Newton* telescope respectively. These orbiting observatories have detected hundreds of thousands of X-ray sources. *Chandra* and *XMM-Newton*, along with other X-ray telescopes, have helped us revolutionize our understanding of material falling into a black hole, debris from exploded stars, hot gas between galaxies, and much more.

▲ Telescopes that look at high-energy light (UV, X-rays, and gamma rays) must be put in space. These images are artists' conceptions of the *GALEX* UV telescope (left) and *Chandra* X-ray Observatory (right). Left credit: NASA/JPL-Caltech. Right credit: NASA/CXC/NGST.

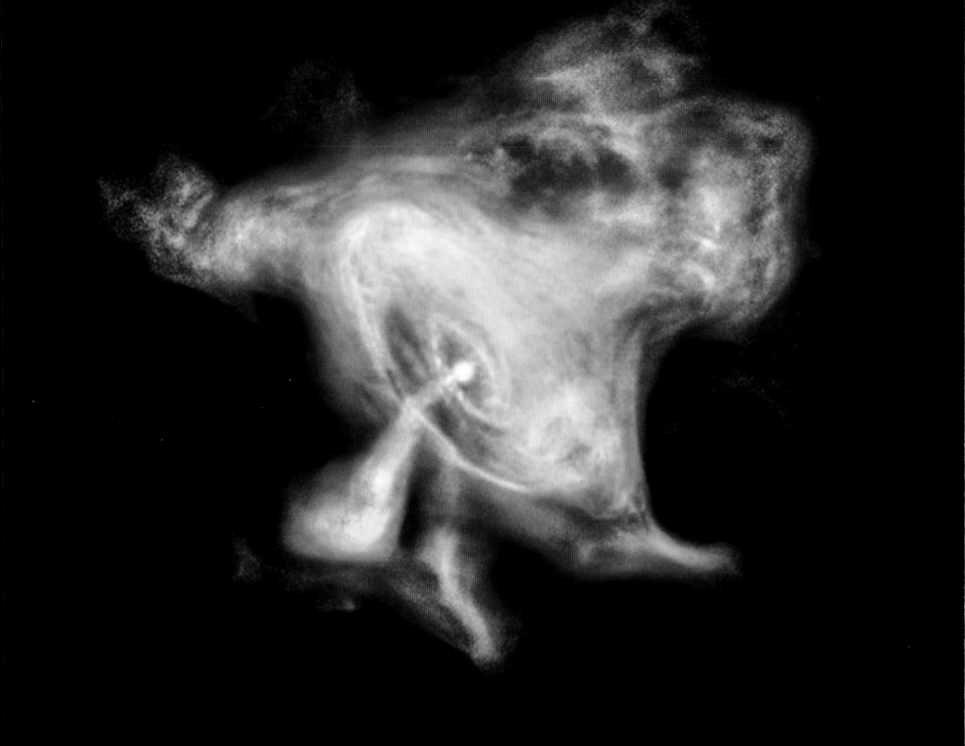

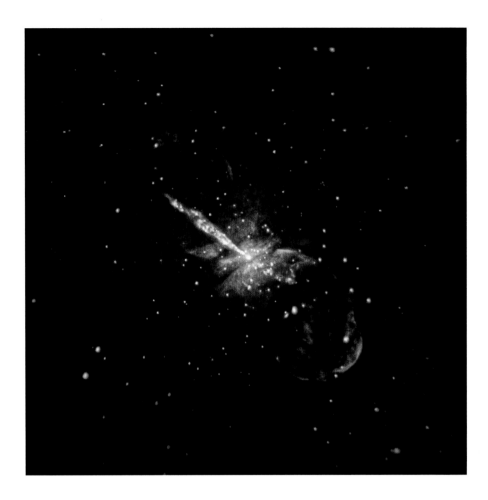

The Crab Nebula (opposite page) is the remnant of a massive star that exploded as a supernova in AD 1054. The explosion produced a **pulsar**, a rapidly spinning neutron star. The pulsar is the bright dot at the center of the image. Hot gas surrounding the pulsar is also visible in X-rays. The galaxy Centaurus A (left) shows a high-speed jet of gas coming from the center of the galaxy. The individual "dots" in the image are not stars but X-ray binary systems that contain either a black hole or a neutron star in orbit with a companion star. Both images are chromatically ordered with the lowest energies in red and the highest energies in blue. Both credits: NASA/CXC/SAO.

A cool trick about X-ray telescopes is that they *can* see color intrinsically. Unlike infrared and visible, the detector in an X-ray telescope records the energy of the light as well as the amount. So you don't need filters. Instead, you use what are called **energy cuts**. You make two or more grayscale images by dividing the X-rays into groups based upon their energy; for example, you could decide X-rays in the energy range of 0.5 to 1.0 keV[25] are red, 1.0 to 1.5 keV are green, and 1.5 to 10 keV are blue.

GAMMA RAYS: LIGHT TO THE EXTREME

Finally, at the highest end of the electromagnetic spectrum lie gamma rays. On Earth some radioactive materials, such as uranium and plutonium, generate gamma rays. Because they can kill living cells, doctors have learned to harness

▷ A map of the entire night sky as seen in gamma rays. This is a pseudocolor image, where orange and red colors indicate brighter gamma-ray sources. The red running across the image represents gamma rays from objects inside our Milky Way galaxy, such as black holes and supernova remnants. Credit: NASA/DOE/Fermi LAT Collaboration.

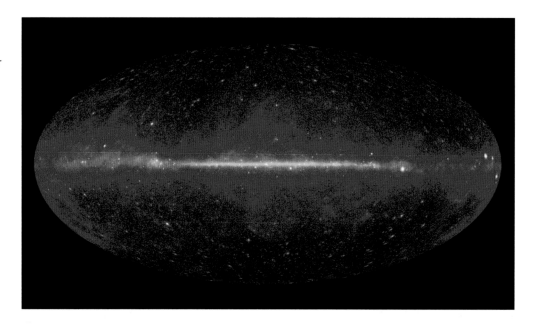

gamma rays to treat cancer and perform diagnostic tests. But much of the action in gamma rays happens in space. Take, for instance, gamma ray bursts. In 1967 the United States put satellites in orbit to monitor for covert nuclear tests by the Soviet Union. Instead, these satellites caught flashes of gamma ray radiation coming from deep space.

In the ensuing decades, there have been several telescopes launched into space with the express purpose of studying gamma ray bursts and other gamma ray phenomena. Today, the research field of gamma ray astronomy tells us about things such as extremely dense stars, super hot gas, and black holes being born.

THE INVISIBLE MADE VISIBLE

Astronomers often look at objects with these different kinds of telescopes because each kind of light gives us different pieces of information. Making images using data from nonvisible kinds of light presents distinct challenges and opportunities. The fundamental task is to make an image that people can see based on kinds of light they cannot. How do you do that?

It would seem that for such images the very concept of color would be meaningless. However, it is largely much the same process for other kinds of light as in the visible. For example, when you look at a red object with your eyes, it appears to be red because it is emitting (or reflecting) more red light than the other colors.

▲ ◀ Over four hundred years ago, Danish astronomer Tycho Brahe first observed the supernova that bears his name. The resulting supernova remnant is now a bright source of X-rays. This *Chandra* image of Tycho reveals the dynamics of the explosion through three energy cuts layered in chromatic order. The outer shock produced a rapidly moving shell of extremely high-energy electrons (blue), and a reverse shock heated the expanding debris to millions of degrees (red for low energy and green for middle energy). The top three images show the separate energy cuts. The bottom image shows the full-color image created when they are combined. Credit: NASA/CXC/SAO.

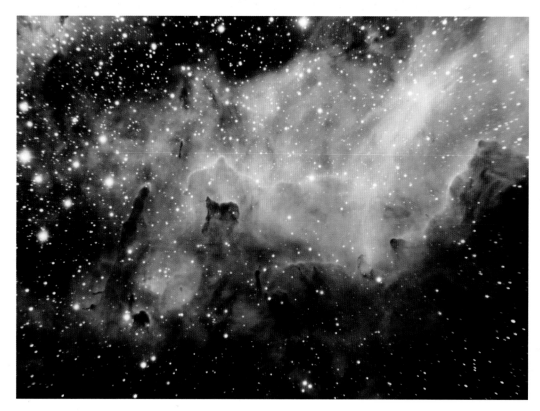

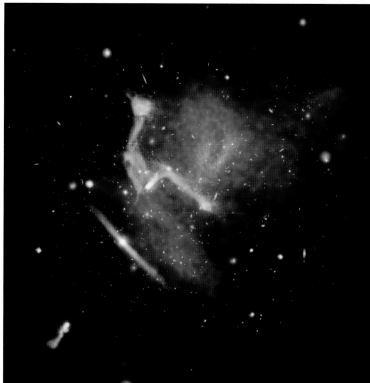

▲ The Omega Nebula (M17) as seen in the near infrared. Four broadband filters were used and chromatically ordered to be red, green, cyan, and blue. Credit: Gemini Observatory/AURA and T. A. Rector (University of Alaska Anchorage).

▶ **Galaxy clusters** are the largest objects in the universe held together by gravity, and sometimes two of these behemoths can run into each other. This image of colliding galaxy clusters (which collectively go by the name MACS J0717+3745) combines data from a wide range of the EM spectrum. The background is a color visible-light image from *Hubble*; the blue light near the center is from an X-ray image with *Chandra*, and the red objects are seen in a radio image from the VLA. The visible-light color image shows the galaxies in the cluster. The X-rays (blue) show the hot gas between the galaxies. And the radio (red) shows jets of high-speed material ejected from radio galaxies in the cluster. Because each energy shows different kinds of objects, the colors do not blend well. And without the presence of the visible-light image it would be difficult to understand what is seen in the radio and X-ray. Credit: Van Weeren et al.; Bill Saxton, NRAO/AUI/NSF; NASA.

Remember that red light is the lowest-energy visible light we can see. So we can adopt the simple rule that, regardless of the kind of light, the low-energy light is made red, the high-energy light is made blue (or violet), and everything else is a color in between. This is the same chromatic ordering we discussed for visible-light images. And it is the standard color set when broadband filters (or wavebands or energy cuts) of other types of light are used.

As with visible light, the situation becomes more complex when narrowband filters are used. In these cases, the color assignments are chosen based upon the science and the aesthetics. For example, if you wanted to convey that a part of the image was colder you might use a color scheme that causes that portion of the image to have a bluish color.

Often data from multiple parts of the EM spectrum are combined to form a single image. Sometimes a single color is assigned to each type of energy, for example, red to radio, green to visible light, and blue to X-ray. But it can make a more

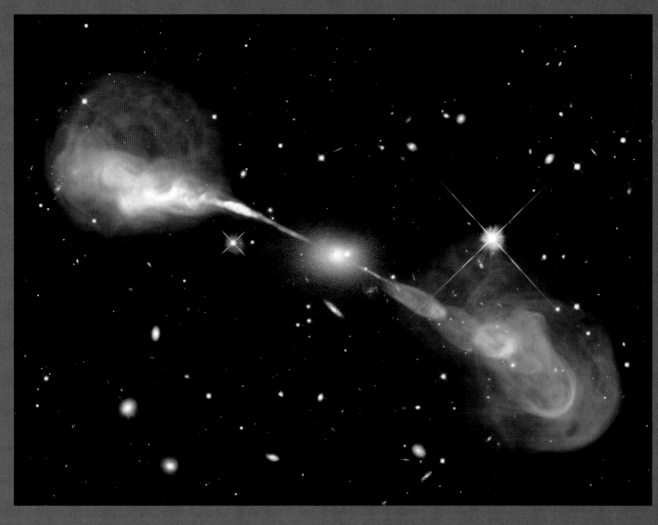

◄ A radio and visible-light image of the galaxy Hercules A. This image shows two jets of gas that are being shot out by a giant black hole located at the center of the galaxy. The energized particles in the jets slow down and collect in the "lobes" in the upper-left and lower-right corners (so called because they look somewhat like earlobes). In this image the starlight from the galaxy can only be seen in visible light, whereas the jets and lobes can only be seen in radio waves. Two visible-light and three radio broadband data sets were used to make this image. Credit: NASA, ESA, S. Baum and C. O'Dea (RIT), R. Perley and W. Cotton (NRAO/AUI/NSF), and the Hubble Heritage Team (STScI/AURA).

▼ The planetary nebula M2-9 as seen with narrowband filters in the infrared. Three versions of the image were created using different color assignments. In the end, the middle image was chosen because it was felt that the colors best conveyed that the interior of the nebula (orange) is warmer than the outer layers (blue). Credit: Gemini Observatory/AURA and T. A. Rector (University of Alaska Anchorage).

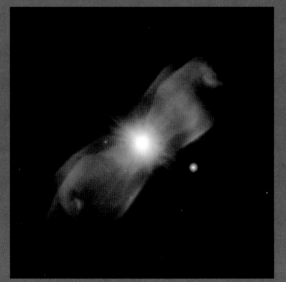
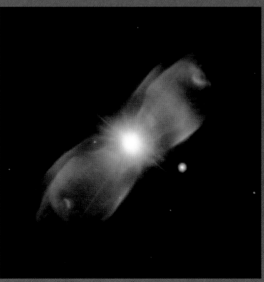
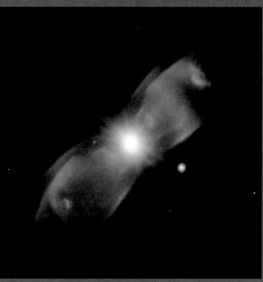

attractive and complete image to have color information from each kind of light; in other words, to use two or more filters, wavebands, or energy cuts within each type of light. One of the challenges when making such an image is that objects seen in one part of the spectrum may not be detected in the others. As a result, the objects in an image can look "overlaid" onto each other if the colors do not blend.

It is especially useful when making an image with radio or X-ray data to include visible light as well. That's because in general stars are not visible in the radio and X-ray. Stars (or at least points of light) are an important visual cue that tells you that you are looking at an astronomical image and not, say, an abstract piece of art. Including them in an image is helpful for nonexperts to intuitively interpret what they are seeing.

▲ Jupiter (top) and Saturn (bottom) look different when observed in near-infrared light. Notice that Jupiter's "great red spot" is white in the image on top. Saturn's moon Titan is also visible in the image on the bottom. Both credits: Gemini Observatory/AURA and T. A. Rector (University of Alaska Anchorage).

▲ The "Bullet cluster" was formed after the violent collision of two large clusters of galaxies. A visible light image shows the individual galaxies in the clusters in yellow. The pinkish red area near the center reveals X-rays produced by hot gas within the cluster. The blue areas are more complex: they show the location of dark matter. Dark matter, as the name implies, does not emit or absorb light. It cannot be seen directly by any telescope. But it can be found by carefully mapping how the cluster's gravity distorts the visible light from background galaxies. (This effect is called "gravitational lensing," which is explained by Einstein's theory of gravity known as general relativity.) Credit: X-ray: NASA/CXC/M. Markevitch et al.; Visible light: NASA/STScI; Magellan/ U. Arizona/D. Clowe et al.; Lensing Map: NASA/STScI; ESO WFI; Magellan/U. Arizona/D. Clowe et al.

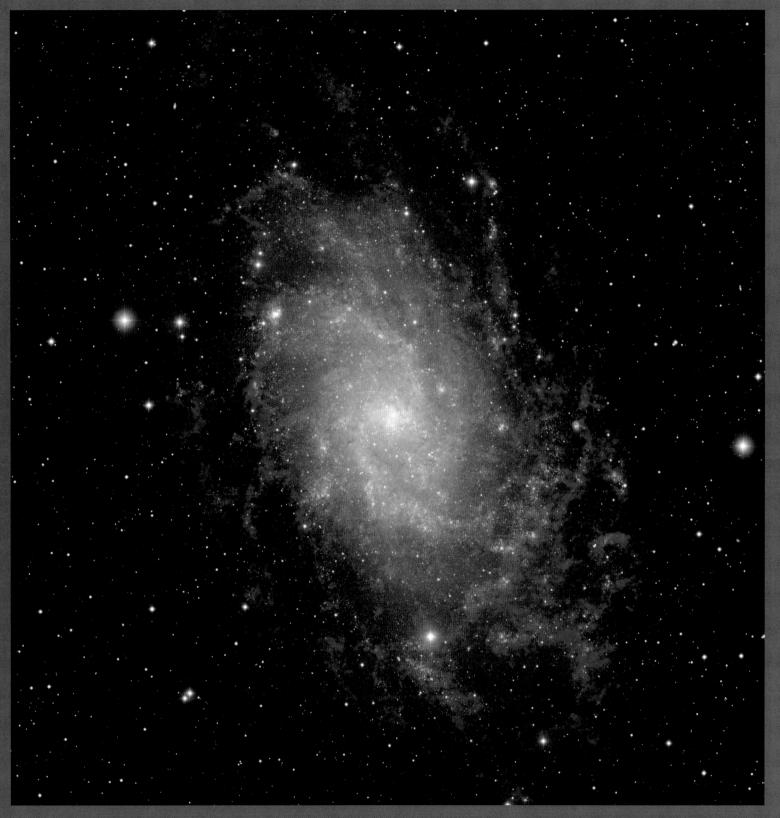

▲ This image of the nearby spiral galaxy M33 combines visible-light data from the KPNO 0.9-meter telescope with radio data from the VLA. The radio data show the distribution of cold hydrogen gas in the galaxy, gas that cannot be seen in visible light. We chose the color violet for the radio data because violet is a combination of blue and red. It therefore blends better with the red hydrogen gas shown in the visible-light image. Because violet contains blue, it correctly conveys that the gas seen in the radio data is colder. Credit: T. A. Rector (NRAO/AUI/NSF and NOAO/AURA/NSF), D. Thilker (NRAO/AUI/NSF), and R. Braun (WSRT/NFRA).

PHOTOSHOPPING THE UNIVERSE

What Do Astronomers Do? What Do Astronomers NOT Do?

We've discussed the ways that different telescopes collect data, capture them with their various cameras, and calibrate them for scientific use. There are, however, other important steps that we've only mentioned briefly in previous chapters. Astronomical data need to undergo a series of additional processing steps to turn them into color images.

This is where programs like Adobe Photoshop come in. Unfortunately, the word "photoshop" has become a verb to describe manipulating an image, and often in a negative or devious way. Nevertheless, Photoshop and other image editing software are used to make astronomical images—without any nefarious intentions or outcomes. Here, we'll look at how Photoshop is used—and, more important, how it is *not* used—when making astronomical **images.**

▶ This image of Barnard's Galaxy (NGC 6822), a nearby irregular galaxy, was created in Photoshop by combining five broadband filters and two narrowband filters: U (violet), B (blue), V (green), R (orange), I (red), hydrogen alpha (red), and oxygen [OIII] (blue). Credit: Local Group Survey Team and T. A. Rector (University of Alaska Anchorage).

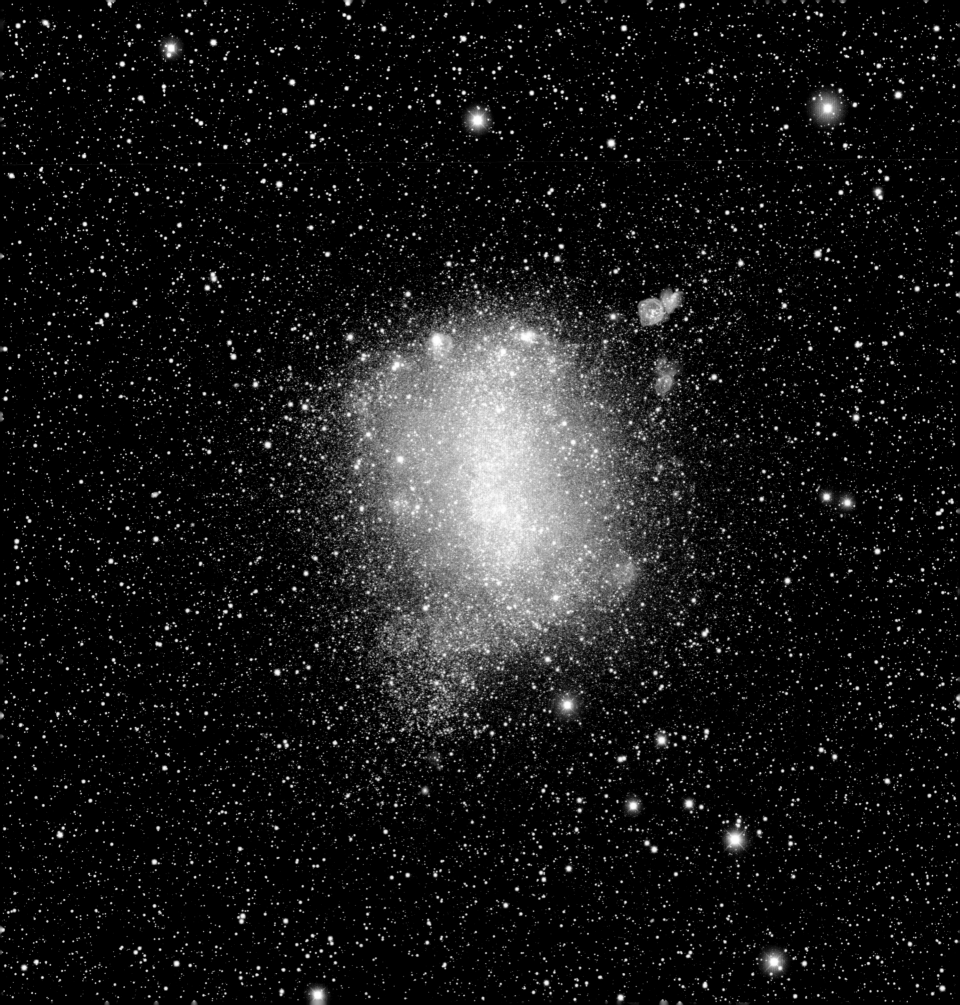

▲ Three examples of scaling the data from a *Hubble* image of 30 Doradus, a massive star-forming region. In the top image, the scaling function nicely shows the detail in the bright areas but little is visible in the dark areas. In the bottom image, the detail in the dark areas is more visible, but the bright areas are now too bright (said to be **saturated**.) The middle image offers a compromise that shows the detail in the bright and dark areas. Credit: Zolt Levay/ STScI/NASA.

FROM DATA TO AN IMAGE

After calibrating data from a telescope (or telescopes, as often data from more than one are used to make an image), the next step is converting the data into black-and-white images. (Remember that usually the telescope's camera can't see color—that part comes later.) Actually, we're converting them into what are called **grayscale** images. In these images, every pixel has a numerical value between zero and 255. Zero is pure black, while 255 is pure white. And everything in between is a shade of gray, with lower numbers being darker. It has to be a whole number, so it can be one of 256 values.[26]

When the data come off of the telescope, each pixel has a numeric value that indicates how much light hit that pixel. But the number can be *any* number, and it doesn't have to be a whole number.[27] It could be, for example, 17,575.34. So we must use a mathematical function to convert the actual value of the pixels into the range of 0 to 255. This is often referred to as the scaling, or **stretch**, function. For example, a simple function (known as a **linear stretch**) would be that everything below 4,000 will be set to zero (a pure black). Pixel values between 4,000 and 4,100 will be set to one (just slightly lighter than pure black). Those between 4,100 and 4,200 will be set to two, and so on. Other types of stretch functions are available. The astronomer picks the type of stretch based on the data and the structure in the image.

Why do we have to do this? The primary purpose of a telescope is to make scientific measurements. The numeric values of the pixels can be used, for example, to precisely measure the brightness of a star or the temperature of gas. Also, the **dynamic range** for a telescope is usually much greater than for your eyes. Dynamic range is defined as the ratio of the brightest object in an image to the faintest. It turns out that 256 shades of gray are usually sufficient for our eyes in differentiating brightness levels. But telescopes can do much better. Therefore, if we want to look at the data as an image, we need to translate what the telescope sees into something that works for our eyes.

Each chunk of data (the **data set** from each filter, energy range, or waveband) is converted into its own grayscale image with a scaling function. Often, astronomers choose a different scaling function for each data set to highlight the detail in the darker and brighter areas of each image. Once you have a grayscale image for each data set, the next step is to combine them to create the color image.

ENTER PHOTOSHOP

Many people think of Photoshop as an image manipulation program designed to change what a picture looks like—think of magazine covers showing celebrities who don't seem to age. But it does much more than that. In particular, it's useful for combining multiple grayscale images to create a single color image, as we looked at in chapter 3. To recap, each grayscale image is loaded as a separate **layer**. The layers are shifted, rotated, and/or rescaled so that the images are aligned. The brightness and contrast of each layer is separately fine tuned to better bring out the detail in the bright and dark areas. Next, each layer is then given a color, and then the layers are stacked together to produce the preliminary color image.

In fact, Photoshop lets astronomers combine as many layers as they wish, which allows for complex images to be made. This is especially useful when we create images with data from multiple telescopes.

A screenshot of Photoshop in action. Along the right side you can see several of the control panels, including the layers panel at the bottom. The layers are labeled with the colors assigned to them (red, orange, green, and blue). Credit: T. A. Rector.

▶ This image of the planetary nebula NGC 6302 (left) was created with data from six narrowband filters, each assigned a different color. The filter names and colors are shown in the lower-left corner. This image of the galaxy cluster MACS J0647+7015 (right) was made with data from thirteen different broadband filters, listed in the upper-left corner. But in this case the filters were grouped together and assigned to only blue, green, and red, in chromatic order. Left credit: NASA, ESA, and the Hubble SM4 ERO Team. Right credit: NASA, ESA, M. Postman and D. Coe (STScI), and the CLASH Team.

▼ This image of the center of our Galaxy was produced from nine data sets in total: Four from *Spitzer*, two from *Hubble*, and three from *Chandra*. X-rays from *Chandra* are blue and violet, near-infrared emission from *Hubble* is yellow, and *Spitzer*'s far-infrared data are red. Credit: NASA, ESA, CXC, SSC, and STScI.

NGC 6302
HST WFC3/UVIS

F673N [S II]
F658N [N II]
F656N Hα
F502N [O III]
F469N He II
F373N [O II]

1 light-year
0.31 parsec 52″.7

E
N

Galaxy Cluster MACS J0647+7015
Hubble Space Telescope

ACS/WFC ACS/WFC WFC3/IR
F435W F775W F140W
F475W F814W F160W
F555W F850W
F606W WFC3/IR
F625W F105W
 F110W
 F125W

1,000,000 light-years
307 kiloparsecs 47″

N
E

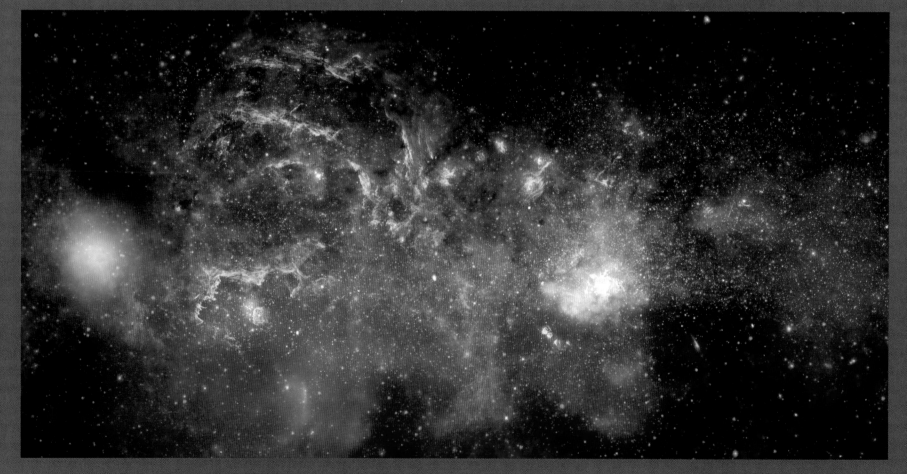

CLEANING THE IMAGE

Photoshop is also used to "clean" the image. What we mean by this is that it is used to remove defects from the image that are not real. The defects are false vestiges that appear in the image because of how the telescope and/or camera function. We remove them because they are distracting, and we want people to focus on the objects in the image that are real—not things we know are not real. It is similar to removing the red-eye effect from photographs taken with a flash. We know that people don't have red eyes; rather, the effect is a result of how the photo was taken. When we remove artifacts from an astronomical image, we do so carefully so as not to alter the actual structure. This process can be difficult and tedious. Often this step takes more time than the rest of the image-making process.

What are some of the defects that are removed? Sometimes **cosmic rays**,[28] asteroids, and satellite trails are not fully removed during the data processing. They appear as specks or streaks in the image. These are easy to see, and usually easy to remove, because each defect appears in only one layer. This makes it possible to remove the defect from a single layer without affecting the others.

A common problem found in visible-light images is called a **charge bleed**. Since each pixel is collecting electricity created by the light that hits it, we can think of every individual pixel as an electricity bucket. If a bright object, such as a star, is observed for too long, the electricity it generates will "spill out" of the pixels near the center of the bright star and spread into adjacent pixels, usually the pixels in the same row or column. We can use Photoshop to remove these bleed defects. If we don't, it would look like laser beams are shooting out of the bright stars, which is definitely not happening.

Another instrumental effect, called **diffraction spikes**, is noticeable in bright stars. These diffraction spikes are not caused by the camera, but by the telescope itself. As light enters into the telescope, it is slightly spread out (or more precisely, **diffracted**) by the structure that holds up the secondary mirror at the top of the telescope. The light spreads out along the structure, causing bright stars to appear to have lines sticking out of them.

While they resemble charge bleeds, the diffraction spikes are a totally different effect. Unlike charge bleeds, the diffraction spikes are usually not removed from the final image. Since the telescope itself produces the spikes (and not the digital camera), these artifacts have been present in astronomical images for as long as such images have been made. They can therefore help function as a visual cue that tells your brain you're looking at an astronomical image. In fact, they serve this purpose so well that artists sometimes put diffraction spikes in their drawings or paintings of bright stars.

▲ An "uncleaned" image shows several defects commonly seen in visible-light images. The horizontal and vertical lines along the top of the image are from defects in the original grayscale images. The color of each line indicates from which filter it came (for example, the red line is from the hydrogen alpha image). The lines are slightly offset because the telescope wasn't in the exact same position when each filter was used. You'll also notice throughout the image several small but bright pixels that are "cosmic ray" events that were not properly removed during data processing. These are also unique to each filter. You can also see a horizontal charge bleed from the bright star. Credit: Local Group Survey Team and T. A. Rector (University of Alaska Anchorage).

▲ The "Christmas Tree cluster," or NGC 2264, is a bright star-forming region. The image on the left shows the nebula before cosmetic defects from the camera were removed. And the version on the right shows the image after it has been cleaned. Notice that the charge bleeds from the bright stars have been removed, but not the diffraction spikes. Other cosmetic defects have been removed as well. Can you spot them? Credit: T. A. Rector and B. A. Wolpa (NOAO/AURA/NSF).

Another defect that astronomers occasionally have to remove is a noticeable ring around very bright stars. If a star's light is intense enough, it can reflect off of optics inside the telescope and camera and produce a noticeable halo around the star. These are known as **internal reflections** and are distracting. Astronomers find these reflections particularly challenging to remove because they are often large and can overlap structures in the image that we don't want to change. They can also have complex shapes that vary depending on where the star is in the image.

Many astronomical images are created when several smaller images are combined. And this can create another need for editing. These multipanel images are made when the telescope looks at one portion of the sky (called a **pointing**) and then moves to look at another, adjacent portion. Or there can be more than one

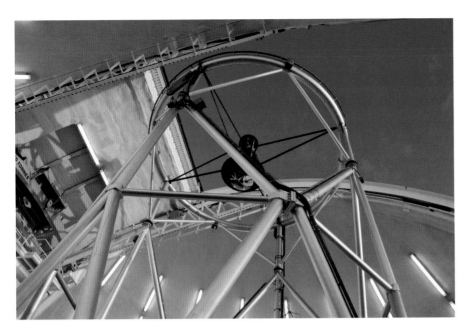

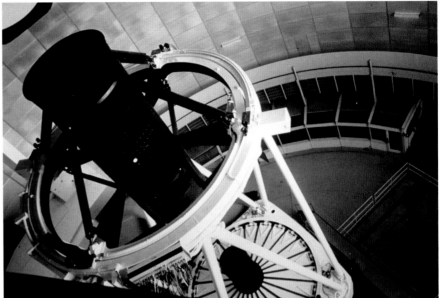

detector inside the instrument. For example, the KPNO Mosaic camera has eight detectors, so each pointing produces eight images. Variations in the sensitivity of each detector are removed when the data are calibrated, but not perfectly. This can leave seams along the locations where the images overlap, or gaps if the images don't align properly along the edges. The brightness of each image can be fine-tuned in Photoshop so the seams or gaps are virtually undetectable. Small gaps can be filled in with additional data from other observations and then blended in with the rest of the image.

WHAT *NOT* TO DO

What's just as important a question in processing images is what do we *not* do with Photoshop? Our goal with each image is to show how a telescope (or telescopes) sees a celestial object. And, in many cases, we also want to illustrate a new scientific result. We assign colors to each filter in a way that aims to be pleasing to the viewer and intuitive to understand, adding to the information the image conveys. For example, it can be distracting to make images of purple or green stars because stars are normally red, orange, yellow, white, or blue (as seen through visible-light broadband filters). Likewise, unusual colors for recognizable objects, such as spiral galaxies, can be distracting. For less familiar images, such as an X-ray image of the

▲ The secondary mirrors for the Gemini North (left) and KPNO 4-meter (right) are housed inside the cylinders seen here atop the telescopes. The secondary mirror is responsible for redirecting the light back through the hole in the center of the primary mirror. In the Gemini image the mirror can be seen at the bottom of the cylinder. The four struts that hold the cylinder in place, not the cylinder itself, are what produce the diffraction spikes visible in the images of bright stars. The struts on the 4-meter are thicker so they produce larger diffraction spikes compared to Gemini. Left credit: Gemini Observatory/AURA. Right credit: NOAO/AURA/NSF.

▲ This painting shows an artist's use of diffraction spikes. Notice how they are painted on all of the bright stars in the image. It's a visual cue that lets the viewers know that they are looking at an illustration of outer space. Credit: P. Marenfeld.

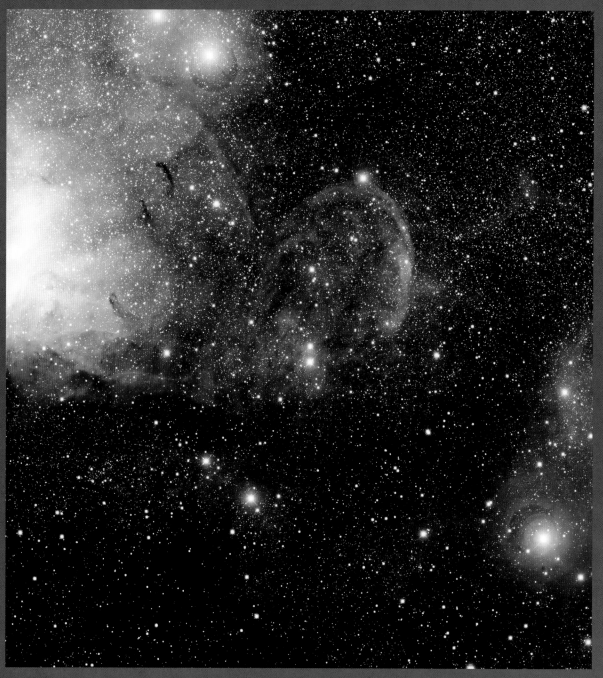

▲ ▶ This is an image of the area around Cygnus X-1, a binary star system where a black hole is in orbit around a massive star. The two brightest stars in the uncleaned image (near the top and right edges of the image above) have halos that are produced by internal reflections within the telescope's optics. The halos have the shape of the primary mirror with the secondary mirror cylinder (and its struts) blocking some of the light. The halo therefore has an "inverted diffraction spike" appearance. In the image on the right the brightness of the halos is reduced so that they don't overwhelm the rest of the image. The charge bleeds have been removed as well. By removing these defects, we can better direct the viewer's attention to the most interesting part of the image: the distinctive "umbrella" shape near the center, which is from a jet of gas ejected by the black hole. Credit: T. A. Rector (University of Alaska Anchorage) and H. Schweiker (WIYN and NOAO/AURA/NSF).

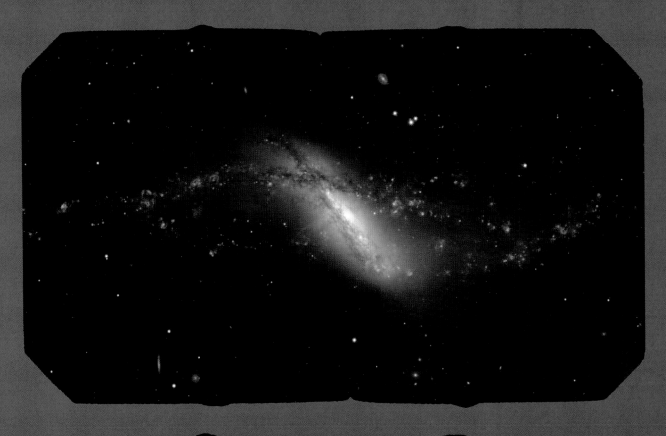

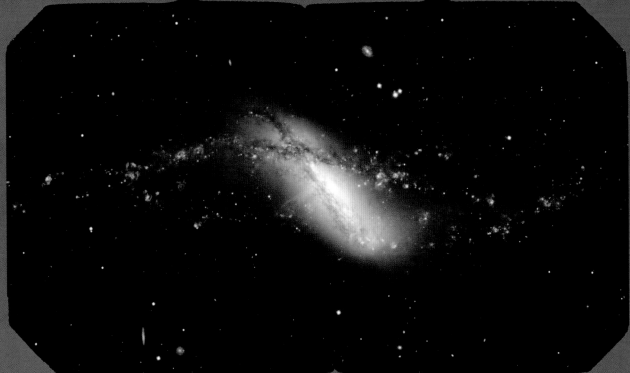

◄ This grayscale image of the galaxy NGC 660 was created with two images taken through the hydrogen alpha filter with the Gemini North telescope. When initially combined, subtle differences in the brightness levels in the two images were visible near the center where they overlap (top). We rescaled the images in Photoshop so that they blend seamlessly (bottom). The images with the other filters were rescaled in the same way before the color composite image was made. Credit: Gemini Observatory/AURA and T. A. Rector (University of Alaska Anchorage).

For these two images of Saturn, produced from data obtained during Voyager 2's fly-by of the planet in 1981, the colors were chosen to enhance the details visible in the body of Saturn (top) as well as its rings (bottom). These pictures were somewhat disconcerting to many nonscientists because Saturn looked considerably different when compared to images they had previously seen. While informative for scientists, the colors can distract from the beauty and familiarity of Saturn. Credit: NASA/JPL-Caltech.

area around a black hole, there is more flexibility in the colors used. Undoubtedly, unusual colors like bright greens can help attract attention to an image. But garish colors can also distract from the overall point. Strong colors can also affect the longevity of the image; that is, you might enjoy an image but is it something that you would want to print and hang on your wall? Will it look as good ten years from now as it does today? (We'll talk in depth about what makes for a good image in the next chapter.)

Another item on the "don't" list includes modifying the actual structure in the image. We don't add or remove stars. We don't enlarge or slim down galaxies by manipulating their proportions or aspect ratio. As tempting as it may be, filter effects that modify the structure are generally not used. (The hashtag #nofilter is popular for a reason for selfies, but perhaps takes on new meaning for astronomical images.) Sometimes an image might be slightly sharpened to counter the blurring effects of stacking multiple images together. But that's pretty much the only such manipulation that is used.

Adjustments to color, brightness, or contrast are done to the entire image; for example, we don't brighten one part of the image so it stands out more. If one star looks brighter than another, that's because it *really is* brighter. As we'll discuss in the next chapter, we might rotate or crop an image to highlight key details. We don't, however, deliberately crop to remove or hide a particular object so as to change the scientific narrative.

An essential part of the scientific process is to be explicit when describing how an experiment is done or how a conclusion is reached. That way other scientists can recreate your experiment and analysis to see if they achieve similar results. Since these images are often used to illustrate science, we adhere to the same principle when describing them. Most astronomical images from professional observatories include details about the observations used to make an image. This information details the telescopes, cameras, and filters used, number and lengths of the exposures, dates of observations, size and rotation of the image, the location of the object, and the people involved in completing the observations, processing the data, and making the image.

Using a specially developed image metadata standard, called Astronomical Visualization Metadata (AVM), this information can also be embedded into the image. AVM is an easy way to learn about the details of an image. It also allows you to do cool things, such as show where the object is located in the sky using software such as Microsoft's WorldWide Telescope or Google Sky. For many observatories, including all of NASA's telescopes, you can also download the raw data from their archives. (See the resources section for a listing of example repositories.)

We've described the principles we follow to produce an image that is scientifically valid. By that we mean the image shows real objects in space as seen by our telescopes. But there is also a subjective, creative element as well. While many scientists are reluctant to think of themselves as artists, there is nonetheless some artistry involved in making an appealing astronomical image. In the next chapter we'll explore what makes for good, bad, and ugly images.

▲ Color can be a matter of preference. Astronomers can use different color combinations, especially for non-visible-light data, to try to get across the point of the scientific story. These two images show different color schemes for the pulsar B1509-58 and its surrounding area. On the left, *Chandra* X-rays are in gold and Wide-field Infrared Survey Explorer (WISE) infrared light are in red and blue. On the right, X-rays are in purple with infrared in red, green, and blue, which is in chromatic order. To the authors, the version on the left is more pleasing and complementary between the two different types of data. But to others, the version on the right might be more eye-catching. Credit: X-ray: NASA/CXC/SAO; infrared: NASA/JPL-Caltech.

THE AESTHETICS OF ASTROPHYSICS

Principles of Composition Applied to the Universe

▶ This image of the nebula NGC 1788 uses several artistic principles of composition to make it more vivid. It also contains visual cues described in chapter 7. For example, look at the four bright blue stars in the lower-center of the image. We perceive the two bottom stars as being closer because they are brighter. Because they are the same color, our mind assumes that these stars are the same intrinsic brightness or size. So the ones that are bigger or brighter appear to be closer, although this is not necessarily the case. Credit: T. A. Rector (University of Alaska Anchorage), H. Schweiker (WIYN and NOAO/AURA/NSF), and S. Pakzad (NOAO/AURA/NSF).

Some astronomical images look absolutely stunning, while others don't seem to have the same impact. What makes for a beautiful image? Perhaps not surprisingly, many of the principles that make a piece of art appealing also apply here. But unlike artists, astronomers are constrained in what they can do. Still, astronomers can use insights from the art world to help them understand what makes for a good image.

THE SHARPNESS OF AN IMAGE

Hubble was put into space in part to get above the blurring effects of the Earth's atmosphere. Perched in an orbit about 350 miles above our planet's surface, *Hubble* can see detail in cosmic objects five to ten times better than visible-light telescopes on the ground. (Although, as we discussed in chapter 2, with adaptive optics some ground-based telescopes can do as well as *Hubble* in the near infrared.) It is natural to assume then that their sharpness is the reason why *Hubble*

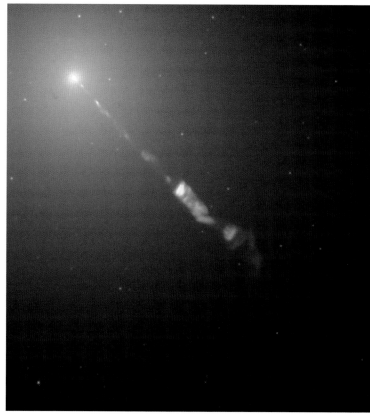

▲ The picture on the left is a pseudocolor image of the core of the quasar B2 1156+295, as seen by the VLBA and another radio telescope, the Highly Advanced Laboratory for Communications and Astronomy (*HALCA*) satellite. This is, in fact, one of the highest-resolution images ever made. On the right is a *Hubble* image of a different quasar, embedded in the giant elliptical galaxy M87. The VLBA image is of such high resolution that the entire image inside the yellow box on the left would fit inside a single pixel of the *Hubble* image on the right. Left credit: Image courtesy of NRAO/AUI. Right credit: NASA and the Hubble Heritage Team (STScI/ AURA).

images look so good. Sharpness is an important element of a good image, but it is just one of many.

There are actually other telescopes that can see detail in higher resolution than *Hubble*. For example, the Very Long Baseline Array (VLBA) radio telescope can see detail up to *fifty* times better than *Hubble*. Imagine you are in Los Angeles and you have a friend in New York City who is holding up a dime. If your eyes had the same ability to see detail as the VLBA, you would be able to read the words "e pluribus unum" written on the back of the dime.

If the VLBA can see detail so much better, then why doesn't it produce images that are just as spectacular as *Hubble,* if not more? One reason is that the VLBA has an extremely small field of view. In other words, you may be able to read the back of the dime, but you wouldn't see anything beyond the dime itself. When a VLBA image is enlarged to the size of a normal piece of paper, the details don't look as sharp. Despite being one of the highest-resolution telescopes in the world, its images tend to look like blobs in space. Astronomers who use this telescope sometimes jokingly call their work "blobology."

What's more important is the **apparent sharpness** of the image, which depends on the resolution as well as the size of the field of view. In order for an image to look sharp, a fine resolution over a wide field is required. The VLBA has the resolution but not the field of view. Surprisingly, some images from ground-based visible-light telescopes with lower resolution can appear to be as sharp or sharper than those from *Hubble* simply because they cover a much wider field of view.

COLOR CONTRASTS

So far we've established that resolution and field of view are two important factors in making an image aesthetically pleasing, but other factors are important as well. Another key reason images from *Hubble* and other telescopes are so popular is because of their use of color.

Color is such a part of our daily lives that we often forget how much of an impact it has. We've already talked about how our brains perceive color. But there's another important factor to consider. When we look at light and color we see them relatively. That is, we don't see light and dark. We see lighter and darker. Our perception of an object's brightness is relative to what's near it. Similarly, how we see a color is affected by the other colors surrounding it.

Artists have known this for many years. In 1961 the Swiss painter Johannes Itten formalized the idea of seven distinct **color contrasts** that influence how we see an image. The use of these contrasts helps the viewer interpret what he or she is seeing. And it can make a more interesting, or beautiful, image.

What are the color contrasts? Let's *briefly* review them. The simplest contrast is that of light versus dark. The presence of bright areas can enhance the appearance

◀ A classic optical illusion that illustrates how we see that a color is affected by other colors. The illusion consists of two squares of different color with a smaller square inset inside each one. The two inset squares are the exact same color. The one on the left appears to be darker because it is surrounded by a lighter color. And the square on the right appears lighter because it is surrounded by a darker color. Credit: T. A. Rector (University of Alaska Anchorage).

▲▲ The **color wheel**. Colors that are opposite of each other are **complementary colors**, for example, red and cyan. The presence of one or more pairs of complementary colors in an image will create a contrast. Credit: J. Arthur, H. Hatt.

▲ Stare at the yellow square in the bottom figure above. Eventually you will notice the gray square in the middle appear to be slightly bluish because blue is the complementary color of yellow. This is the simultaneous contrast. It is a physiological effect; the gray square is not actually tinted blue. Credit: T. A. Rector (University of Alaska Anchorage).

of darkness in fainter areas of an image, and vice versa. There is also the less familiar contrast of hue. This occurs when two or more **hues** are present in an image. There are six distinct hues: red, orange, yellow, green, blue, and violet. (Colors that are based upon these six are not considered distinct. For example, pink is not a separate hue because it is simply a lighter version of red.) There will be a contrast of hue if you have, say, red and orange in an image together.

There is also the contrast of saturation. **Saturation** is a measure of the purity of a color of a particular brightness—a vivid red that contains no cyan (a color created by mixing blue and green) is purely saturated. The contrast of saturation refers to differences between colors of the same hues that have different saturation. So a pure red would contrast with a red that is diluted with some green and blue.

There are also contrasts that are based upon specific pairs, or groups, of colors. Take, for instance, the contrast between **warm colors** (for example, red, yellow, and orange) and **cool colors** (for example, blue and green). As you might guess, warm colors are labeled as such because they are associated with hot objects such as fire and the Sun. And cool colors are associated with colder objects, such as plants and ice. As we mentioned in chapter 7, most people tend to interpret cool colors as being background to warm colors. This contrast also helps give a feeling of depth within an image. Next, the complementary contrast happens when colors on the opposite side of the color wheel are in an image. For example, cyan is a complementary color to red.

The simultaneous contrast is related to the complementary contrast. When we see a particular color for a long period of time, the cones inside our eyes begin to fatigue and our brain will think that the complementary color is present. The simultaneous contrast is therefore the effect of seeing a particular color and its complementary color at the same time.

Finally, there is the contrast of **extension**. Because of the eye's varying sensitivity to different colors, some colors are more intense than others. Yellow and orange are the most intense. Red and green are intermediate. And blue and violet are the least. These colors should therefore appear in an image in appropriate proportions so that the more intense colors don't overpower the weaker ones.

Itten's seven color contrasts can contribute to creating an eye-catching image. If ignored or used incorrectly, these contrasts can make an image that is unattractive to many people. Astronomers who create a "wow" image either work hard on using these contrasts correctly—or sometimes are just lucky!

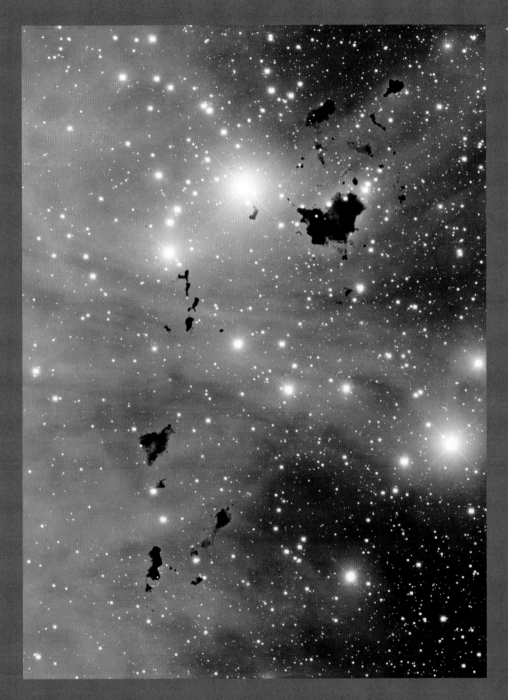

◄ This image of IC 2944, informally known as Thackeray's Globules, is an example of the light/dark contrast. The dark globules stand in stark contrast to the bright nebulosity and stars nearby. Yellow is a bright color to which our eyes are more sensitive. In this image the hydrogen alpha filter was deliberately made yellow to maximize this contrast. Credit: T. A. Rector (University of Alaska Anchorage) and N. S. van der Bliek (NOAO/AURA/NSF).

◀ The M16 Eagle Nebula, the object that contains *Hubble*'s iconic "Pillars of Creation," is shown here in images taken by the KPNO 4-meter (left) and the 0.9-meter (right) telescopes. The image on the left was taken in 1973 with broadband filters and photographic plates. Despite being of smaller size, the 0.9-meter telescope was able to capture more detail in the fainter regions because it used the Mosaic electronic camera to observe this nebula in 2000. Both images have about the same resolution, but the image on the right shows much more detail. Just as important, it uses narrowband filters and the *Hubble* palette. Its many colors make it stand out in comparison to the monochromatic red. This is an example of the contrast of hue. Left credit: Bill Schoening/NOAO/AURA/NSF. Right credit: T. A. Rector (University of Alaska Anchorage) and B. A. Wolpa (NRAO/AUI/NSF).

▲ In this image of the nebula Monoceros R2, the red nebula in the upper-left corner has a greater saturation than the structure on the right side of the image. The nebula on the right is less saturated because it contains cyan, the complementary color to red. This is the contrast of saturation. Remarkably, the presence of the nebula on the right causes the nebula in the upper left to appear to be more vivid. The light/dark contrast is also present in the upper left because the deep red gas contains dark dust lanes. However this contrast is less powerful than that for IC 2944 because red is a less intense color than yellow. Credit: T. A. Rector (University of Alaska Anchorage) and N. S. van der Bliek (NOAO/AURA/NSF).

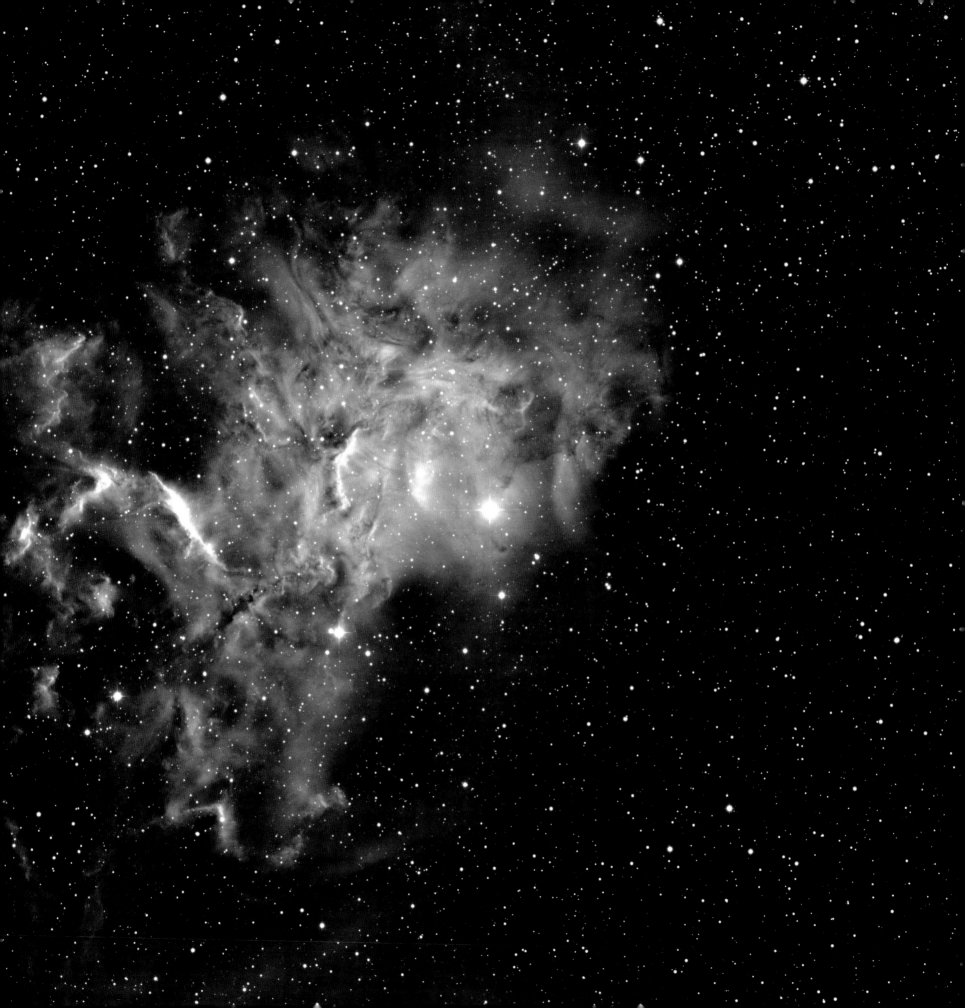

THE COMPOSITION OF AN IMAGE

In painting, drawing, and photography, composition is the practice of arranging elements within the picture so that it looks better. In astronomy, we don't have that same flexibility. First, we cannot control what is in the field of view or where objects are located. We can't, for example, ask stars to politely move out of the way or for galaxies to move closer together. Neither can we control our point of view. Even though telescopes in space orbit the Earth, the change in their position is so miniscule that it has virtually no impact on the distant cosmic objects we study. This means that, unlike taking a picture here on Earth, we can't change what's in the background or foreground by moving to a different location.

Despite these limitations, we can use some principles of artistic design to help us make a better astronomical image. The first technique we can use is to carefully crop and orient (rotate) the image. As with many things in astronomy, many practices are done simply because that is how they have always been done. Take the orientation. Traditionally astronomical images have been shown with a map-like orientation with the northern part of the image at the top. The images were also usually made with as wide a field as possible (that is, basically no cropping) to show all the detail that the image contained.

By accident, *Hubble* revolutionized both of these practices. Let's start with cropping. Because it was built to take high-resolution images, the cameras originally onboard *Hubble* had a tiny field of view compared to telescopes on the ground. For comparison, the WFPC2 camera that was onboard *Hubble* from 1993 to 2009 had a field of view that was 990 times *smaller* than the Mosaic camera on the KPNO 0.9-meter telescope. Think of *Hubble* as a supertelephoto lens—it can see fine detail but often at the expense of seeing the entire object. As a result, many of its images are tightly cropped around the object the scientist wishes to study.

While it was unintentional with *Hubble*, tight cropping is a powerful tool that photographers have used for years. It can create the illusion that an object is enormous—so big that the eye cannot capture it all. This is especially true in astronomical imaging, where the intrinsic size of an object is unclear because the object is unfamiliar. (As a contrasting example, the true size of a person's head is clear in a photograph no matter how it is cropped because it is a familiar object. In other words, we all know how big a head usually is.)

Also, when we crop so tightly that not all of the object is in the image (that is, it extends beyond the borders of the picture), it gives the sense that there is more to see. This frequently gives viewers the impression that *Hubble* is showing only a tantalizing slice of a larger celestial landscape. Tight cropping can also give the sense that the object is nearby (which may be the origin of the misconception that

◀ This image of the Flaming Star Nebula (also called IC 405) contains the contrast of complementary colors as well as the contrast of extension. The violet and yellow are close to complementary colors. Because yellow is much more intense than violet, it occupies less of the image. The two colors appear to be in balance with each other. This is because there are roughly three times as many violet pixels as yellow. Credit: T. A. Rector (University of Alaska Anchorage) and B. A. Wolpa (NRAO/AUI/NSF).

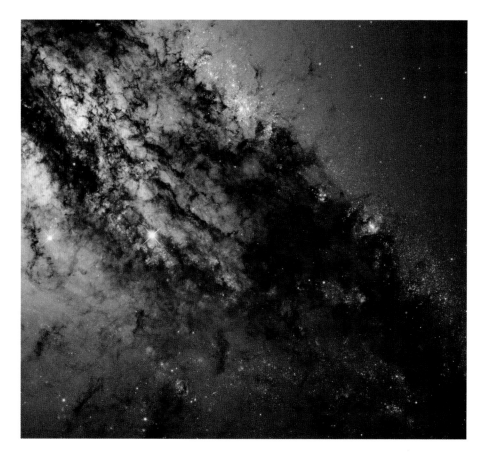

▲ The relatively small field of view of *Hubble* means that it is often unable to take an image of the entire object. In photography parlance, this gives the effect of a **tight cropping**, which makes the object appear to be close by as well as big. In this image of the galaxy Centaurus A (left), only a region near the center of the galaxy is visible and gives the sensation that you're in a spacecraft flying close to the galaxy. The image on the right of IC 2944 was taken with the WFPC2 camera on *Hubble*, which was unusual in that the field of view was not square. The black "upside-down L" in the upper-left corner of this image is an area that the camera could not see. Here it seems to help in that it gives a tighter cropping, enhancing the visual effect. Left credit: NASA and the Hubble Heritage Team (STScI/AURA). Right credit: NASA, ESA, and the Hubble Heritage Team (STScI/AURA)–ESA/Hubble Collaboration.

Hubble flies out to be closer to the objects it observes). Finally, a tight cropping can also remove other objects in the field that would be distracting. It helps focus the viewer's attention on what is most interesting.

In the decades since *Hubble* was launched, astronomical images from other observatories are now often cropped to draw your attention to the object or areas that are most interesting, scientifically or aesthetically, by using rules of composition. For example, like painters and photographers, we often use a basic principle of composition called the **rule of thirds**. Imagine that an image is divided up into a 3 x 3 grid with nine areas of equal size. Using the rule of thirds, we crop the image so that interesting objects or structure appear at or near the four intersection points of the grid. This creates a more dynamic and interesting image than if a single object sits at the center. If, by necessity, the object appears near the center, another composition principle states that it helps to make the image more viewable if the image is cropped such that the object is located just above the center.

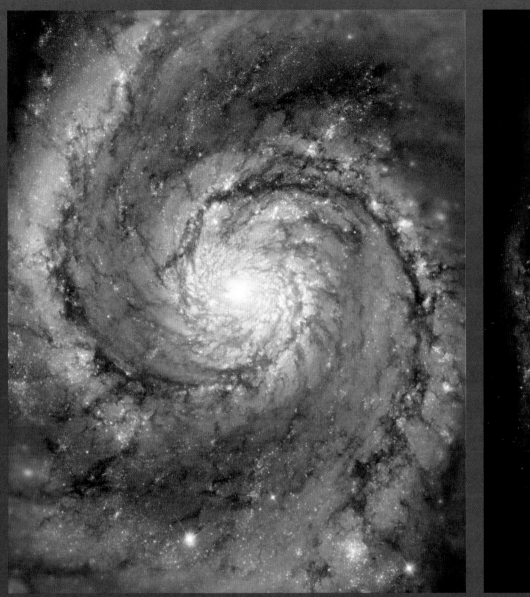

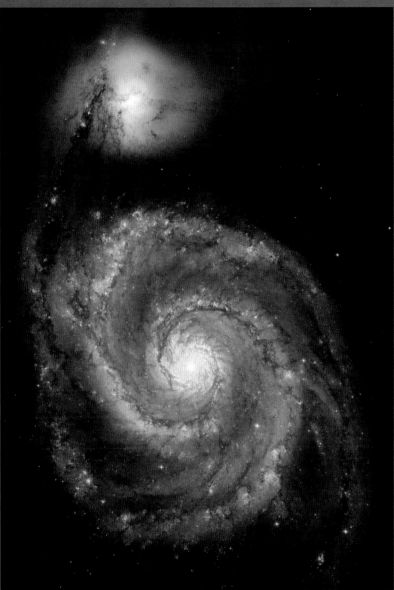

▲ These *Hubble* images of M51, the Whirlpool Galaxy, were taken with different cameras. The one on the left was taken with the WFPC2 camera, whereas the one on the right was made with the newer and more advanced ACS (Advanced Camera for Surveys). The image on the right is of higher resolution and contains twenty-seven times more pixels. Yet when scaled to roughly the same size, the image on the left feels more intimate because of its tight cropping. Another interesting effect in the left image is that the corners are blurry compared to the center. That's because lower-resolution data from a ground-based telescope was used to help fill in parts of the image for which *Hubble* didn't have data. The blurriness creates the illusion of depth of field, an effect often seen in photographs on Earth, where the background or foreground is blurry because it is out of focus. Here the effect gives the illusion of depth, with the center appearing to be more distant. Left credit: NASA and the Hubble Heritage Team (STScI/AURA), N. Scoville (Caltech), and T. A. Rector (University of Alaska Anchorage/NOAO). Right credit: NASA, ESA, S. Beckwith (STScI), and the Hubble Heritage Team (STScI/AURA).

192

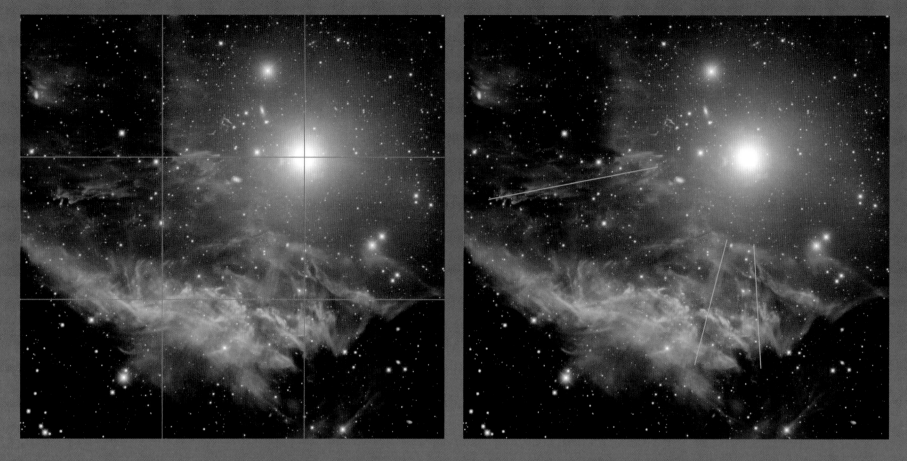

▲▶ This image of the planetary nebula NGC 3242 (opposite page) was cropped in accordance to the rule of thirds (as shown by the red grid overlaid onto the left image). By placing the bright, white core of the nebula at the upper-right intersection, it de-emphasizes it (when compared to if it were at the center of the image). Note that other interesting elements of the nebula are located at the other intersection points. Structure in the nebula naturally produces several lines. Wisps in the nebula (marked in green in the right image) point back toward the bright core, making that a convergence point. This creates an illusion of depth, with the orange nebulosity feeling closer than the core. The illusion is enhanced by the warm/cool contrast, where cool colors, such as the blue halo around the core, feel more distant. Finally, the image is cropped so that the entire nebula is not seen. Structure in the nebula runs off of all the edges in the image, making the nebula feel large. Credit: T. A. Rector (University of Alaska Anchorage), H. Schweiker (WIYN and NOAO/AURA/NSF), L. Frattare, and Z. Levay (STScI).

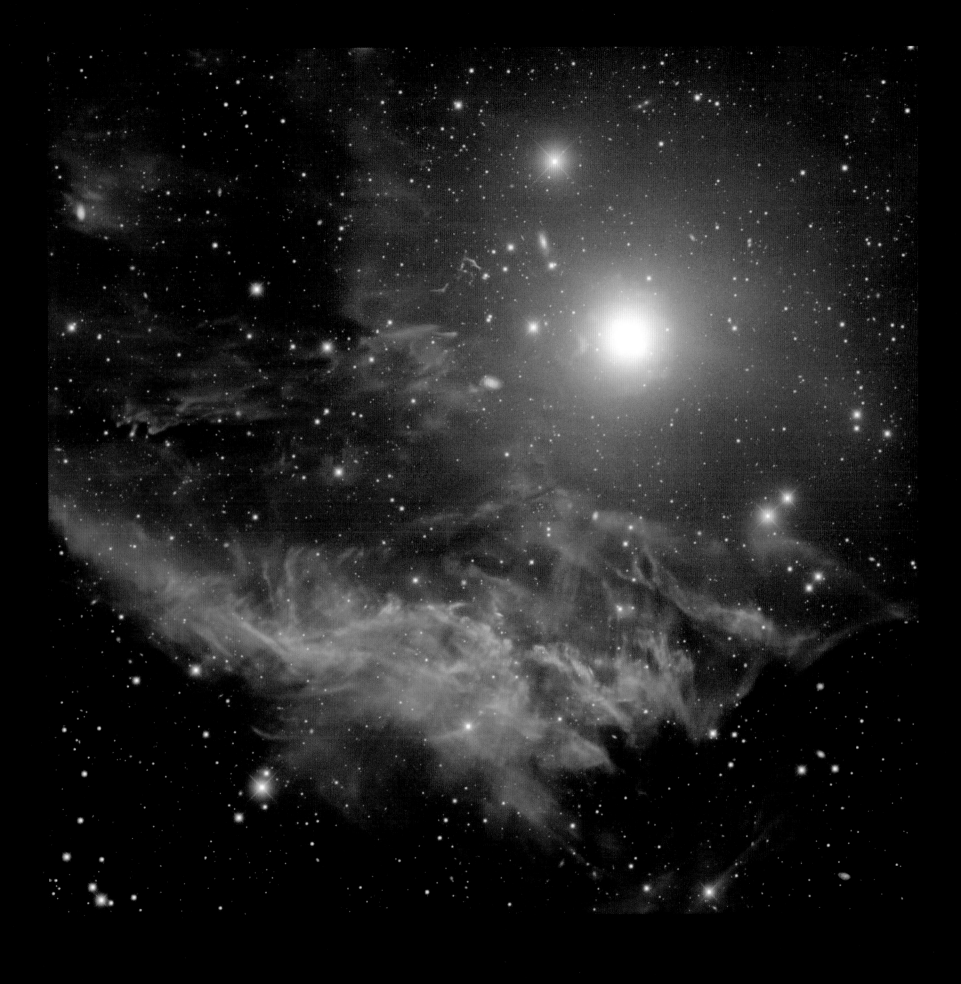

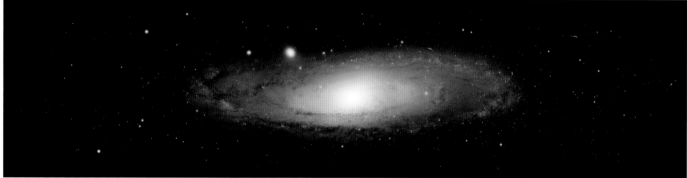

▲ Many astronomical images are created by combining more than one image (or "pointing") from the telescope. The top image shows a dramatic vista of the center of the Milky Way galaxy that was produced by combining eighty-eight separate pointings from *Chandra*. The bottom image shows a wide-field panorama of the nearby spiral galaxy M31 that was produced by combining fifty pointings of the KPNO 4-meter telescope. In both cases the edges of each pointing are visible in the final image, creating the effect of looking out of a window, perhaps from a spacecraft? Top credit: NASA/CXC/UMass/D. Wang et al. Bottom credit: Local Group Survey Team and T. A. Rector (University of Alaska Anchorage).

That is not to say we always want to tightly crop our images of space. A wide field can help give perspective about an object or put it in context. The Universe is mostly empty space after all! Artists know this as the concept of **negative space**, where largely empty space surrounds the object of interest. When used properly, it can emphasize an object and draw your attention to it. With visual cues such as size and color, smaller objects in the negative space can help create the feeling of depth within the image. For example, if a painting has two objects of similar appearance (for example, green triangles), the brain will interpret the smaller one to be farther away. Similarly, the distance to stars of similar color will be inferred by their apparent size in the image, although their "size" is actually a consequence of their brightness, where bright stars appear to be bigger (which is not necessarily the case.)

▶ This wide-field image of the galaxy NGC 660 uses negative space to put it in context. Cropping and rotating the image so the galaxy is in the upper half with a vertical orientation gives the sensation that it is hanging or floating in space. Moving it away from the center of the image de-emphasizes it and draws attention to other elements in the image. The stars of different color and size (brightness) appear to be glowing orbs that surround the galaxy (although in reality they are much closer). The small galaxies in the negative space also help convey depth, as they appear to be in the distant background (which is true in this case). Credit: T. A. Rector (University of Alaska Anchorage) and H. Schweiker (WIYN and NOAO/AURA/NSF).

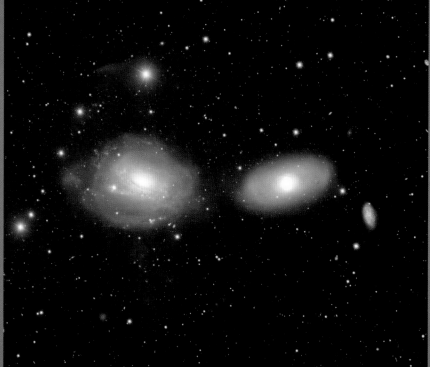

▲ NGC 3166 and NGC 3169 are two spiral galaxies trapped in a death spiral. Gravity is causing the two galaxies to be pulled into each other. Eventually these two galaxies will merge to form a single galaxy. As these two galaxies begin to merge, they are also starting to be pulled apart. The faint wisps surrounding NGC 3169 (the leftmost galaxy in the image) are its outer spiral arms being pulled off by NGC 3166. Rotating the image (left) so that the two galaxies form a diagonal line produces tension and conveys a sense of motion. This helps to communicate what is happening to the galaxies as they orbit around each other. If the image is rotated so the two galaxies lie along a horizontal line across the center (right) the galaxies feel motionless. Credit: T. A. Rector (University of Alaska Anchorage) and H. Schweiker (WIYN and NOAO/AURA/NSF).

▶ In this image of NGC 253, the "Silver Dollar" galaxy, the image is rotated so that the galaxy is horizontal, giving a sense of openness that invites the viewer to look at details in the galaxy. It also helps convey a sense of calmness that is appropriate for this galaxy, as it is relatively inactive. The image was also cropped to help create this sensation. It feels balanced because the center of the galaxy is slightly above the center of the image. Credit: T. A. Rector (University of Alaska Anchorage) and T. Abbott (NOAO/AURA/NSF).

Let's return to the other element of astronomical image composition that *Hubble* accidentally helped to pioneer: orientation. Unlike telescopes on the ground, *Hubble* is in space and can rotate its cameras any way the astronomer wants. This means that north is not always at the top like it is for many telescopes firmly rooted to terra firma. Usually the camera is rotated for scientific or technical reasons, but we can also rotate images for aesthetic purposes.[29]

For example, often there are perceived lines within an image. These lines may be real, such as striations within a nebula. Or they may be imagined, such as an imaginary line between two galaxies. Our mind uses these lines to understand the image in a host of ways: horizontal lines can create a sense of stability, tranquility, and spaciousness; vertical lines can give a perception of size and majesty; diagonal lines can cause a feeling of tension and motion; converging lines can create the illusion of depth—for example, train tracks converging in the distance—and, lastly, curved lines can give the sensation of softness as well as gentle movement.

▲ In contrast to NGC 253, this image of the spiral galaxy IC 5332 feels dynamic because the galaxy is significantly offset from center. Its position on the left gives a feeling of motion, as if it were flying by when the picture was taken. Credit: Gemini Observatory/AURA, T. A. Rector (University of Alaska Anchorage), and Isobelle Teljega (St Margaret's Anglican School).

STRUCTURE AND DETAIL

Needless to say, what's actually *in* the image is the most important factor. Beauty is in the eye of the beholder, of course, but there are some common characteristics that most good-looking images have. Oftentimes, attractive pictures contain something that appears familiar. In photography this could be visual elements, such as people or trees, that give the viewer a starting point for interpreting an image. For astronomical images, an important visual cue is the presence of stars. It "flips a switch" in our minds, telling us that it is astronomical, which can be especially useful if the image is in the news (or on a website) where astronomical images aren't necessarily expected. Images made with only radio or X-ray light often lack this visual cue, making interpretation more difficult.

It may seem contradictory, but having the presence of both familiar *and* unusual elements can help an image. The familiar helps to ground the viewing experience and give the elements context. The unfamiliar, on the other hand, gives you a reason to keep looking. It is as if your mind is saying, "I've seen this before, but never quite like *this!*"

▼ Is this object big (astronomical)? Or small (microscopic)? On the left is an image of the supernova remnant SN 1006 made only with X-rays. Because stars are not visible in the X-ray data, it is not clear that this is an astronomical image. It could conceivably be a jellyfish, for example. By adding a visible-light image from the same location in the sky we can produce an image that includes stars. This is an important visual cue that helps the viewer interpret the image. Credit: X-ray: NASA/CXC/Middlebury College/F. Winkler; Visible light: DSS.

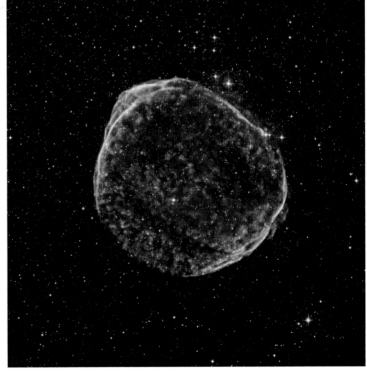

◄ Curved lines within the planetary nebula Sharpless 290 make the nebula feel soft. The blue interior also feels slightly farther away, giving the illusion of depth. Credit: T. A. Rector (University of Alaska Anchorage) and H. Schweiker (WIYN and NOAO/AURA/NSF).

▶ This image of the star-forming region IC 417 (opposite page) contains several visual cues that help us interpret the structure. The bright blue stars near the top center of the image energize and illuminate the red nebulosity. The nebula has several dark areas (for example, just to the left of center) that are in shadow. Our brains know how to interpret the shadows to infer the structure. For example, we can tell that the globules near the top of the image (just above the blue stars) are closer than the stars because their near sides are darker and brownish, meaning they are in shadow. If they were farther away, they would be fully illuminated by the stars. Credit: T. A. Rector (University of Alaska Anchorage) and H. Schweiker (WIYN and NOAO/AURA/NSF).

If you ask an astronomer what are the most beautiful objects to look at, they will probably respond with whatever they are currently studying. (Think of it as trying to ask someone to name his or her favorite child or grandchild—it's impossible to answer.) If we take a step back, however, it does seem like some types of astronomical objects tend to make more beautiful images than others.

Let's look at different classes of astronomical objects, and what makes some of them more interesting for nonexperts to behold. That's not to say every object of one class is more beautiful than the objects in another class. But some types of objects have an inherent advantage because they naturally contain many of the visual elements we've discussed.

Some of the most beautiful objects in space are star-forming regions. These are the giant clouds of gas in which new stars are being born. The most massive stars in the nebula, which are luminous and form first, produce ultraviolet light that energizes the gas surrounding them and causes the gas to glow. Since the gas near the stars can be hot, we can see a wide range of colors within it if we look at it through narrowband filters (as discussed in chapter 8). Or if we observe regions of star formation through broadband filters (see chapters 3 and 6), the blue colors from reflection can contrast with the red from emission. The energy from these stars can also transform the gas, blowing away less dense areas and sculpting more dense regions. As a result, the structure inside the nebula can be diverse and complex. The combination of intricate structures and the range of colors can make star-forming regions truly stunning.

There's one additional important factor that aids the aesthetic appeal of nebulae: the stars externally light them. That's also true of most objects we look at here on Earth. Most terrestrial objects don't produce their own light, but instead are lit by the Sun, light bulbs, or some other source. This produces visual effects, such as shadows, that your mind uses to perceive structure and depth. In a star formation region, the stars illuminate the clouds of gas and dust. This can give these otherworldly objects the same visual cues of shadows and overlapping features that we're accustomed to here on Earth. We can use this to interpret depth and detail within the nebula.

Planetary nebulae—the end stages of some dying stars—are also often beautiful objects. Like star-forming regions they too tend to have strong variations in temperature, making beautiful colors when viewed through narrowband filters. They also have an external light source—the white dwarf star at the center of the nebula. Planetary nebulae can have simple to highly complex structures. In addition, they can be highly symmetric, and in many cases this can add to their appeal. Planetary nebulae tend to be quite small, astronomically speaking, which has made them a popular target of *Hubble*.

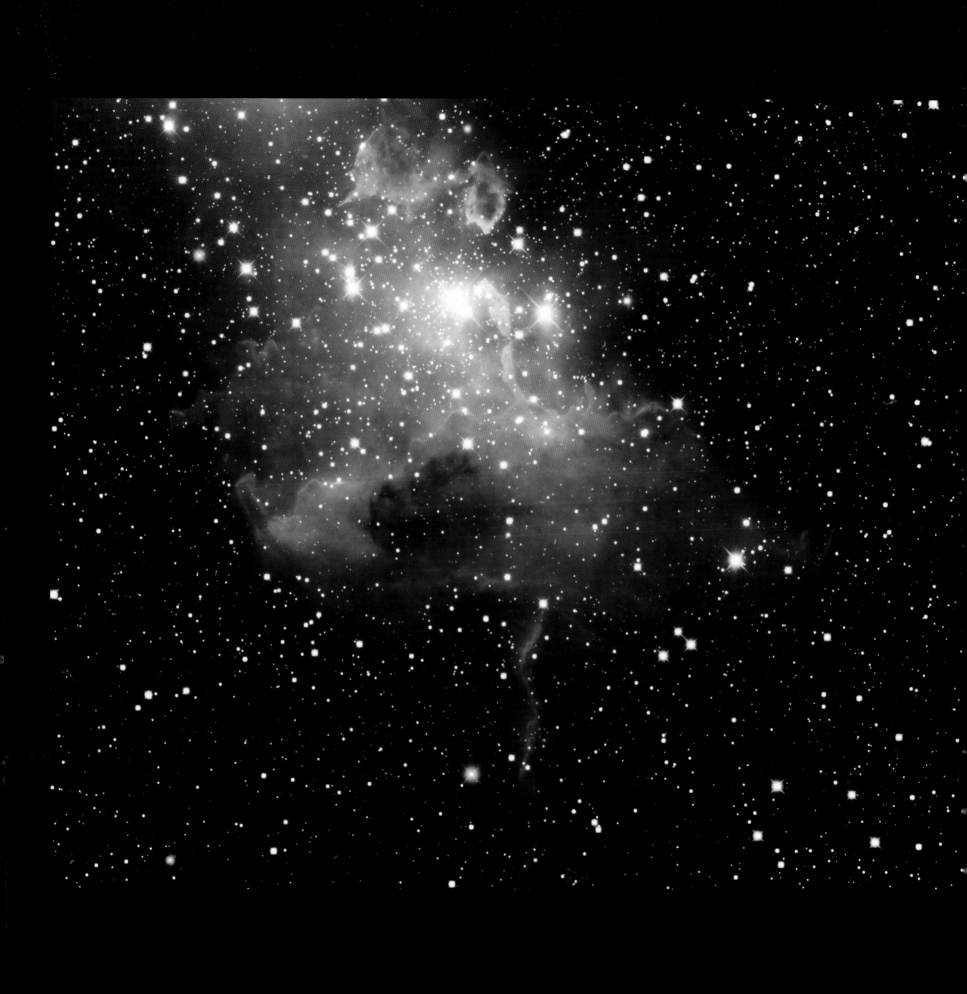

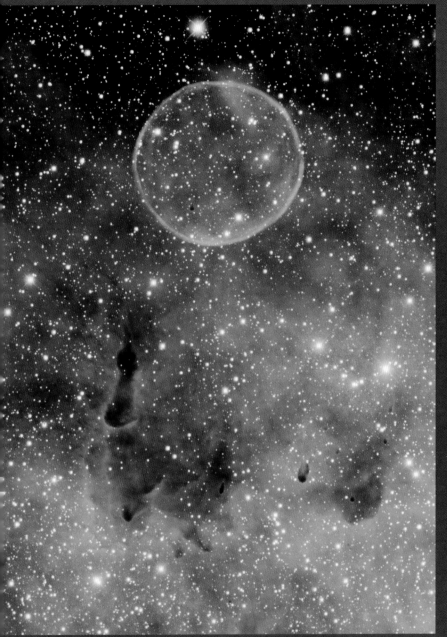

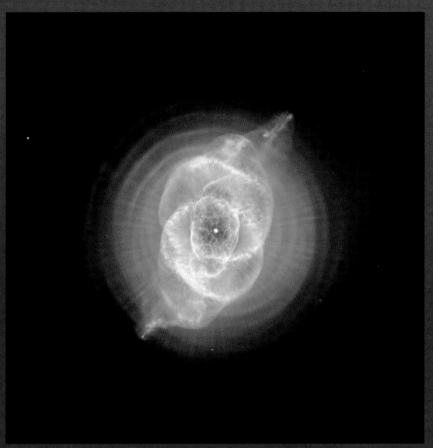

◄▲ The Soap Bubble planetary nebula (in the top of the left image) is remarkably simple whereas the Cat's Eye (NGC 6543) planetary nebula (right) has a highly complex structure. In both cases they are remarkably symmetric, adding to their beauty. Left credit: T. A. Rector (University of Alaska Anchorage) and H. Schweiker (WIYN and NOAO/AURA/NSF). Right credit: NASA, ESA, HEIC, and the Hubble Heritage Team (STScI/AURA), R. Corradi (Isaac Newton Group of Telescopes, Spain), and Z. Tsvetanov (NASA).

Supernova remnants, the remains of a star that exploded hundreds to thousands of years ago, can also make striking images. Similar to planetary nebulae, they can be remarkably symmetric, especially when seen at X-ray energies. They also have complex and intricate details that speak to the tremendous energy that produced them. Unlike planetary nebulae, however, they are not externally lit. Instead, the extremely hot gas within the remnant produces the light, which can be several million degrees even thousands of years after the explosion. When viewed through narrowband filters in visible light, subtle differences in temperature will appear as dramatic variations in color.

Galaxies—giant concentrations of stars, dust, and gas—are great subjects of beautiful images. Astronomers have organized galaxies into three different categories based upon their characteristics. In **spiral** and **irregular** galaxies, these characteristics often combine to make the galaxy colorful. The older, smaller stars

▲ In X-rays, supernova remnants often show a beautiful circular symmetry. Subtle variations in this symmetry, such as in the middle of the Kepler supernova remnant (left) and the lower-right edge of 1E 0102.2-7219 (right), can add intrigue to these objects. Left credit: NASA/CXC/NCSU/M. Burkey et al. Right credit: X-ray (NASA/CXC/MIT/D. Dewey et al. and NASA/CXC/SAO/J. DePasquale); Visible light: (NASA/STScI).

▶ In visible light, supernova remnants can be highly asymmetric and chaotic. Pickering's Triangle (next page), which is part of the Cygnus Loop supernova remnant, is a striking example of this. Credit: T. A. Rector (University of Alaska Anchorage) and H. Schweiker (WIYN and NOAO/AURA/NSF).

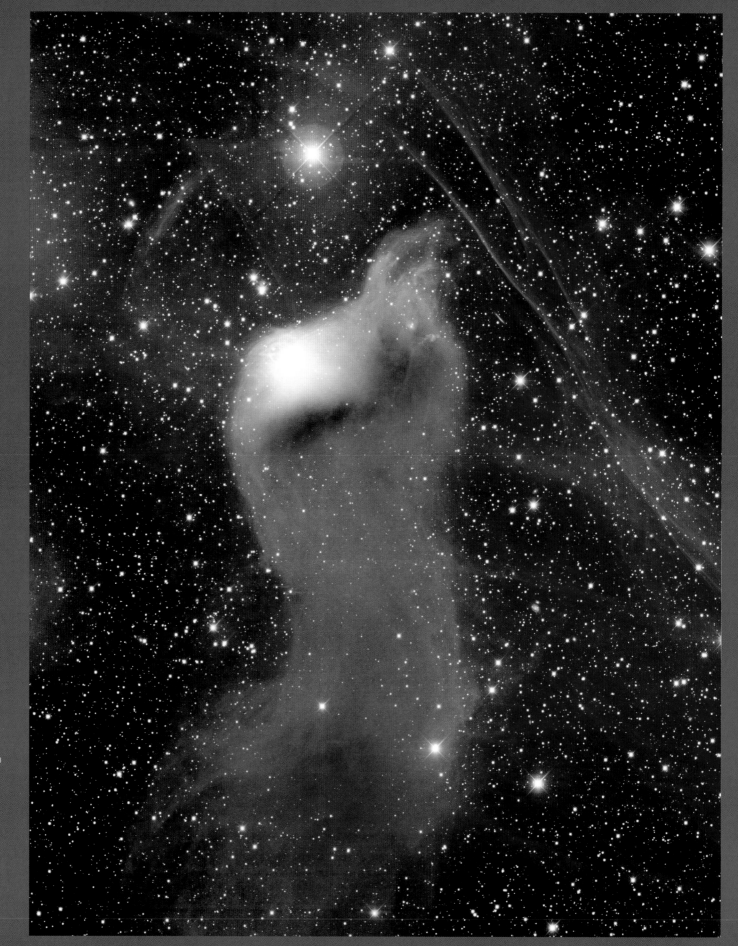

▶ This image contains several photogenic objects. The giant dark brown nebula (named vdB 152) dominates the image. The faint red wisps in the upper-right corner belong to a supernova remnant. Finally, a red Herbig-Haro object can be seen peeking out of the right edge at the top of the dark nebula. Credit: T. A. Rector (University of Alaska Anchorage) and H. Schweiker (WIYN and NOAO/AURA/NSF).

are orange to yellow in color, while the young, massive stars are bluish. Much of the gas within the galaxy is in star-forming regions that glow in hydrogen-alpha red.

Unlike star-forming regions and planetary nebulae, galaxies are internally lit so that all of the light seen comes from objects within the galaxy. Without external lighting it is more difficult to perceive depth in galaxies. However, dust in a galaxy can obscure an area and give us visual cues that help us interpret the structure.

Many people would say that the most beautiful galaxies tend to be the spirals. They usually have a wide range of colors and often have beautiful symmetry in their arms. However, breaks in this symmetry can also make a galaxy interesting—again a mix of the familiar and the unusual. **Elliptical galaxies** are also

▲ The Sombrero Galaxy (M104) contains a disk with a prominent dust lane. The dust absorbs starlight, giving a visual cue that helps to make the galaxy appear three dimensional. Credit: NASA and the Hubble Heritage Team (STScI/AURA).

▲ This visible-light image of the spiral galaxy NGC 6946 (left) shows remarkable symmetry as well as a wide range of colors from the yellow and blue stars and the abundant red star-forming regions. Dust in the galaxy also adds structure. Spiral galaxies are mostly flat, which means their appearance depends strongly on the direction from which they are viewed, as can be seen in this interacting pair of galaxies (right). NGC 5426 (upper right) is seen more on edge and therefore looks flatter than NGC 5427 (lower left). Both credits: Gemini Observatory/AURA and T. A. Rector (University of Alaska Anchorage).

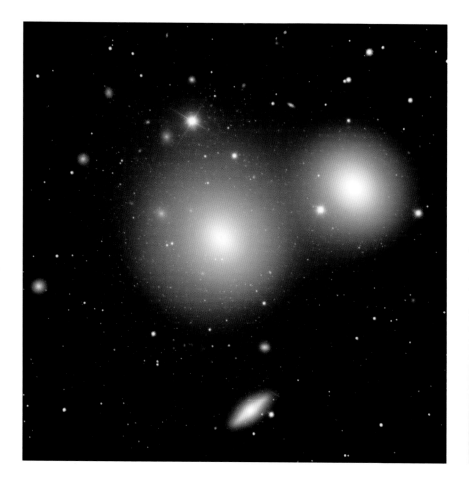

▲ Elliptical galaxies tend not to be as visually interesting as spirals or irregulars. The image on the left shows the two elliptical galaxies NGC 3311 (center) and NGC 3309 (right). We find the image on the right of the elliptical galaxy NGC 1316 more interesting because it contains complex patterns of dust, likely the result of a recent collision with a spiral galaxy. Left credit: Gemini Observatory/AURA and T. A. Rector (University of Alaska Anchorage). Right credit: NASA, ESA, and the Hubble Heritage Team (STScI/AURA), P. Goudfrooij (STScI).

usually highly symmetric. Because they do not have much active star formation, they tend to contain only yellowish older stars, no star-forming regions, and little dust. Thus they usually have little color variation or interesting structure. Irregular galaxies, as the name implies, do not fit into either the spiral or elliptical galaxy categories. They can have complex and unusual structures. Often the structure is so chaotic that they can lack visual cues that help to understand them.

Perhaps the least diverse class of astronomical objects is the globular cluster. These are ancient, compact, and dense objects that contain hundreds of thousands of older stars. Gravity holds these stars tightly together. Globular clusters are visually interesting because of the remarkable density of stars. However, they tend to all look the same, and it usually takes an expert in globular clusters to tell one from another.

THE NATURAL AND SUPERNATURAL

Imagine you're on a camping trip in Colorado. As you're sitting around the camp-fire, shortly after sunset you see a majestic full Moon begin to rise above the mountains. You and your camping buddies gasp at the immense size of the Moon. A few hours later the Moon will be high in the sky. It doesn't look nearly as impressive now—even though it is actually still the same size. It's an optical illusion caused by its location. When the Moon is close to the horizon, it will seem big because it is near objects we know to be large, such as mountains, buildings, and tall trees. Once high in the sky, it is silhouetted against the blackness of space. It feels small and lonely indeed.

When looking at the night sky, we often have Earth-bound visual elements that help us interpret what we see. With a few exceptions, **deep sky** astronomical

▲ Irregular galaxies often have unusual, chaotic shapes. They tend to be smaller than spiral and elliptical galaxies, but frequently contain relatively high fractions of hot, massive stars that are the result of recent star formation. The Wolf-Lundmark-Melotte (WLM) galaxy (left) shows evidence of moderate star formation (with some HII regions near the center of the galaxy), whereas NGC 1569 (right) is a hotbed of vigorous star birth. Left credit: Local Group Survey Team and T. A. Rector (University of Alaska Anchorage). Right credit: ESA, NASA and P. Anders (Göttingen University Galaxy Evolution Group, Germany).

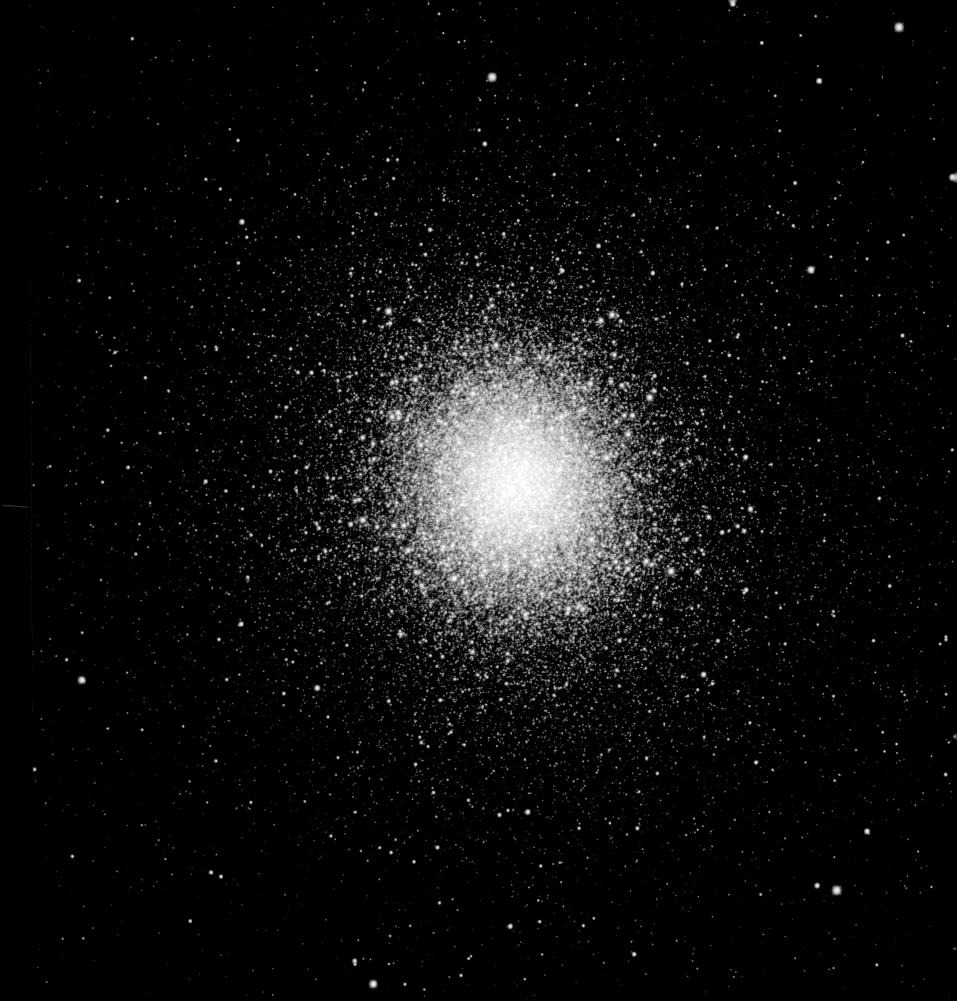

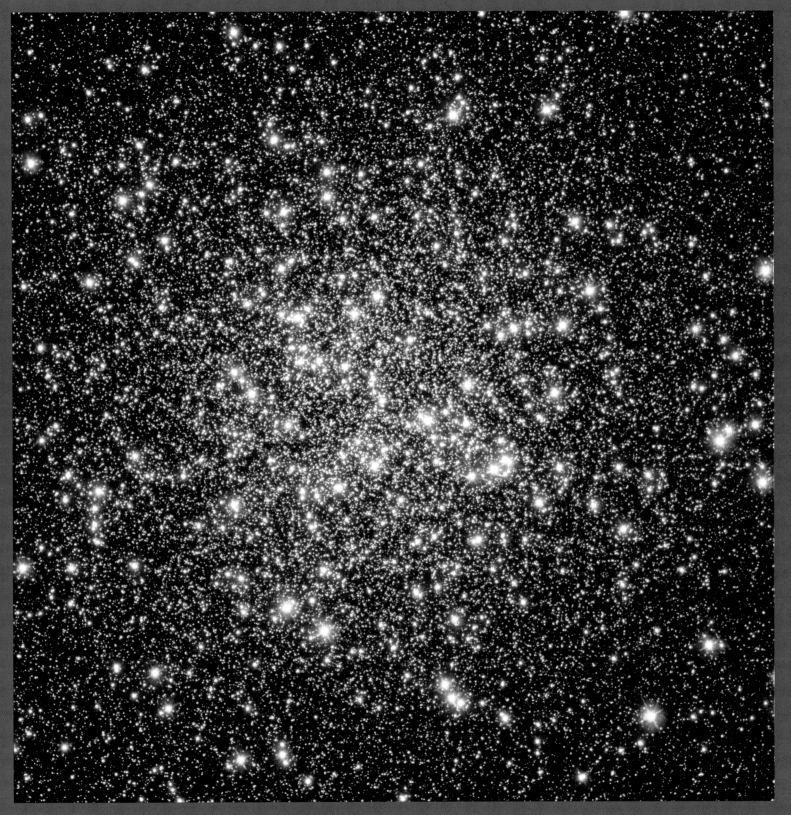

◄ ▲ A wide-field view of the globular cluster M13 with the KPNO 4-meter telescope (opposite page) and a zoom-in with *Hubble* (above). You've now seen pretty much every type of globular cluster image out there! Left credit: T. A. Rector (University of Alaska Anchorage) and H. Schweiker (WIYN and NOAO/AURA/NSF). Right credit: NASA, ESA, and the Hubble Heritage Team (STScI/AURA).

◀ In these images of Comet Hyakutake (opposite) and Comet Hale-Bopp there is a juxtaposition of the familiar and unfamiliar—an Earthly landscape with an exotic celestial visitor. The trees and tent give perspective to these images. You can easily imagine being there and seeing it yourself. Both credits: T. A. Rector (University of Colorado).

▶ Moonrise over the Puy de Dôme with the towers of the cathedral of Clermont-Ferrand. The Moon seems particularly large because of its visual proximity to the mountains. Credit: This file is licensed under the Creative Commons Attribution-Share Alike 3.0 Unported, 2.5 Generic, 2.0 Generic, and 1.0 Generic license. Author: Arcane17.

images (those taken through a telescope) lack these direct visual cues. But we can still use elements *within* the image that look familiar to understand it. Structures that look like objects we may see here on Earth, such as mountains or pillars, can help give us perspective. They can make the objects in the astronomical image seem big because, just like with the Moon, we perceive mountains and pillars on Earth to be big. This familiarity helps the viewer to better understand these images, whereas the color and other details may make the object seem exotic and unfamiliar. Again, we can take advantage of the familiar and unfamiliar working together to make these astronomical images more visually engaging.

This familiarity may serve an additional purpose. Art historian Elizabeth Kessler found that astronomical images from *Hubble* and other observatories serve a role similar to nineteenth-century paintings of the American West. At that time quality photography did not yet exist. Paintings, by artists such as Albert Bierstadt and Thomas Moran, were the only way that Americans who lived in the East could see western landscapes. Astronomical photography serves a similar purpose, giving people an opportunity to see exotic worlds they too will never visit. In both cases, visual cues in the images help people to understand and interpret what they see.

◀▲ Pillars seen in IC 5070 (upper left) and NGC 6820 (upper right) bear a remarkable similarity to pillars seen on Earth, such as those in Bryce Canyon National Park in Utah (bottom). The pillars above were sculpted by ultraviolet light from nearby stars, whereas the pillars in Bryce were eroded by water. Their visual similarity is striking. Top two credits: T. A. Rector (University of Alaska Anchorage) and WIYN. Bottom credit: This file is licensed under the Creative Commons Attribution-Share Alike 2.5 Generic license. Author: Luca Galuzzi—www.galuzzi.it.

▲ Americans living in the East had not yet seen mountains the size or shape of those in the Rocky Mountain range. But visual cues, such as their bluish color, conveyed the large distance to (and therefore immense size of) the mountains in this painting. Other visual cues, such as the horses and lake, also help provide a frame of reference. Credit: Albert Bierstadt painting, *The Rocky Mountains, Lander's Peak*.

ANATOMY OF AN IMAGE: BREAKDOWN OF THE PILLARS OF CREATION

In 1995, NASA released one of its most popular and enduring images. Just a couple of years after astronauts repaired its vision, *Hubble* captured an image of M16, the star-forming region known as the Eagle Nebula. Specifically, the image shows the "talons" of the eagle, which are the three bright pillars of gas and dust near the center of the nebula. Since the release of *Hubble*'s image, this particular region has earned the nickname the "Pillars of Creation."

This image is regarded as one of the greatest astronomical images ever made. Surprisingly, how it was made was almost entirely by accident. So why was it so successful? In hindsight, with what we know about artistic principles of composition, we can understand its popularity.

First, the image is enhanced by the presence of several of Johannes Itten's color contrasts. Astronomers observed the nebula with the narrowband filters of [OIII], hydrogen alpha, and [SII], and assigned the filters blue, green, and red colors respectively (a chromatic ordering). Because the gas at the center of M16 is hot, subtle variations in temperature and density cause significant differences in color, meaning the contrast of hue is abundant in the image. The light/dark contrast is visible between bright and dark areas in the pillars. The warm/cool contrast is seen between the cyan (blue-green) "cool" gas and the "warm" yellow pillars. This contrast gives depth to the image, causing the pillars to stand out against the backdrop. The complementary contrast is also present between pink (light red) halos of the stars and the cyan gas.

As a star-forming region, the pillars are also externally lit by several stars inside and out of the image, giving strong visual cues that help us to infer the shape of the pillars. For example, the large pillar on the left is illuminated by a star above the image, creating complex shadows underneath the top of the pillar. At the bottom of the pillar, the lighting makes it clear where additional ridges and "knobs" are present. The middle and right pillars are illuminated from behind, causing the outer edges of the pillars to glow. The viewer can infer the right pillar as being in front, because a portion of it overlaps the middle pillar.

The composition of this image was unintentional; the camera was oriented so that the pillars would fill the unusual shape of the WFPC2 camera. Nonetheless, the composition is compelling. The tight cropping gives the illusion that the pillars are large and seen close-up. The strong vertical lines in the pillars give them a sense of size and grandeur. However, curved lines within the pillars make them seem soft and pliable. The pillars also seem familiar, like those seen in canyons here on Earth. But the green and yellow colors make them seem unfamiliar—a place like something on Earth, but not quite.

Warm/Cool and
Hue Contrasts

Complementary
Contrast

Tight cropping

Light/Dark
Contrast

External Lighting

Overlap

▲ Many of the successful elements of the
Hubble image of M16 are labeled here. Credit:
NASA, ESA, STScI, J. Hester, and P. Scowen
(Arizona State University).

The image also benefited from being one of the first of its kind. Using narrow-band filters to produce images in this way was in 1995 a novel technique. As discussed before, it also greatly benefited from rapid distribution from a relatively new Internet. It was a perfect storm with a near-perfect image. Keith Noll, the leader of the Hubble Heritage program, once said that its only imperfection is that the cosmetic defects in the image (for example, the CCD bleeds from the bright star near the center left) were not removed. Aside from that, it is an image that is worthy of being hung in an art gallery.

SCIENTIFIC *AND* BEAUTIFUL

In this book we've talked about the complex process of converting what the telescope can see into something we humans can see. It's a fundamental challenge because our telescopes observe objects that, with a few exceptions, are invisible to our eyes. That is of course the reason why we build telescopes. There would be no point in building machines like Gemini, *Hubble*, and *Chandra* if they didn't expand our vision. Astronomers use telescopes to study and understand the fundamental questions of how we came to be: from the formation and fate of the Universe; to the generation and function of galaxies; to the birth, life, and death of stars inside galaxies; to the planets and moons around these stars; and to the origin of life here and possibly on worlds beyond our own.

The images in this book (and elsewhere) show the science that is being done with these telescopes. The reputations of the observatories, and the scientists who use them, are tied to the truth of what's in the image. No self-respecting scientist would intentionally do something to create a misleading image from his or her data. Think of a doctor who has taken an X-ray of an ailing patient. He or she may use techniques to enhance the picture so that more detail can be seen, but he or she would never add or remove a fracture in a bone. The same is true here.

But as we've also described, there are many steps and many choices involved when creating an astronomical image. Scientists are people and they have their own preferences, tastes, tendencies, and biases. We've tried to break down how the image creation process can use time-tested artistic principles of color and composition. If applied properly, these techniques can help a fascinating starscape be even more so. Ultimately the goal is a scientific one: to share with people the discoveries astronomers are making with these fantastic machines of exploration. With advances in telescopes, cameras, and image-processing software, we continuously improve our ability to see planets, stars, and galaxies. Although each image is a representation, it offers a real view into our real and fascinating Universe.

EPILOGUE

Seeing the Eye (and Hand) of God: Pareidolia, or Seeing Faces/Objects in Astronomical Imagery

Throughout the book we've talked about how our goal is to make astronomical images accessible and aesthetic. We hope we've inspired you to find out more about the many fascinating objects in our Universe, and what scientists are learning about them. We've also discussed many of the factors that can help make an image appealing. But there's one more factor that, strangely enough, can make an image hugely popular. And that's the phenomenon of seeing the appearance of familiar objects or faces. A spectacular image of two galaxies tearing themselves apart may get some attention. What if it happens to look like a cat? It has a high chance of going viral.

The phenomenon in which our brains find seemingly significant patterns in images or sounds has a name: **pareidolia**. Our minds can perceive faces or other recognizable patterns where none actually exist. A game most kids have played is to look for recognizable objects in clouds as they pass by on a sunny day. One cloud might look like an elephant, the next, a pirate ship. Even Leonardo da Vinci—a man of many talents—suggested that artists could use pareidolia as a creative exercise for painting.

▶ Sharpless 68 is a planetary nebula that is estimated to be around 45,000 years old. But that's not as interesting as the fact that it looks like a flaming skull! Credit: T. A. Rector (University of Alaska Anchorage) and H. Schweiker (WIYN & NOAO/AURA/NSF).

▲ The Bucegi Sphinx (left), a Romanian national natural monument, earned its name from its appearance when viewed from this angle. The pulsar B1509-58 (right), as seen in X-rays, has earned the nickname "The Hand of God." Left Credit: "Bucegi Sphinx—Romania— July 2009" by Radu Privantu—licensed under creative commons attribution 2.0 via Wikimedia commons. Right Credit: NASA /cXc/ SAO /P. Slane et al.

Pareidolia also happens in astronomy. The constellations are the original example of seeing people, animals, or objects in the random arrangement of stars in the night sky. There is also a long tradition of giving informal names to galaxies and nebulae that describe what they look like. We've already talked about the Eagle Nebula, Horsehead Nebula, Cat's Eye (and Cat's Paw) Nebula, and more. Take a look at this image in the upper-right corner. It was released by *Chandra* in 2009.

Not surprisingly, this object was nicknamed the "Hand of God," which quickly became a much more popular name than its dull astronomical handle of PSR B1509-58. At the center of B1509-58 is a tiny, dense, spinning star known as a pulsar. This little dynamo is responsible for spewing energized particles that resemble the "fingers" and other structures seen in this X-ray image. Even though scientists can explain the object's shape without any references to extremities or deities, we nonetheless can't help but see them.

Why do we see such shapes in our landscapes, food, and cosmic images? Part of it is that human brains have evolved to efficiently recognize facial features. We can imagine that for our ancestors, who descended from safe perches in trees, the

◀ Circinus X-1 (left) was created by a neutron star in orbit around a star several times the mass of the Sun. NGC 246 (right) is a planetary nebula. What we see: Skulls in space! Left credit: X-ray: NASA/CXC/Univ. of Wisconsin–Madison/S. Heinz et al.; Visible light: DSS; Radio: CSIRO/ATNF/ATCA). Right credit: Gemini Observatory/AURA and T. A. Rector (University of Alaska Anchorage).

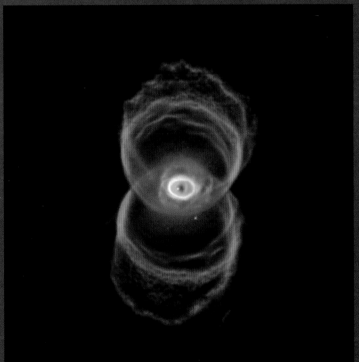

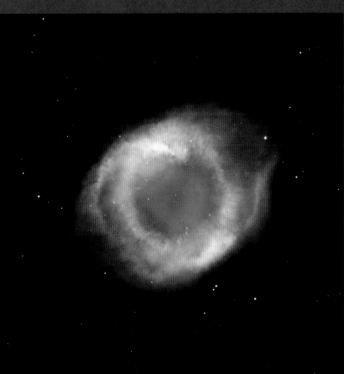

◀ MyCn18 (left) and the Helix Nebula (right) are planetary nebulae, low-mass stars like our Sun that are at the end of their lives. What we see: Eyeballs in space. Left credit: Raghvendra Sahai and John Trauger (JPL), the WFPC2 science team, and NASA. Right credit: NASA, NOAO, ESA, the Hubble Helix Nebula Team, M. Meixner (STScI), and T. A. Rector (NRAO).

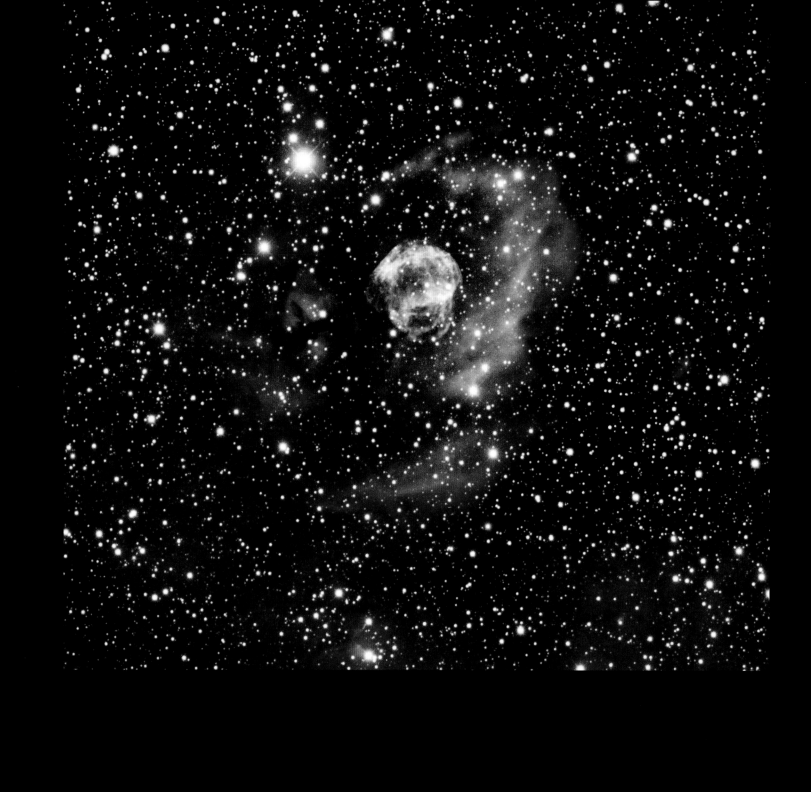

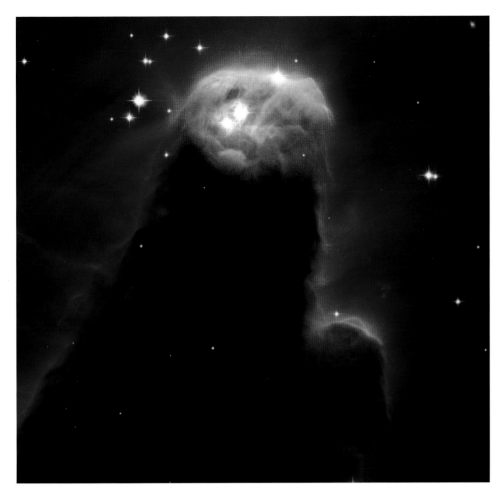

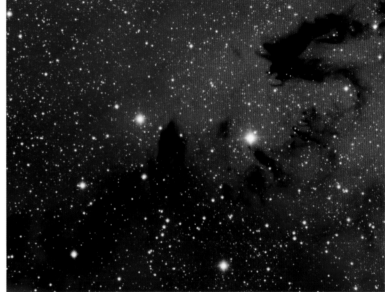

ability to quickly spot a predator in the bush was an asset. Our brains learned to process recognizable shapes; for example, newborn babies will more often look at an object that resembles a face than one that doesn't.

Our minds process and store a tremendous amount of information. And that information is recalled when seeing the world around us. The process of creating meaning out of these patterns might say something about your knowledge base, and your expectations as well. Part of what makes pareidolia fun with astronomical images is that it gives us some familiarity with objects quite literally unlike anything here on Earth. Once again it's the combination of the familiar and unfamiliar that makes it appealing.

◀ The Cone Nebula (NGC 2264) is so named because of its shape. But it has also evoked religious pareidolia, with people claiming to see either Jesus praying or the Virgin Mary, as seen from behind cradling a baby Jesus. Credit: NASA, H. Ford (JHU), G. Illingworth (UCSC/LO), M. Clampin (STScI), G. Hartig (STScI), the ACS Science Team, and ESA.

▲ NGC 6559 is part of a larger star-forming region in the southern constellation Sagittarius. What we see: The dark nebula resembles a Chinese dragon. Credit: Gemini Observatory/AURA and T. A. Rector (University of Alaska Anchorage).

◀ Cataloged as IPHASX J205013.7+465518, this relatively old and faint planetary nebula was discovered by the INT/WFC Photometric H-alpha Survey of the Northern Galactic Plane (IPHAS) in 2005. What we see: An ear. Credit: T. A. Rector (University of Alaska Anchorage) and H. Schweiker (WIYN and NOAO/AURA/NSF).

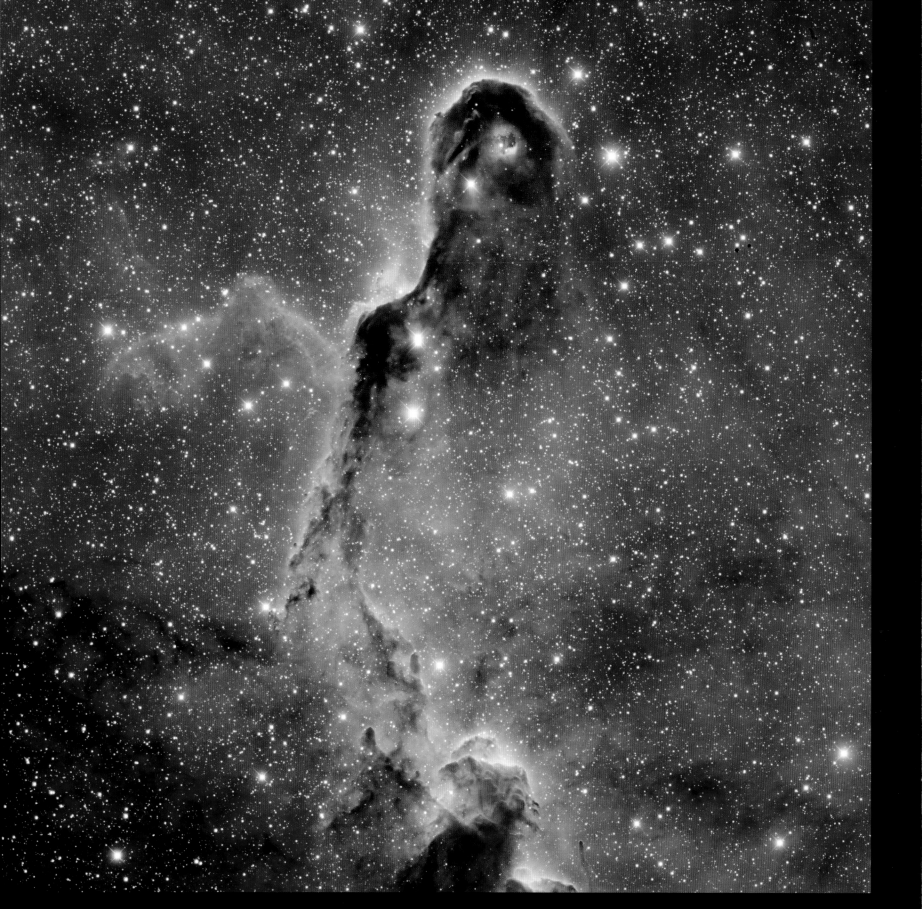

NASA's *Viking 1* orbiter spacecraft photographed this region (left) in the northern latitudes of Mars in 1976. The speckled appearance of the image is due to missing data, called bit errors, caused by problems in transmission of the photographic data back to Earth. Bit errors comprise part of one of the "eyes" and "nostrils" on the eroded rock that resembles a human face near the center of the image. Shadows in the rock formation give the illusion of a nose and mouth. A high-resolution close-up image (top) taken in 2007 by the *Mars Reconnaissance Orbiter* shows that it does not really look like a face. Left credit: NASA/JPL. Top credit: NASA/JPL/University of Arizona.

Perhaps the most famous example of pareidolia in astronomy is the "Face on Mars." When NASA's *Viking 1* orbiter observed the northern hemisphere of Mars in 1976, a rock formation in the Cydonia region seemed to bear a striking resemblance to a human face. The image captured the imagination of the public and was even cited by conspiracy theorists as "proof" of advanced alien life on Mars. Imaging of the rock by later missions to Mars showed that it didn't really look like a face; it was just an illusion caused by shadows and data errors in the original image. But that's not nearly as much fun.

To wrap up the book we present our own catalog of cosmic pareidolia with images from deep space. Some of these have been floating around the astronomical community for years, while others are our own personal favorites. The "what we see" part of the caption describes what we, and others, think that it looks like. At the beginning we've placed the strongest visual objects (to us, at least). Toward the end of the epilogue, you might have to get more creative to see the same shapes we do. Enjoy!

◀ Formally known as IC 1396A, this dark nebula is more commonly known as the Elephant Trunk Nebula. We think the nickname is spot on. Credit: T. A. Rector (University of Alaska Anchorage) and H. Schweiker (WIYN and NOAO/AURA/NSF).

▲ ▶ Saturn is the second largest planet in the Solar System, surpassed in size only by Jupiter. Around Saturn's north pole, a storm (above) in its atmosphere is raging. The storm shows a strange six-sided weather pattern known as "the hexagon." Sharpless 174 (right) is a combination emission and reflection nebula. What we see: Red roses, from the top and the side. Above credit: NASA/JPL-Caltech/SSI. Right credit: T. A. Rector (University of Alaska Anchorage) and H. Schweiker (WIYN and NOAO/AURA/NSF).

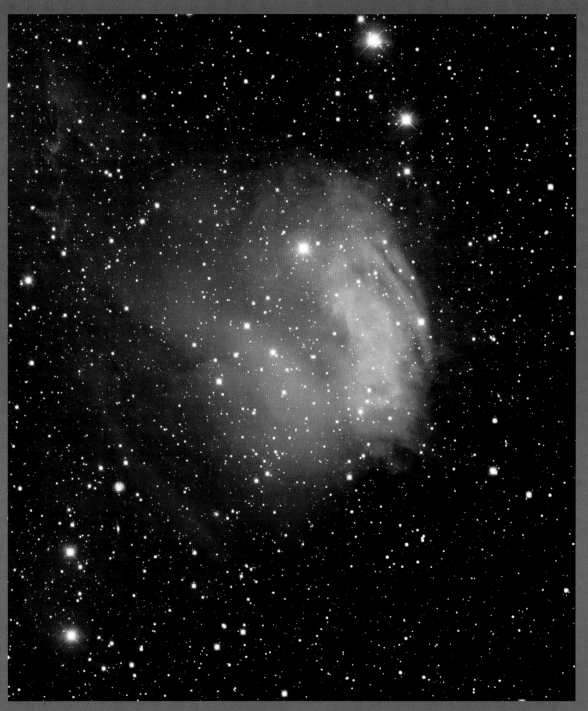

▲ These images of VV 340 (left) and Arp 194 (right) each show two galaxies in the early stages of an interaction that will eventually lead to them merging to form one. What we see: An exclamation point and a question mark. Left credit: X-ray: NASA/CXC/IfA/D. Sanders et al.; Visible light: NASA/STScI/NRAO/A. Evans et al. Right credit: NASA, ESA, and the Hubble Heritage Team (STScI/AURA).

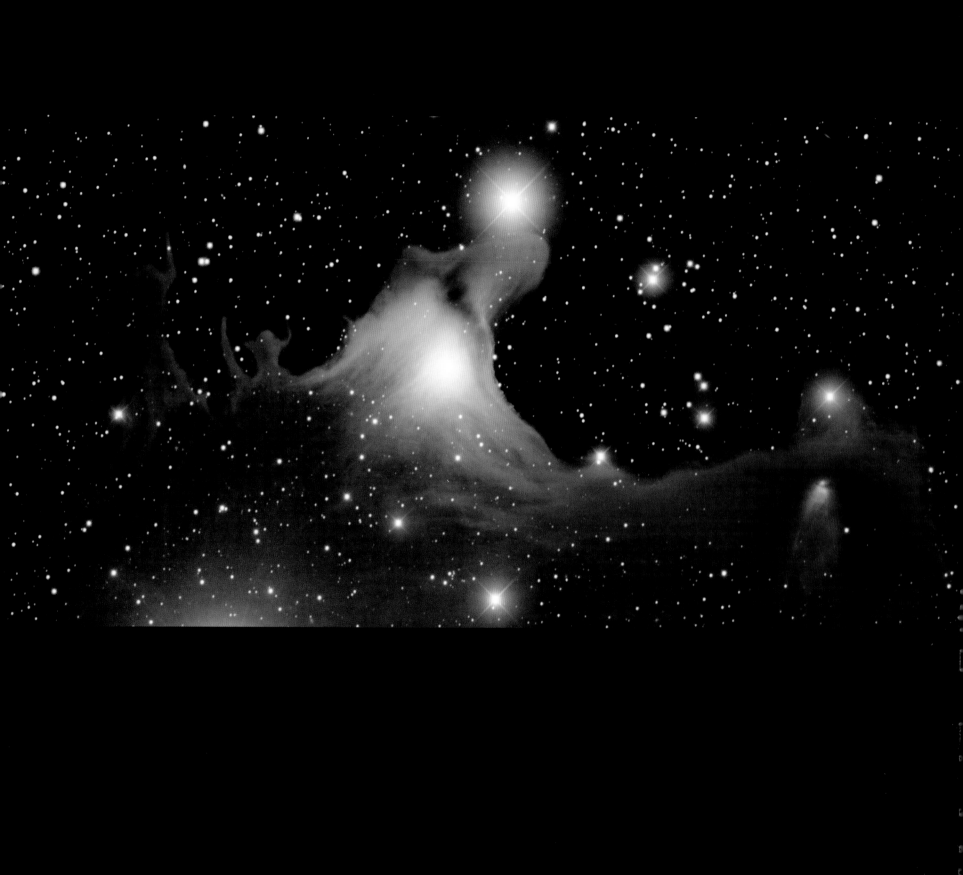

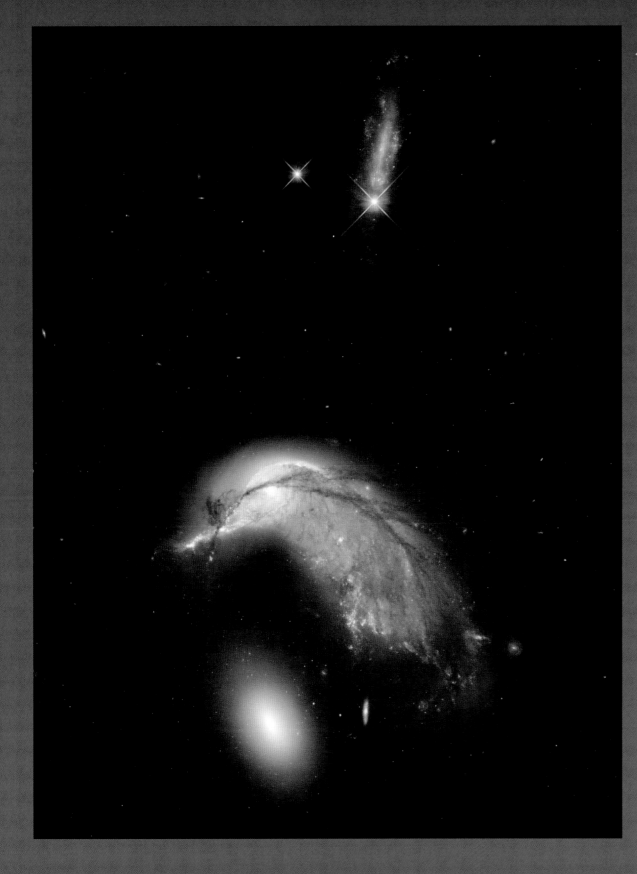

◄◄ vdB 141 is a reflection nebula in which interstellar dust shines in the reflected light of nearby stars. In some parts of the nebula, the dust accumulates to form dense clouds of gas from which it is thought young stars are born. What we see: A flying ghost. Credit: T. A. Rector (University of Alaska Anchorage) and H. Schweiker (WIYN & NOAO/AURA/NSF).

◄ The once-flat disk of the spiral galaxy NGC 2936 (bottom center) is warped into the profile of a bird by the gravitational tug of the companion NGC 2937 below it. What we see: A penguin's head coming out of the water. Credit: NASA, ESA, and the Hubble Heritage Team (STScI/AURA).

▲ ▶ W49b (above) is a supernova remnant and MWP1 (opposite page) is a planetary nebula. What we see: Flying
bats! Above credit: X-ray: NASA/CXC/MIT/L. Lopez et al.; infrared: Palomar; radio: NSF/NRAO/VLA.
Right credit: T. A. Rector (University of Alaska Anchorage) and H. Schweiker (WIYN & NOAO/AURA/NSF).

234

▲ ▶ Barnard 163 (at the center of the image on the opposite page) is a dark nebula embedded in the giant emission nebula IC 1396. Another dark nebula (above) that is just south of vdB 141. What we see: Birds in flight. Both credits: T. A. Rector (University of Alaska Anchorage) and H. Schweiker (WIYN and NOAO/AURA/NSF).

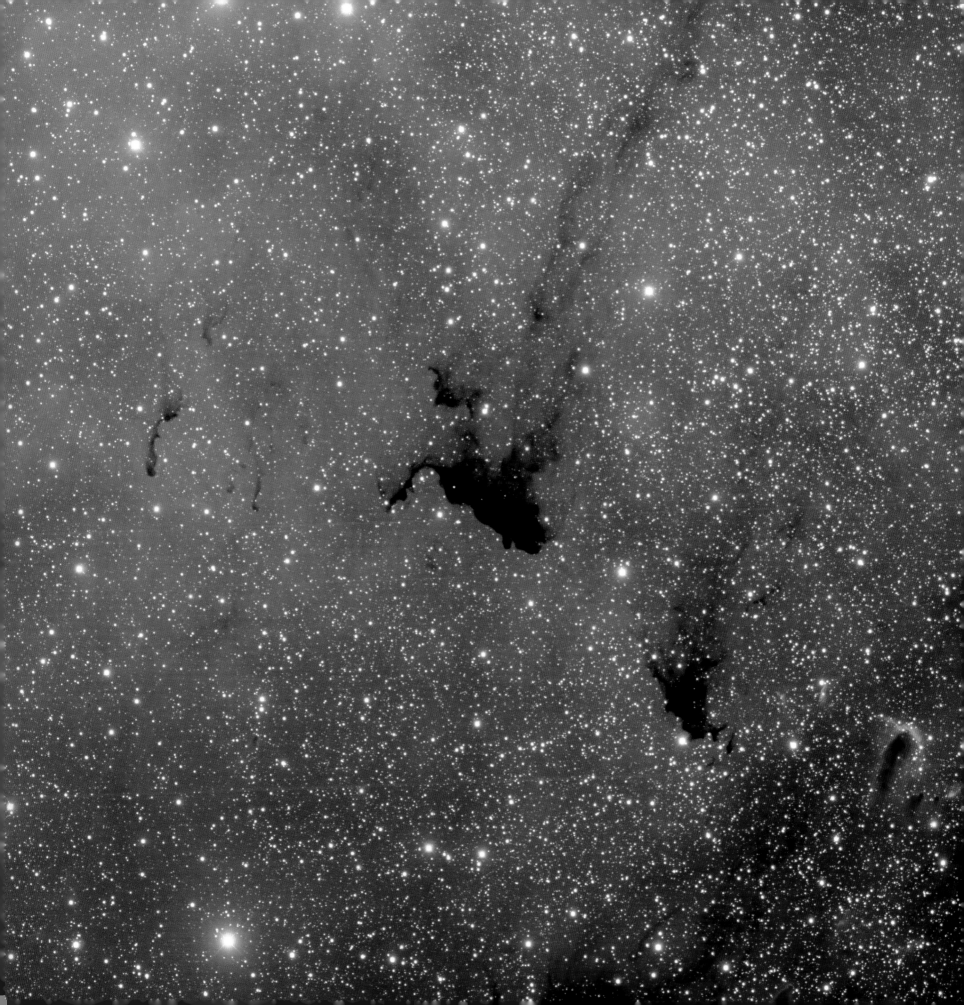

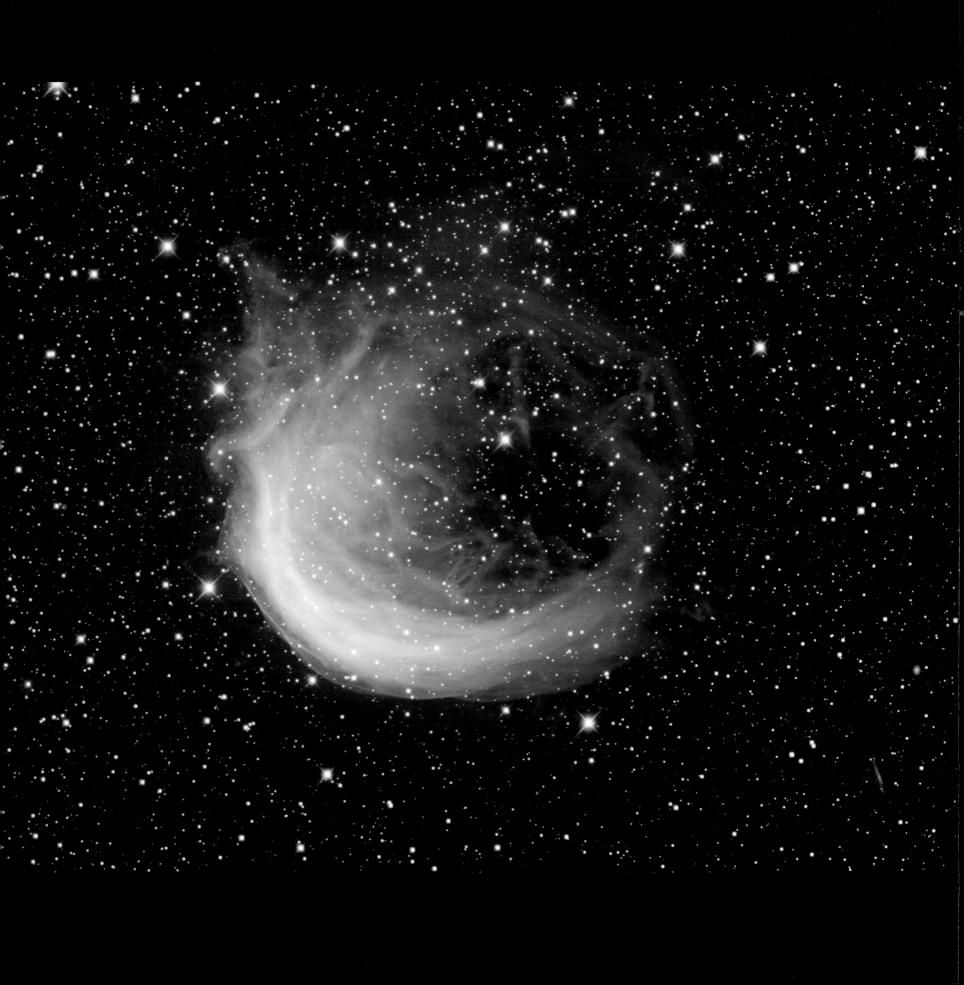

▲ The planetary nebula Abell 21, informally known as the Medusa Nebula (left), doesn't really look like Medusa to us, but a portion of the giant HII region Sharpless 260 (right) does! What we see: The head of Medusa looking to the left. Credit: T. A. Rector (University of Alaska Anchorage) and H. Schweiker (WIYN & NOAO/AURA/NSF).

◄ Sharpless 188 is a planetary nebula whose shape is distorted by its motion through space. What we see: The Firefox logo. Credit: T. A. Rector (University of Alaska Anchorage) and H. Schweiker (WIYN & NOAO/AURA/NSF).

238

▶ Informally known as "Thor's Helmet," NGC 2359 is a giant bubble that is being blown off of the Wolf-Rayet star HD 56925 near the center of the nebula. Wolf-Rayet stars are extremely massive, hot, and luminous. Their intense energy blows off the outer layers, causing the bubble shape seen here. The complex shape of the bubble is due to its interaction with the dust and gas in which the star is embedded. What we see: A squished frog. Credit: T. A. Rector (University of Alaska Anchorage).

▶ G70.5+1.9 is located near the edge of the giant HII emission nebula Sharpless 100. It is likely a supernova remnant, the leftovers of a star that exploded years ago. What we see: An eagle in flight (its blue beak on the left). Credit: T. A. Rector (University of Alaska Anchorage) and H. Schweiker (WIYN & NOAO/AURA/NSF).

NOTES

CHAPTER 1

1. Kitt Peak National Observatory (KPNO) and the Cerro Tololo Interamerican Observatory (CTIO) are part of the National Optical Astronomy Observatory (NOAO), which is operated by the Association of Universities for Research in Astronomy (AURA) under a cooperative agreement with the National Science Foundation (NSF).

2. One light-year equals the distance that light travels in a year. This is roughly 6 trillion miles (10 trillion kilometers).

3. In this book we'll use both the "imperial" system of measurement (inches and feet) and the metric system. The imperial system will seem more familiar to readers in the United States, although metric is the standard system for science. There is a joke that "only scientists, Europeans, and drug dealers use the metric system." But in reality just about everyone, except for those living in the United States, Burma, and Liberia, uses metric.

CHAPTER 2

4. In this book we'll use the phrase "visible light" when referring to the light our eyes can see. Sometimes this is also called "optical light."

5. From here on out we'll use *Hubble* when referring to the telescope, not the man (that is, astronomer Edwin Hubble).

6. For you camera buffs, a nice super telephoto lens for nature photography may have an effective focal length of 800 mm and an f-ratio of f/8. The Gemini Observatory telescopes have an effective focal length of 130,000 mm and an f-ratio of f/16.

CHAPTER 3

7. Think Pink Floyd. You can Google it if the reference doesn't ring a bell.

8. Note that this is true only for light and our eyes. If you add red and green paint together, you get brown.

9. Red, green, and blue are the most commonly used colors for **additive color**, wherein adding light makes overall color brighter. Historically red, yellow, and blue have been used as the primary colors for painting. This is **subtractive color** because adding paint makes the overall color darker.

CHAPTER 4

10. Historically astronomers have used the Latin method of pluralization. For example, when referring to more than one supernova we tend to say "supernovae" instead of "supernovas."

11. **Dark matter** is an exotic form of material that is unaffected by light. That is, it neither emits nor absorbs any kind of light. Dark matter appears to consist of particles very different from the material out of which stars and planets are made.

CHAPTER 5

12. The Southern Astrophysical Research (SOAR) telescope is a joint project of Conselho Nacional de Pesquisas Científicas e Tecnológicas CNPq–Brazil, the University of North Carolina at Chapel Hill, Michigan State University, and NOAO.

13. Other types of electronic cameras, such as **complementary metal-oxide semiconductor** (CMOS) detectors, are also now common. But CCDs remain the standard for visible-light astronomy.

14. By random coincidence, 1990 was also the year that Photoshop 1.0 was released.

15. Not to be confused with the Mosaic camera at KPNO.

16. A fourth "Great Observatory" called the Compton Gamma Ray Observatory was de-orbited in 2000.

CHAPTER 7

17. There is one observatory that can "see" in 3D. STEREO (Solar TErrestrial RElations Observatory) consists of two nearly identical space telescopes—one ahead of Earth in its orbit, the other trailing behind—that can see the Sun three dimensionally because they are far apart from each other. STEREO works only because it consists of two telescopes that are significantly far apart compared to the distance to the Sun.

CHAPTER 8

18. The planetary nebula will last about 10,000 years, which is a blink of an eye by cosmic standards.

CHAPTER 9

19. As expensive as this may sound, it is actually a tiny fraction of total government expenditures. The 2014 NASA budget for science (which includes the operating costs of *Hubble* and *Chandra*) was about $5 billion. The astronomy budget of the National Science Foundation, which operates KPNO and Gemini, was about $240 million during this time, or about one-twentieth that of NASA's budget. The total federal budget for the same year was $3.8 *trillion*, meaning that about 0.1 percent—a tenth of 1 percent—went to astronomy. That's equivalent to *one penny* out of a ten-dollar bill. It's also five times less than what Americans spend on pizza every year. And it's one hundred times less than how much Americans spend on gambling.

20. Telescopes are put in space to get above the Earth's atmosphere because it blurs visible light and blocks much of the other kinds of light objects emit in space. Unfortunately, launching telescopes into space is expensive. To maximize observations from the ground, telescopes are put on some of the highest and driest spots on the planet to bypass as much of the Earth's atmosphere as possible.

21. The instruments are the electronic devices that go on the telescope to analyze the light that it collects. Many instruments have cameras that can be used to create images in the ways described in this book. But other kinds of instruments exist as well. For example, spectrographs are instruments that precisely measure the kinds of light coming from an object in space. Many telescopes, including *Hubble*, are used for spectroscopy as much as for any other type of observing.

22. Although occasionally people think that astronomers fly out to these space-based telescopes to use them. Now wouldn't that be cool!

23. Musical tastes are as varied as astronomers. Loud music is popular for staying awake on long nights, but not always. One time we got stuck observing with someone who insisted on listening to the Moody Blues at 4:00 a.m.

CHAPTER 10

24. Exposure to UV light through tanning beds significantly increases the risk of developing skin cancer, including melanoma. The risk increase is greatest for young adults (under the age of thirty-five). Don't do it!

25. "keV" is shorthand for **kiloelectronvolt**, a unit of energy used in X-ray astronomy.

CHAPTER 11

26. Why 256? These are called 8-bit images, where 2^8 = 256. You can make 16-bit images as well, but computers and printers can't (yet!) display more than 256 shades of gray.

27. At first this number doesn't have any real meaning. Through a series of calibration steps, astronomers can turn this number into a meaningful measure of the brightness of an object. However, it's not necessary to calibrate the data for the purpose of making an image.

28. Cosmic rays are energetic particles from space that frequently bombard the Earth.

CHAPTER 12

29. Typically, when astronomical images have been rotated so that north is *not* up, astronomers make note of that change in the image's text, in its metadata, or even as a compass drawing on the image itself.

FIGURE CAPTIONS

1. The WIYN Observatory is a joint facility of the University of Wisconsin–Madison (W), Indiana University (I), Yale University (Y), and the National Optical Astronomy Observatory (N).

2. A joke at many observatories is, "Astronomers shouldn't be allowed near the telescope, because they'll break it. And they shouldn't be allowed near the data, because they'll accidentally delete it."

3. The Very Large Array (VLA) and Very Long Baseline Array (VLBA) are operated by the National Radio Astronomy Observatory (NRAO). NRAO is a facility of the National Science Foundation operated under cooperative agreement by Associated Universities, Inc.

RESOURCES

OBSERVATORY, SPACE AGENCY, AND ASTRONOMY IMAGE WEBSITES

- ALMA: http://www.almaobservatory.org/.
- AstroPix: http://astropix.ipac.caltech.edu/.
- *Chandra* X-ray Observatory: http://chandra.si.edu.
- European Southern Observatory: http://www.eso.org/.
- European Space Agency: http://eas.int.
- Gemini Observatory: http://www.gemini.edu/.
- *Hubble* Space Telescope: http://hubblesite.org/.
- MMT Observatory: http://www.mmto.org/.
- NASA: http://nasa.gov/.
- NOAO: http://www.noao.edu/.
- NRAO: http://www.nrao.edu/.
- Portal to the Universe: http://portaltotheuniverse.org/.
- *Spitzer* Space Telescope: http://www.spitzer.caltech.edu/.

WORKING WITH ASTRONOMY DATA AND IMAGES

- ESA/ESO/NASA FITS Liberator: http://www.spacetelescope.org/projects/fits_liberator/.
- Chandra OpenFITS: http://chandra.harvard.edu/photo/openFITS/.
- Chandra Education Data Analysis Software and Activities: http://chandra-ed.cfa.harvard.edu/.
- List of Image Archives and Virtual Observatories: http://tdc-www.harvard.edu/astro.image.html.
- MicroObservatory: http://mo-www.cfa.harvard.edu/MicroObservatory/.

BOOKS

- *The Cosmic Perspective Fundamentals*, J. Bennet.
- *Eyes on the Skies: 400 Years of Telescopic Discovery*, G. Schilling, L. L. Christensen.
- *Far Out: A Space-Time Chronicle*, M. Benson.
- *First Light: The Search for the Edge of the Universe*, R. Preston.
- *Giant Telescopes: Astronomical Ambition and the Promise of Technology*, W. Patrick McCray.
- *Hidden Universe*, L. L. Christensen, R. Fosbury, and R. Hurt.
- *The Hubble Wars: Astrophysics Meets Astropolitics in the Two-Billion-Dollar Struggle over the Hubble Space Telescope*, E. Chaisson.
- *The Invisible Universe*, D. Malin.
- *Picturing the Cosmos: Hubble Space Telescope Images and the Astronomical Sublime*, E. A. Kessler.
- *Voyages through the Universe*, A. Fraknoi.
- *Your Ticket to the Universe*, K. Arcand and M. Watzke.

POPULAR ASTRONOMY WEBSITES

- Astronomy Picture of the Day: http://apod.nasa.gov/apod/astropix.html.
- Astrophotography and Astrophysics, Dr. Travis A. Rector: http://aftar.uaa.alaska.edu/.
- Microsoft's Worldwide Telescope: http://www.worldwidetelescope.org/.
- Phil Plat's Bad Astronomy blog: http://www.slate.com/blogs/bad_astronomy.html.
- Space.com: http://space.com/.
- Universe Today: http://www.universetoday.com/.

INDEX